Baron
Wolman

Every Picture Tells a Story...

Baron Wolman

The Rolling Stone Years

ISBN: 978.184772.740.4
Order No: VO10450

Design: Don Wise & Co., Kim Maharaj-Mariano
Picture Editor: Dave Brolan
Interviews by Dave Brolan

End Paper Photograph: Psychedelic Liquid Light Show
from the Light Sound Dimension (LSD), San Francisco, 1968

Exclusive Distributors
Music Sales Limited,
14/15 Berners Street,
London, W1T 3LJ.

Music Sales Corporation,
257 Park Avenue South,
New York, NY 10010, USA.

Macmillan Distribution Services,
56 Parkwest Drive
Derrimut, Vic 3030,
Australia.

Printed in China

A catalogue record for this book is available from the British Library.

Visit Omnibus Press on the web at www.omnibuspress.com
Visit Baron Wolman on the web at www.baronwolman.com

Limited edition prints of all photographs appearing in the book
are available from Baron Wolman, baron@baronwolman.com

Baron Was There

It is the face, the expression on the face, to which Baron is most sensitive. You see the subjects the way he saw them, held from the moment he pushed the shutter. The record company told the recording artist to be there. That didn't guarantee them a pleasant time being documented. There are certain photographic documentarians whose images still show the fear discernible in the eye of the hapless subject as if head clamps were still keeping a difficult subject still. In Baron's photos there is acceptance and often delight showing in the twinkle of an eye, a gentle smirk or an enchanting smile, and never the fear often generated by certain uncomfortable demands of contemporary publicity and branding.

The nonchalant innocence of these early simple reflective images eventually morphed into the constructed photographs that dominate pop culture magazines today. Less time, less access, and in the age of the cell phone camera and celebrity gossip websites such as TMZ, maybe less interest in a simple powerful honest portrait. Today everyone knows they are their own brand. Back then in Baron's photographs the subjects seem to know they are their own persons in control of their image by simply putting themselves in his camera-laden hands. So those open, howling, growling, ecstatic faces live on for us in these wonderful Baron Wolman photographs.

The picture was often a partnership between subject and photographer. I understand Baron considered that shot of Pete Townshend with arms outstretched and gaze towards lens a gift, a pose held just a moment longer to make sure Baron "got" the shot. Here's the picture, Pete Townshend poses, arms in flying V, triumphant in white ruffles and gold lamé. But what a face, almost a Buster Keaton deadpan face just for Baron. Backstage in another shot Baron is invisible, the subject's pose is down and his posture is relaxed. In contrast to his heroic stage stance, Pete's posture is downright awful, the weight of all those Les Pauls already bending his thin frame further into the Hammond organ keyboard while a casual Keith looks on and a smiling Roger chats.

It is a delight to write about a Baron Wolman picture, even the most simple of his photographs have something to say. A portrait of Miles Davis at home became one of my favorites by just merely looking at it as he sits spaced out in a fringed space suit, eyes focused on a distance so far away it appears behind him. It makes you wonder, does Miles blow to say that space is truly curved? The two-dimensional folk from his own brush stay behind. Painted backgrounds hoping to hear a muted far-off horn.

Even when posed, like Jerry proudly showing his missing digit, or an enthroned Janis, or Frank Zappa sitting smug on a bulldozer, they remain comfortably themselves. These pictures happened for one reason, Baron was there. He was given absolute access to his subjects and that rarely happens today. He and just a few others were there and have encapsulated precious moments of the rock 'n' roll life. It seems today that the ground they trod, Nikons and Leicas jangling, was rather unexplored. Publications relied mostly on publicity photos from the record companies back then, allowing Baron to choose his shots mostly unhampered by management's image-molding concerns. And choose he did with an eagle eye for the moments that moved him and now move us, on film that ran through his cameras roughly 40 years ago. There they all are, still fresh, still alive, thanks to Wolman and company.

Jim Morrison in ecstatic inner beatific glory nuzzles a sharp-eyed, tight-cropped Dylan next to a Jumpin' Jack Flash Jagger, mouth stretched into Stones-logo abandon. There's Carlos and Jerry, Jimi, Pete, Janis and George Harrison rounding out the frieze that runs along the top of the Baron Wolman Photography website

(www.baronwolman.com). It is heroic; it is a Greek God pantheon-like line-up of rock 'n' roll mugs in transcendent disarray.

The web designer has apple-cored into the heart of Baron's photos – the people. These are not just people but rock gods. Well, in Baron's pictures the rock gods are gods simply because of their still undiminished presence, you see them being moved by the music as they made it and it still moves us, somewhat we hope, as it moved them in making it. Jerry sits in the middle like a goofy Zeus holding up the ceiling, just a Buddha being. There are basically three kinds of photographs happening here. Live concert performances, documentary portraits and studio/semi-posed portraits. Of the whole pantheon only Jerry Garcia notices who's holding the camera and he's glad to meet cha.

So it is in the face, the human face, here less a mask than a mirror for some dancing souls in full life-celebration. The rest of a Wolman picture is composed around the ever-so-expressive faces in the timeless moments created by these musicians.

Back then in the Sixties there weren't too many photographers other than Baron and Jim Marshall who worked this area. Baron and Jim and a few others supplied the images that showed the Sixties revolution in all its iconic and iconoclastic glory. But Baron's are set apart for me because of the consistent humanity in his pictures. Whether it is in a studio portrait, a backstage document or an on-stage performance shot, Baron's subjects always seem to embody the essence of themselves.

Tony Lane, former Art Director of *Rolling Stone*, Oakland, California 2011

The Paper Was Called *Rolling Stone*

I was 32 years old and with a buddy was operating Los Angeles' first headshop – the third in the country, according to *Newsweek* when it featured us in a story – a small store near the UCLA campus called Headquarters. I was also writing both a weekly column as well as regular features for two local "underground" newspapers, the *Los Angeles Free Press* and *Open City*, among the many that we offered for sale. One day in late 1967, someone brought in a new paper and asked if we'd sell it, too. The paper was called *Rolling Stone*.

I said, "Sure, put it over there on the table with the others." I looked through a copy, noticing a request for freelance submissions. I'd recently seen The Doors perform at the Cheetah Ballroom on the beach at Santa Monica where we had a second, smaller shop. I thought Jim Morrison's dive off the stage into the audience was pretentious and said so in my review. The piece was published in the little tabloid's fifth issue and I was sent a check for $15.

At the time of my first submission, someone else was listed on the twice-monthly's masthead as the LA correspondent. Apparently he wasn't sending in much material and the editor, Jann Wenner, a recent graduate of UC Berkeley, asked me to take his place. I didn't think *Rolling Stone* would last much longer than my shop, or The Doors, but I sure wasn't making any money selling roach clips and rolling papers to UCLA students, so I accepted the job.

Well, as history has made abundantly clear, I was wrong about Jim Morrison and The Doors, and I was wrong about *Rolling Stone*, and in the years that immediately followed my telling Jann, "Yes," my life changed both wonderfully and utterly. So, too, did the lives (and lifestyles) of millions, many of them Doors fans, more of them avid readers of *Rolling Stone*.

Baron Wolman was one of them. He was 30 when he met Jann, who was 21, at a one-day rock 'n' roll symposium hosted by Mills College in Oakland, California. At the time, Jann was freelancing for *Sunday Ramparts* and writing for UC Berkeley's *Daily Californian*. With the support of Ralph Gleason, the 50-year-old music columnist for the *San Francisco Chronicle*, he was trying to raise money for the launch of *Rolling Stone*. (I'll explain my insistence on identifying everyone's ages later.) Jann told Baron he needed a staff photographer and they quickly reached an agreement. Baron said he'd take pictures for free if Jann paid for his film and processing and gave him stock in the new company as payment for his services. Baron also noted he would keep all rights to the photographs, although Jann would have unlimited use of them.

I honestly don't remember what I was paid, but it wasn't a staggering sum and there were no vacations, perks, or benefits offered to either of us, save for those we might individually stumble into while on the job. Both of us were already habitués of the scene and that didn't have to be spelled out. Though should anyone reading this think I'm talking about payoffs, I can only suggest a viewing of Cameron Crowe's poignant yet stunningly accurate re-creation of his own life during that period in the 2000 film *Almost Famous*. Cameron was one of *Rolling Stone*'s many illustrious contributors to emerge during the 1960s and 1970s and his film about what it was like to travel on the road with a band on assignment for what had become the hippest magazine on the planet would make anyone who lived through that time wish instantly to return and those who didn't to go there, now. (Cameron was just 16 at the time.)

It was – no question – a glorious time, both celebration and liberation, when the most delicious dreams came true. It was also a period of hype and hyperbole, but it wasn't entirely a falsehood when someone in 1967 coined the phrase "Summer of Love." That was the season of the Monterey Pop Festival and the release of the

Doors classic 'Light My Fire,' Jefferson Airplane's first album, and The Beatles' masterpiece *Sgt. Pepper's Lonely Hearts Club Band.*

The only music media at the time was "establishment" press, boring trade periodicals like *Record World,* *Cashbox*, and *Billboard* that covered the "music biz" with statistics and servility. Jann and Ralph saw the need and opportunity, as Baron put it, "for some sort of journal that would reflect the greater, more personal interest of those of us who listened to music and for whom music had become a big part of our lives." The first issue was dated November 9, 1967 and as Baron and I saw it, our job mission was to roll around in the music and then share what we experienced with however many readers Jann could attract.

A superb little magazine called *Crawdaddy* had preceded *Rolling Stone* by about a year, but Jann's effort quickly roared ahead of it, becoming the vehicle that seemed most accurately to reflect the desires and dreams of its young readers. For my parents' generation, the Sears, Roebuck catalog was the "wish book," as in, "I wish I had the money to buy that." For the *Rolling Stone* generation, it was the wish book of dreams as in, "I wish I was in San Francisco, so I could do that, too." It wasn't so easy to be in America's hinterlands in 1967.

In just a couple of years, Jann and his staff took care of that, creating not only a window through which readers in the most remote cities and towns could look at the world as they wished it to be. He also produced a sort of guidebook that demonstrated how *Rolling Stone*'s readers could reconfigure their own lives and maybe, just maybe, go down that rabbit hole where Grace Slick sang, "Feed your head!" It may have been the first magazine in history you could dance to.

Eventually, it further provided a platform for some of the generation's most creative writers and photographers and it put Jann at the top of the century's media mountain. What Henry Luce was to a much earlier generation and Hugh Hefner was to the next, Jann became for the one that followed. I was recently married and living in Laurel Canyon, which at the time was "rock 'n' roll central" in LA, and once I joined the staff, Jann periodically slept on our couch. He seemed to have two main purposes in making those visits: one was to goose me along when he thought I needed it to finish feature stories. More important was his fund-raising activity, comprised of trips to record company offices to beg for advances on future advertising, to keep the paper afloat. *Rolling Stone* was then, and would be for many years, always in financial crisis.

The record companies were in a state of some disarray, too, as the Sinatra geriatrics and even the Elvis dinosaurs tried to comprehend the rock underground thing, not sure whether to endorse it or not. We were, after all, a bunch of long-haired, anti-establishment hippies who dropped acid, marched in the streets, and fucked in groups. In the end, I think they were afraid not to lend support. Thus also was born the "company freak," the cultural interpreters who served as a bridge between the executives (who began to wear love beads, too) and the musicians and others with whom the executives had so little in common; often they were called A&R men. I'm sure a lot of the record company execs gave Jann a lot of crap on his money runs, but they also gave him the advances he needed.

It was inarguable that he believed in the music's power, and he was always, always poised and ready to defend it. I also thought Jann was an instinctual editor, blessed with the ability to know what was going to be the next big thing before anyone else did, making odd choices sometimes for the cover, but by the time the issue hit the newsstands, his guess was nearly always right. I thought he was a "kid," 10 years my junior and clearly lacking in experience, but I also considered him a good editor.

OK. The age thing. Abbie Hoffman was a fun-loving anarchist who called himself a Yippie, one of the wise guys who at the Democratic convention in 1968 found themselves jailed for their behavior and later tried as the "Chicago 10." He famously once said, "Don't trust anyone over 30" and it became a catchphrase for the era. (Under 25? You were *Time* magazine's "Man of the Year" in 1966!) That made Jann acceptable and Baron and me and, definitely, Ralph Gleason not. (Cameron Crowe was very acceptable.) In the end, it didn't matter. It was where your head was "at," as we used to say, not how many gray hairs were on it.

Baron Wolman was at the center of all this. It was his photography that along with the writing and the attitude of the loyal staffers and freelancers formed the solid base upon which *Rolling Stone*'s future was built. Baron was on the *Rolling Stone* staff for just three years- as was I, although I later returned for a year as a London correspondent and remained on the masthead as a contributing editor for some time – but those were the formative years. Annie Leibovitz succeeded Baron and in the early 1970s, after we'd gone, the staff included a string of firecrackers that included Hunter S. Thompson and his inspired illustrator and cohort Ralph Steadman, Joe Eszterhas, Tim Cahill, Greil Marcus, and Jon Landau, among many more, but the trail was already blazed.

Baron's images were not as memorable as Annie's eventually became, or as commercial. Nor were they intended to be. Where Annie did things like put Mama Cass in a tub of chocolate (long before Whoopi went into a bath of milk) – often, it seemed, for effect – Baron was shooting for a magazine in a newspaper format; during those early years, when you read *Rolling Stone*, you got ink on your fingers. And where Annie shot portraits, Baron was nearly always a photojournalist, preferring, in his words, to capture his subjects "as he or she was in life. As music videos insinuated themselves into our lives," he said, "the musicians became increasingly aware of their public image and began to feel they needed to manage that image. The photographic skills that Jim Marshall and I and other talented music shooters brought to the music scene were supplanted by highly stylized, mostly studio image makers. Their pictures were published only upon the approval of the musician and his or her management."

That's a good appraisal, I think. What came to be called "the Sixties" (although they literally slopped over into the following decade) was a time of considerable innocence, when we were trying to discover who we were – wearing star-burst tie-dyed shirts, reeking of patchouli – and not worrying much about what others thought of how we conducted that search. Unfortunately, even before the chronological 1960s were over, much of this changed and I say now without fear of much challenge that few of us think it's been for the better since.

Baron and I worked together on at least a dozen major stories and many of the photographs in this collection illustrated those articles and interviews. We also collaborated on a book (Jim Marshall was a third partner) called *Festival! The Book of American Music Celebrations* and some of those images are here, too. Perhaps most important, it was Baron's portraits that accompanied the "groupie issue" – a story he suggested to Jann – and his Woodstock coverage that helped make those two phenomena phenomena.

Baron lived in the Bay Area; one of the first occasions for him flying to LA was to take pictures for my *Rolling Stone* interview with Frank Zappa. Another time was to photograph Tiny Tim for my cover profile of Mr. Khaury. I remember these two artists together because in so many ways, except musical, they were two peas from the same mutant pod. Many – if not most – of those who came to be called "hippies" and "freaks" had much of their look and lifestyle – their wardrobe, hair, dope and musical habits – set by others. This is a group to which I humbly belonged.

I may have grown my hair to my shoulders, worn flowers and beads, and become a lifelong cannabis devotee, but I was hardly the first on the block.

Frank and Tiny, on the other hand, lived on their own blocks. They really were different, the kind of "different" you had to be born to be. Frank's "act" visually may have been a send-up – he was willing to do almost anything for its impact – but he was also one of the first to obliterate the walls between rock, jazz, and classical music and, much to the surprise of his contemporaries (many of whom wanted to play or sing with him), he was unbendingly anti-dope. Herbert Khaury became world-famous by playing a ukulele and singing 'Tiptoe Through The Tulips' in a falsetto voice. Appearing and recording under the name Tiny Tim, he not only lived in his own world, he also had his own "time," and it wasn't even the 1960s, it was 30 or 40 years earlier. His hero wasn't Elvis, it was Gene Austin, a crooner from the 1920s.

At the time of our interview/photo, Frank was living not far from me in Laurel Canyon, in the funky but large log cabin that was once the home of cowboy star Tom Mix (directly across the street from the ruins of Harry Houdini's castle). As Baron's pictures show, there were some caves and heavy earth-moving equipment in a wooded area behind his house and that's where Frank's portraits were taken.

Baron thought of Tiny as the ultimate flower child, so he took him a bouquet of long-stemmed flowers and as a result, we nearly lost the interview due to Mr. Tim's ecstasy. Some of the pictures were taken in a garden near the Beverly Hills Hotel, others at his manager's office, where I asked my questions. I noted with some irony that behind him in the office was a fish tank full of piranha, the carnivores of the Amazon.

For three years, that is what our life was like: profiling a paternal Rick Nelson holding his two infant twins, Matthew and Gunnar, who later became stars as well (recording as The Nelson Brothers); being welcomed into the groupie world; and touring with The Rolling Stones the year Tina Turner, who had just dumped Ike, and B.B. King were the opening acts. It was, as it's said, a crappy job, but someone had to do it.

We're now into the 21st century. *Rolling Stone* is more than 40 years old (too old to trust?) and Baron and I are old farts, enjoying our memories. After leaving *Rolling Stone*, we both went on to other things. He photographed for the National Football League, founded a magazine called *Rags* ("the *Rolling Stone* of fashion") along with a small book publishing company, and even learned to fly an airplane, publishing books of photos taken from the air. I wrote a slew of books, including biographies of Elvis Presley, Jim Morrison, Jimi Hendrix, David Bowie, Yoko Ono, and Don Ho.

Yet both of us are remembered for our work at *Rolling Stone*, a connection that in Baron's words, "define(s) my photographic reputation." Walk into a Hard Rock Hotel anywhere on Earth today and the big pictures of Jimi and Jim and Joni and Janis and Jerry (and those are just the J's) and many more on the lobby and hotel room walls are his. He also presents gallery exhibits of his photographs across the world with some regularity, from San Diego to Berlin. And now, of course, there is this retrospective book. Baron says he's in the "recycling business." I say he's still selling dreams.

Jerry Hopkins, Bangkok, Thailand, 2011

In 1967, I was in San Francisco earning a living as a photojournalist, working for anybody who would pay me to take pictures – magazines, newspapers, ad agencies, universities, anyone...

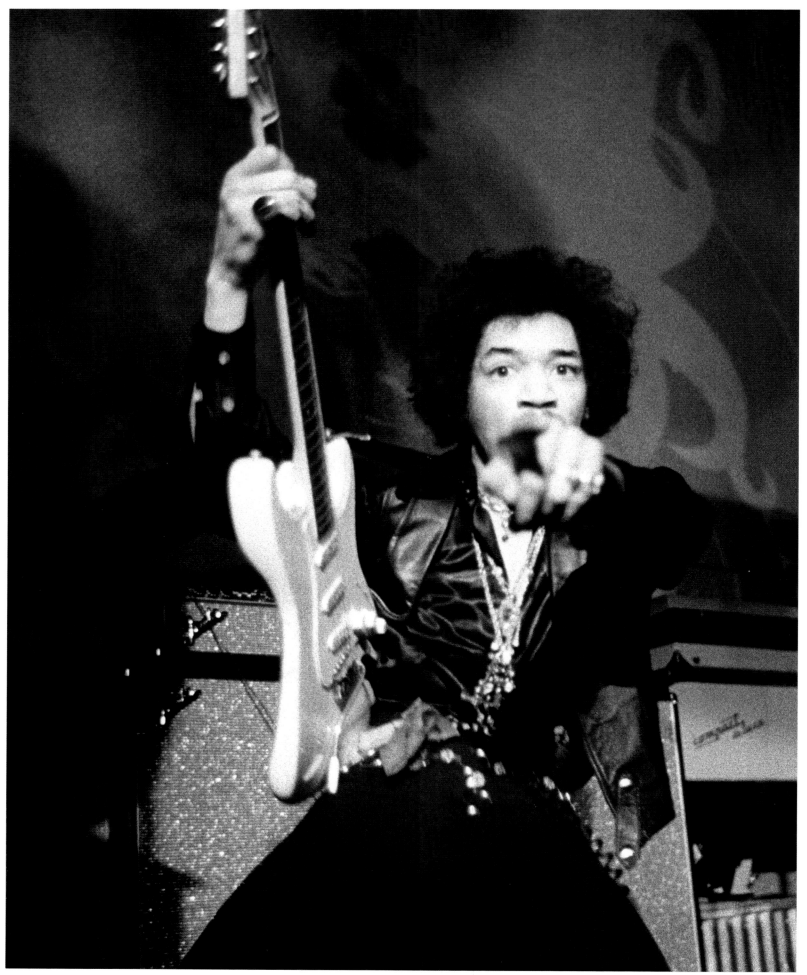

Jimi Hendrix, San Francisco, 1968

Tom "Big Daddy" Donahue, San Francisco, 1967

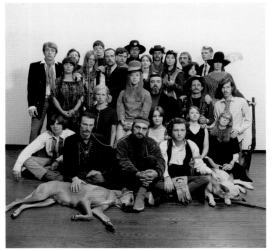

KMPX Radio Station, 1968

...and then Rolling Stone came into my life.

In 1965, my wife, professional ballet dancer Juliana, and I moved from Los Angeles to San Francisco. She wanted to dance with the San Francisco Ballet and I needed to get out of LA where the combination of bad air and endless driving was making me increasingly cranky. Plus, I had fallen in love with San Francisco during my first visit in 1959 and was ready to return. We settled in the Haight-Ashbury; soon enough she joined the ballet company and I started hunting for freelance photo assignments.

One of my regular clients was Mills College in Oakland, California. I took pictures for their catalogues and brochures, and in the process became quite attached to the school and its activities. Mills had an advanced, highly respected, music department which in April 1967, held a weekend pop music industry seminar. The subjects were the emergence of the San Francisco concert scene and how and why popular music had become so important in the Bay Area.

Mills invited some of the biggest names in music at the time: local concert promoter Bill Graham and "Big Daddy" Tom Donahue who was the driving force behind KMPX, one of America's first underground FM radio stations. These radio stations had no playlist; the DJs could spin whatever music they wanted for as long as they wanted – if they wanted to play for 20 minutes without an ad they could play for 20 minutes without an ad, something unheard of in the radio business. The legendary Phil Spector – already a widely-acclaimed writer, producer, manager and music publisher – flew in from Los Angeles. Other local music luminaries were there, too, including the Jefferson Airplane, who played a set during which the attendees were treated to a liquid light show.

Ralph Gleason, the hugely respected music writer for the *San Francisco Chronicle*, was on the panel; if Ralph gave you his blessing as a musician, you had been anointed, you had it made. Also in attendance – at my invitation – was the young journalist, Jann Wenner.

13

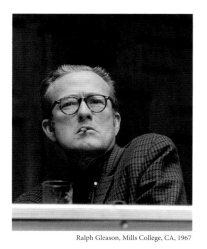

Ralph Gleason, Mills College, CA, 1967

Rolling Stone magazine, Issue No.1, Nov 9, 1967

Jann and Ralph had come up with the idea to start a newspaper about music, not a trade publication like *Billboard* or *Cashbox*, but another sort of periodical. Jann expanded upon the idea to me. The problem, as he saw it, was that the music media of the time was too focused on the music industry alone; articles were business related rather than music or' musician related. Both he and Gleason saw the need and opportunity for a journal which would reflect the greater, more personal, interests of those of us who listened to music and for whom music had become such a big part of our lives. Furthermore, the publication they envisioned would be professional in every sense, from its appearance to its editorial excellence. They pointedly did not wish this nascent publication to resemble the well-intentioned but often naïve – in look and feel – "hippie" publications which had become ubiquitous around the San Francisco Bay Area during the mid and late Sixties. At Mills, Jann asked me if I would like to join the team as its photographer, and, if so, did I have 10 grand to invest.

I could tell Jann was a smart kid; I mean, he was only 21 at the time. I was the old guy at 30. I didn't have that kind of money but I said, sure, I was interested and agreed to hook up with him, adding that I would shoot for free, asking only to be reimbursed for film and processing – digital was an unknown concept at the time – and be given stock in the company as payment for my services. Without understanding its ultimate importance, I also specified that I would own all the photographs I took although the still unnamed publication would have unlimited use of them, on covers, inside on the editorial pages, for advertising, promotion, whatever. The deal seemed like a fair exchange at the time and it was. And that's how *Rolling Stone* came into my life...

The actual spark for *Rolling Stone* started long before I met Jann; he and Gleason had been talking about it for quite a while. But it was at Mills in April of 1967 that he introduced the idea to me and articulated the need for a staff photographer. That seminar itself was ground-breaking in its own right. For a university to acknowledge the importance of rock music when the economic potential of the industry had only just begun to show up on corporate radar was very forward-thinking.

The first issue was printed in October 1967 and dated November 9, 1967. On the front page it featured a PR photo of John Lennon in the film, *How I Won The War*.

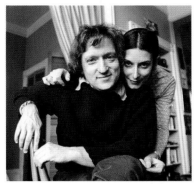

Baron and Juliana, 1968

Jann and Janie, 1968

Inside, as my first assignment for the fledgling magazine, was a spread of my photos of the Grateful Dead, some of whom had been busted for allegedly dealing the "killer weed" marijuana. As the photojournalist I considered myself, I photographed the band posting bail and then posing on the steps of their house at 710 Ashbury Street following a delightfully memorable press conference where the band members articulated their position vis-à-vis the arrest.

During my tour of duty at the magazine I resisted having a space in the office or even going in every day. I did then and still do run solo – that was the way I liked to live, one of the many reasons I liked photography. I always preferred to work one-on-one; as soon as you introduce a team of other people into the photographic experience it is no longer intimate and it is no longer one-on-one.

So in one sense I never really felt a part of *Rolling Stone* even though I felt a part of *Rolling Stone*. Jann was a bit dismayed that I chose not to have a room in the office but everything I needed professionally was at home: my darkroom was at home, my dry mounting press was at home, everything: why should I come in every day? Of course, I would come in with the pictures, it wasn't that I wouldn't come in – it was like, "Why do you need me all the time? You're not paying me, I gotta earn a living." So that's why my office was at home. I had other work to do; I needed to pay the bills. Perhaps for that reason I never felt an intimate part of the *Rolling Stone* family, even though everyone else might have felt otherwise towards me.

Juliana and I were friends with Jann and his wife Janie; we hung out a lot together, and the two of them had great taste. That's one thing about Jann – he had great editorial taste, he had great design taste, he had great decorating taste. The guy is taste on steroids.

> *I did then and still do run solo – that was the way I liked to live, one of the reasons I liked photography.*

Hot type lino

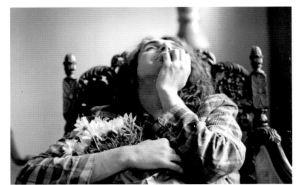

Tiny Tim, Los Angeles, 1968

As the magazine became more successful, it employed more and more staff and took on bigger offices. It was small and intimate at the beginning but it grew and other friendships developed. Some of the staff started doing drugs fairly regularly, so Jann and Janie began to hang out with their other friends. Because Juliana and I were rather straight (maybe too straight, although there are pictures of her enjoying a toke over at Wenner's home), neither of us became big users.

When I left and Annie (Leibovitz) joined the staff her style of shooting was pretty much my style, and she was fabulous – she was a great photojournalist and she had a terrific eye for the human element. If you look back at her pictures you'll see they are brilliant. I loved them. I don't know her well enough to know why she later made a change in style, maybe she got bored. She started using the musicians as elements in her own photographs rather than taking pictures of them; she moved into a visual arena where they became pieces of a tableau she was building. As a photographer my style has remained the same. I've stayed with the old style, my style, that's what I was comfortable with no matter what the subject was: live music, fashion, portraiture, reportage.

Tiny was a mercurial eccentric, as eccentric as Zappa but in a different way.

The other message I got from my days at *Rolling Stone*, one that I carry with me to this day, is the joy of having an idea and bringing it to reality. It was so wonderful; Jann presented this idea in April of 1967 and not even six months later the idea had turned into a reality as we watched our new baby come off the presses. An idea, Jann's and Ralph's idea, had now become a reality.

There it was; you can't imagine how great that feeling was. Over the years I explain to people that I had become addicted to printer's ink – that's the way I say it because you could see it, you could smell it. That's why I felt so comfortable publishing the fashion magazine and publishing books; with each of those you had an idea, you then formed that idea and brought it into reality. There was something about that transformation of an idea

Tiny Tim, Los Angeles, 1968

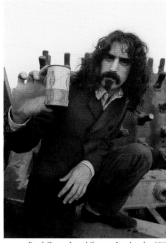

Frank Zappa, Laurel Canyon, Los Angeles, 1968

in the mind into something you could physically hold that was so satisfying; you could literally see and hold the result of your effort, the birth of your dream.

I never had any formal photographic training. It started as a hobby and I learned by doing. I discovered what worked by trying. In those days I'd go into a camera store and say, "I've got this problem, can anybody tell me what do to?" Everyone was so helpful; they'd help you find a solution.

For me portrait photography was more about putting your subjects at ease. If you could do that, they would give you something more intimate, something about themselves. They would relax and they wouldn't pose, would lose their anxiety about being photographed.

For almost every *Rolling Stone* assignment I was never given a specific brief, only the subject. I would get the best pictures I could, process the film, then hand the contact sheets over to the art director and the editors. I didn't get involved in discussions about which shots I thought they should use, I trusted those guys. I gave them everything, I gave them the contact sheets – and sometimes I'd mark the ones I liked, but more as suggestions. Sometimes they'd use my choices, sometimes not, but they were great at what they did and I was often pleasantly surprised at the selections they made.

For example, Jann would say to me, "Jerry Hopkins is going to do a story on Zappa, go with him, and get a bunch of pictures to go with his interview." You never knew what was going to happen once you got with your subject. Like with Tiny Tim – I was worried about how this session might turn out. Tiny was a mercurial eccentric, as eccentric as Zappa but in a different way, so we had to figure out a way to put him at ease; you don't put Tiny at ease the way you put somebody else at ease, right? So we bought a bouquet of daisies and said, "Tiny this is for you," and he went crazy, he held them to his chest and he kept smiling and thanking us, smiling and thanking, and that small gesture gave us the ability, number one, to do the interview, and, number two, for me to do the pictures. I always explain that I was *photographing* the music, not really *hearing* it. There was a whole technique to doing that – since you can't capture the sound of the music itself in a still photo, you try to shoot the process of the musician making the music, try to isolate a peak moment of the music being made, try to communicate the ecstasy of somebody playing, singing, performing.

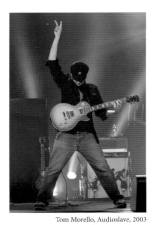

Tom Morello, Audioslave, 2003

Brad Wilk, Audioslave, 2003

Because I was watching the musicians I missed a lot of their music. I was a fan of rock 'n' roll but I wasn't a huge fan of any particular musician. I liked Steve Miller – his music was so simple and accessible; how could you not be a fan? But as the music and lyrics became more complex, as a photographer I missed the subtleties because I was *observing* the music, not hearing it.

Even to really understand some of The Beatles' songs I had to put down the cameras and think about what they were singing. They were younger than I and yet they wrote lyrics that made an old guy like me pay attention and consider their messages. Here I was listening to music made by kids 10 years younger than I, working with a young staff whose founder was 10 years younger than I, but other than chaffing at the command not to trust anybody over 30, age was never really an issue for me. Over the years I've always pretty much been able to relate to any generation.

There was one time that the age and generation thing was a problem. Brad Wilk, the drummer of Audioslave, visited the Andrew Smith Gallery in Santa Fe, saw my photos on display and openly admired the music pictures I'd taken. He even bought a large Pete Townshend contact sheet. At the time I didn't know who he was. I simply received a call from the gallery that somebody from the band Audioslave loved my stuff and wanted to meet me. We met at the gallery; Brad was a really nice guy who then asked me to come on tour with the band and take some pictures for them. I had stopped photographing bands long ago and I didn't want to do it again. "No, I can't do it, but thanks for asking."

Long story short, they talked me into going out with them. In Phoenix I'm wondering, "Why am I going on tour with a bunch of 20/30 year olds?" I found myself sitting in the hotel lobby waiting to meet the band; the tour manager walks back and forth in front of me, didn't even notice me. "Hi, I'm Baron. I'm here to take the pictures." "What?" they said. "We looked over at you and there was this old man sitting on the sofa, we had no idea it could have been you." And right then and there I knew this was going to be a bad trip, and it was. Even though I got some decent pictures, the fact of the matter is it was neither comfortable nor fun for me. They were used to being told what to do in front of a camera. I never told musicians what to do, I always wanted to get them the way they were – be yourselves and I'll take some great pictures. By then they all expected the photographer to be a director –

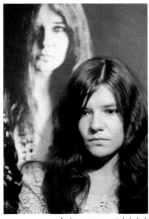
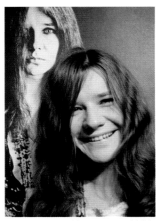

Janis... one moment she's dark

... and the next moment she's light

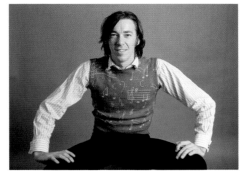

Boz Scaggs, San Francisco, 1968

you know, arrange me, make it a big deal, do something special, bring your lights, bring your stylist… That's what they expected, but that was never the way I worked. So that was the only time that I felt really uncomfortable with a band. I actually liked the guys and some of their music; they did two albums, I think, then the band disappeared. But all of this was 20–30 years too late for me. I don't hold that against them but our heads weren't in the same place. It was a rude awakening I'll tell you that.

Most of the bands wanted to be in *Rolling Stone* and as far as I could tell they trusted me in the same way they also trusted Jim Marshall and the rest of us who were shooting in those days. They trusted us to be honest with them and not make them look like fools, and none of us did. Even those two pictures of Janis that Jim took where one moment she's wasted and the next moment she's happy, those are both the faces of Janis and she understood that and she was OK with that. Everybody was OK with the way we were shooting, and then suddenly they became *not* OK with our style.

And right there and then I knew this was going to be a bad trip, and it was.

I think things changed with the advent of MTV when musicians began seeing themselves and others in music videos on TV. They thought, "Oooh, we want to look like this and we want to look like that." MTV changed everything. It was also the management who changed things for us as much as the bands. Too many people getting involved, putting us further and further from that one-on-one situation where something special can happen. This was even before artists were idolized… now there is very little honest portraiture of the musicians themselves, everything is stylized.

Perhaps shooting for record covers can justify the effort put into stylizing photographs because it's for selling the album, but that's not what *Rolling Stone* was about when I was shooting for them.

We did a story about the Steve Miller Band signing with Capitol Records in 1967 for a $50,000 advance, which was a humungous amount of money in those days. Jann was good friends with Boz Scaggs and a few other guys in the band; he sent me over to their house to

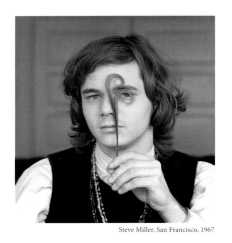

Steve Miller, San Francisco, 1967

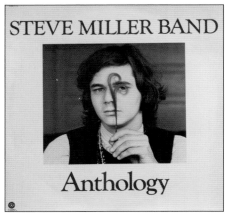

Steve Miller, *Anthology* album, 1972

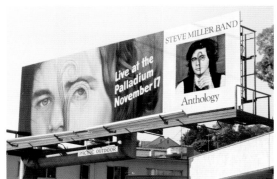

Steve Miller billboard, Los Angeles, 1972

shoot some pictures for the story. I made a bunch of pictures of Steve and the band, and of Steve alone. A feather was just lying on the table. I thought it would make a good prop. "Hold it up, Steve. Let me get a shot." After the pictures ran in *Rolling Stone* I got a call from the record company asking if they could use some of them for publicity for the band and offering to pay me to use them. They wanted them for an advertisement; they wanted to use the feather shot as a record album cover and as a billboard. That was the moment I was introduced to the inner workings of the music business, and it was at that moment I caught my first glimpse of the financial potential of my pictures. It was a shock… in the best sense of the word. First of all it was a chance to make money from something that I loved doing – the first time I ever made any decent money off photojournalism in general, let alone from *Rolling Stone* since I was still shooting for free.

Capitol Records put my Steve Miller photo on the cover of the *Anthology* album, a single image from a group of pictures I had shot for *Rolling Stone* and in my own personal style. Shortly after, I happened to be in LA and saw

I had no idea what to expect and when they finally made it to the stage I was in for a big surprise.

they'd reproduced the album cover with my photo of Steve with the feather on a billboard – my first billboard! It was a nice payday, several hundred dollars which was a big leap from nothing. It was so great.

My first live concert assignment for *Rolling Stone* was shooting The Who at the Cow Palace. I had no idea what I was getting into. I'd not shot live music before; I was a concert virgin. Everybody was shooting the clubs in London because of all the stuff happening there. Our best-known club was probably the tiny Matrix but I don't think I ever shot there. Maybe I went there once, but I didn't take any pictures. I went to the Trips Festival but I didn't shoot there either. So I was sent out to shoot The Who and it felt like I was being sent into battle – out to the front lines. When I got to the Cow Palace I didn't quite know what to do, I just started walking around backstage. I know I had a press pass because I could go wherever I wanted to go. I just wasn't sure *where* to go!

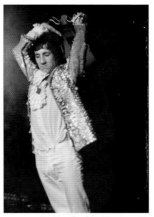

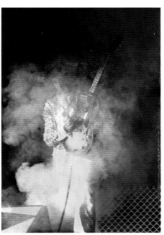

Pete Townshend, San Francisco, 1967

Pete Townshend, San Francisco, 1967

Smoke bomb, The Who, San Francisco, 1967

I didn't take any pictures before the show because I didn't know what backstage was, what it was all about, didn't even know I could go there. I thought, OK, these guys are going to perform and I'm going to take pictures of them performing; backstage was the place you waited for the show to begin. I walked backstage; it was a huge hall if I remember correctly. "Where are they? Where's the band?" So I walked out and found myself in front of the stage. The Who did not play first that night, nor were they the featured band. I had no idea what to expect and when they finally made it to the stage I was in for a big surprise.

Sadly, I didn't go to Monterey Pop. Had I gone and seen The Who before then everything would have been clear, and I would have known what was coming, but I hadn't so therefore I knew nothing, which was too bad. As it is I was thinking, "What's this guy Townshend doing? He's breaking his fucking guitar, why is he doing this? That's an expensive guitar." I had no idea this was part of the act.

Then I saw him do the windmill or whatever he calls it; "That's neat." I tried to photograph everything that was going on but it was coming at me fast and furious. I didn't know who Keith Moon was at the time or I would have taken more pictures of him; John Entwistle had this cool looking bass which I thought was a good photo and took too many of him. I was so damn naïve; all I was doing was looking for a good picture. Toward the end of the set the smoke covered the stage and the band left so I ran up on stage and there's a smoke bomb. "Oh, that's what happened," so I grabbed the smoke bomb and took it home and made a portrait of it in my studio. I had no idea that the device was significant other than, "That might make an interesting picture." When Townshend destroyed his guitar I was stunned, nearly traumatized. It would be like me pounding my Nikons and my Leica against the concrete, totally beyond my nature or comprehension. It wasn't just that he broke the neck, he completely destroyed the thing (at least he did that night). It shocked me to the point of being afraid that something bad was going to happen.

At that time I don't think there were that many serious photographers covering the concerts; yes, there were people with cameras, but not with "heavy artillery," the long lenses and expensive bodies that professional photographers use. I don't recall if it was before or

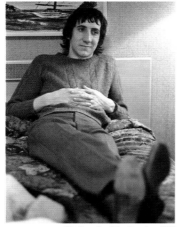

Pete Townshend, San Francisco, 1967

Photographer Jim Marshall, San Francisco, 1968

after the Cow Palace concert that Jann and I went into Townshend's hotel room and I photographed him. The magazine was doing the very first 'Rolling Stone Interview' in which Jann would have these long, long conversations with a given musician. I went with him and photographed Townshend during the first part of the interview. Pete was lying in the bed and you can see the painted background of the hotel room wall – you know – if they don't hang a picture on the wall they paint the wall. My iconic Townshend photo was shot during the same 1967 concert but I don't know if the interview took place before or after. If it was before, then Pete would probably have recognized me and given me that picture. If it was after, then it was an accident, a fortunate accident when Townsend in his signature spread-eagle stance looked straight down at me, "Here you go, this is for you, pal." Either way I like to think of it as a gift from Pete to me.

I wasn't back there smoking pot, I wasn't in the band. I was kind of a fly on the wall.

When I was backstage I always felt somewhat estranged because I wasn't one of the guys back there fooling around with a groupie, I wasn't back there smoking pot, I wasn't in the band. I was kind of a fly on the wall. It reminds me of what my friend the photographer Michael Zagaris said: "I don't do weddings, I do honeymoons." And that's the way I felt; I was an interloper looking at something very intimate in which I wasn't participating so I was usually anxious to get out of there and get back on the stage again.

That being said, in my own way I did get to hang around a bit backstage. There were always intriguing "activities" going on and "distinctive looking" folks to photograph. At first, I didn't even realize that backstage was such a desired destination and very much the place to be. And while there was never much one-on-one socializing going on for me, I enjoyed being there. On the other hand, Jim [Marshall] and Zagaris were two shooters – Jim more than anybody – who felt comfortable being backstage and who actually liked hanging out with the musicians, developing deeper friendships. Jim would sit around with them all night long. It was almost as if they were his best friends. I was a little bit standoff-ish – I had a whole other life, I was married, I had Juliana, her ballet world, other activities and other responsibilities.

22

Janis Joplin, Marin County, CA, 1967

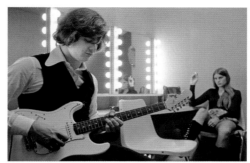

Steve Miller, backstage, Marin County, CA, 1972

Jim was already making money from his music pictures because he had started shooting in the Fifties. He had amazing portraits of the older jazz and folk musicians and by the time I started shooting music his photos had already graced countless album covers. The record companies knew Jim had the pictures and they featured them regularly on their large 33rpm vinyl albums. It was different for me; I was busy doing anything I could do to earn a living.

Over the years, this pretty much remained my way of working. I became acquainted with the musicians from being around them, and I was the *Rolling Stone* photographer so I was also known by most of them, but I didn't hang out with them. It never occurred to me to do so. I spent time with other photographers, but that was about it.

Because I didn't feel like I was part of the family of musicians, I sometimes wondered what I was doing backstage. They knew me, I knew who they were but I *wasn't* part of their posse and therefore I didn't always feel totally comfortable sitting around with them. Still I loved it back there because everybody was having a great old time together – drinking, smoking, telling stories, having fun. That was what backstage was all about, always will be. But you have to feel as though you're welcome. I didn't think I wasn't welcome, I just wasn't totally comfortable. I don't know, perhaps it was just me feeling a bit intimidated because I didn't play an instrument, was reluctant to get high or who knows what. I'm still trying to figure that one out…

One of the things that kept me from becoming closer to the musicians I photographed was that I didn't want to impose upon them. I saw what was happening around them – people always wanting something from them – and that's one of the reasons I was less successful in accumulating more photos: I simply didn't want to bother them. I could see how they responded to the hangers-on; they were hounded a lot of the time, why would I want to do that? This was their place of work. The result of my reluctance, of course, is that I have fewer photos than I might have. But at least I always got what was required for any given assignment, that's true. That was my job; that was my gig.

Looking back I wish I had taken more pictures but who knew what role these images would play in the future, how cherished they would become? Even the guys who shot tons of photos wish they had taken more, more black and white, more color. Nobody knew what value

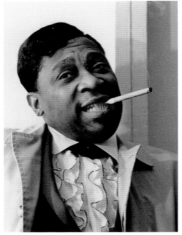

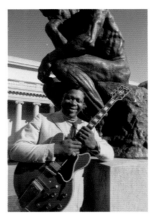

B.B. King, San Francisco, 1967

B.B. King and "Lucille," San Francisco, 1970

these photos would have two, three or four decades down the line, that we photographers were preserving important cultural and historical moments of the day.

I don't know about the others but for me photography wasn't only a passion, it was a job; yes, it was something I loved doing but it was still a job and I maintained a distance from my subjects. I never got close to them the way some of the other photographers did, never hung around after the shows. I was happy to leave, first because I had other things to do and second because I hadn't developed friendships with the musicians. The only one with whom I developed any sort of closeness was Steve Miller. Steve was educated, he liked photography, he had a great collection of cameras, he liked taking pictures, and he understood and appreciated pictures.

I wish I had more pictures but at the time who knew what role these images would play in the future, how cherished they would become?

B.B. King welcomed me into his inner circle like few others. He was ever so hospitable – "Want something to eat? Want something to drink?" Backstage with B.B. and his entourage I felt as if I was a guest at his home. I took B.B. King out to the Palace of the Legion of Honor in San Francisco where there is a copy of *The Thinker*, the famous statue by Rodin in the courtyard. I posed B.B. against this statue so that Lucille, his red guitar, and the arms of the sculpture are kind of parallel. It's a beautiful shot but most people don't quite understand what I was trying to do, what I meant by the slightly ironic juxtaposition.

The best music photographs are those where the musicians are expressive, where they are doing something photogenic with their faces or with their body movements. B.B. had these weird expressions – you didn't know if he was in pain or in ecstasy – his face would crinkle up and he'd make these peculiar squints with his eyes and his mouth when he was playing. Hugely photogenic.

In 1970, I had to shoot a James Brown New Year's Eve concert, that is, once I finally

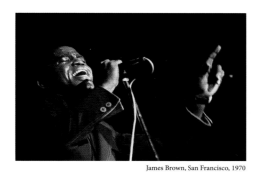

James Brown, San Francisco, 1970

Mills College Rock 'n' Roll Conference, Oakland, CA, 1967

made it through his multiple layers of security. He had more security than I had ever seen; everybody checked me out, "What are you doing here? Does James know about this?" Big black guys made me very aware of being a small white guy. But once they approved you, once they brought you in with the "family," they left you alone, you could shoot what you wanted, and you were golden.

I didn't really know enough about the status of the different musicians I photographed to be intimidated, didn't know much about their careers or their place in the musical hierarchy, a fact which was probably both good and bad. I would liked to have had greater musical knowledge but had I known more I might have been intimidated, so being dumb I could walk into the intimidation danger zone without even knowing I was in the danger zone. I should've taken more pictures though – a recurring theme when I look back on my career as a music shooter.

Mills College was a client of mine; they told me they were going to have a weekend rock 'n' roll conference. They must have seen the gathering as something bigger than just a symposium about music because they invited precisely the right people to conduct a serious discussion about the state of popular music at that time. The conference at Mills didn't kickstart the idea of *Rolling Stone* but it probably confirmed that the idea was a good one. Suddenly, it wasn't just Jann and Ralph but a much-respected university taking pop music seriously, too. Basically, Mills had said to the world, something significant is going on, let's take a look at it.

> *Big black guys made me very aware of being a small white guy.*

But Jann and Ralph were already well on their way; the conference was just a very fortunate corroboration that they were on the right track, a perfect opportunity to take the next step because it was only a matter of time before someone else picked up on the tone of the moment and started their own magazine. Back then there were hippie papers that featured counterculture lifestyle, while *Crawdaddy* and later on *Creem* concentrated on music. *Rolling Stone* wasn't the first but there was something about the vision that Wenner

Jann Wenner, San Francisco, 1968

Record company ad in *Rolling Stone*, 1969

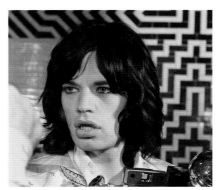

Mick Jagger on the set of *Performance*, London, 1968

and Gleason brought to the concept that separated them from the others and led to their success. From day one Wenner wanted the magazine to look and be professional; this was not a short diversion for him, it was the beginning of a long-term effort. I remember him telling us, "This is what we're going to do and it's going to work and it's going to be national." That's just the way he was.

Because we were in San Francisco it was easy to get distribution in California; very quickly Jann also arranged for distribution in New York since we simply had to be on both coasts. Eventually we acquired a national magazine distributor which put us pretty much everywhere in the country.

What kept *Rolling Stone* afloat at the beginning were the ads from the record companies. We'd get an ad contract and Jann would negotiate payments in advance. The record companies would buy ad space in future issues; they'd give us the money up front because we needed the money to keep going and the record companies needed us to keep going. For a long time it was touch and go financially. I was on the board of directors in the beginning – Jann and I both were – and I thought (mistakenly, as it turned out) maybe being a little older (and wiser!) I could bring some common sense to this effort. But I couldn't, nobody could. Jann made all his own decisions; he did what he wanted to do.

Shortly after we began publishing Jann traveled to London; we had an American Express card, and he flew first class. He wanted to meet with Mick Jagger to see if together they could start a UK edition of *Rolling Stone*. When he came back and we went over the charges we saw the guy had already run us out of money. He returned all dressed up in the tasty clothes of the day that he'd bought in London; I think he even stayed at Claridges. He liked making an impression, that's for sure, and he was always thinking big. There were plenty of hard times where we had to beg, borrow and steal to find more investors to buy shares in Straight Arrow Publishers (the name of the corporation which owned *Rolling Stone*) simply to get sufficient day-to-day operating money. I had some contacts in the San Francisco financial world so I helped locate money to keep it going. By then working for *Rolling Stone* started becoming more of a full-time gig for me; it increasingly took up more of my time. Every month I was flying down to LA and back and forth across the country to New York; there was so much to

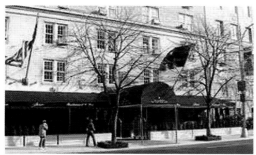
The Stanhope Hotel, New York City

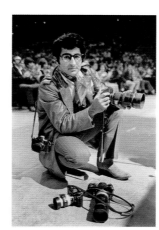
Photographer Jim Marshall, Oakland, 1970

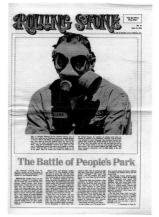
Political story in *Rolling Stone*, 1969

shoot in both cities. In New York Jann and I almost always stayed at the elegant Stanhope Hotel on Fifth Avenue, right across from the Metropolitan Museum of Art. As I said, the man had taste.

I couldn't shoot every picture for every issue so we began giving assignments to other photographers, and other shooters began to submit pictures. I'd introduce them to the art director and editors; every publication needs freelancers. Jim Marshall took a lot of pictures for the *Stone*; he was the grandfather of music photography in San Francisco, there are no two ways about it. He knew the musicians; music was his beat and I admired him greatly for it. What we – he and I – practiced was photojournalism, it was honest journalism in the form of pictures. As photojournalists we were able to produce great pictures to illustrate the articles because our style of shooting was in sync with both the music world and the publication itself.

There were plenty of hard times where we had to beg, borrow and steal to find more investors.

Rolling Stone was and still is a successful and intelligent publication; it looks good and it reads well. To a great degree, its success was, and is, based upon Jann's unique blend of refined editorial instincts and his equally intuitive ability to apply a business model to what is essentially an artistic endeavor. Sure there were and have been other music magazines but it is *Rolling Stone* that has endured, that assumed leadership among music-lover periodicals and that has published continually since its birth.

I, too, saw my career as a photographer as a combination of art and business; my photos were an expression of my soul, but they were also a commodity that allowed me to live an exciting and fulfilling life. Perhaps that was one of the reasons Jann and I communicated so easily in spite of the decade difference in our ages.

If you study *Rolling Stone* over the 40 years plus that it's been publishing and you read its serious political articles you get a pretty good picture of what life has been like in the US over those four decades. It wasn't that music was a by-product or of secondary importance;

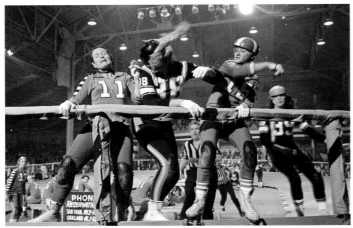

Roller Derby, San Francisco, 1967

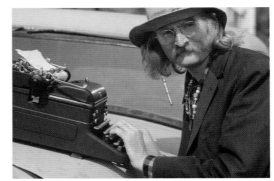

Richard Brautigan, San Francisco, 1968

music was the product, the reason for *Rolling Stone*'s existence. Nevertheless, politics has always played a significant role editorially. I recall editorial battles over the mix; one of the editors fought with Jann because that editor believed that *Rolling Stone* should be more political. "This is why we're here, we're political," claimed the editor. Jann said, "No, music is why we're here. We are music, we're about music, politics is important but we're first and foremost about music." I'll never forget that.

Yes, *Rolling Stone* was about music but in the end nothing was off limits if it interested us. For example, my friend's father had invented the game Roller Derby. Every week it was filmed for TV within walking distance of my house in the Haight so I started hanging out at the track. Men would skate against men and women would skate against women, and they'd knock one another off their skates in order to pass them and score a point. I mean they would really slug hammer each other big time.

First thing I noticed was they had some gorgeous women skating Derby, too. I had always been told that boys don't hit girls – but these women were slamming each other, pounding on one another. Anyhow, I mentioned to Jann that I thought Roller Derby might be an interesting story; he agreed, so we featured Derby in *Rolling Stone*. I also turned him on to a poet named Richard Brautigan. "Jann, he's writing this terrific poetry, kind of a hippie poet in a way but not really and I've got these great pictures of him." Eventually Brautigan produced a poem in each issue; for a while he became the *Rolling Stone* poet laureate.

We are music, we're about music, politics is important but we're first and foremost about music.

By 1969, the magazine had become a much respected voice in the journalism community. That same year Timothy Leary decided he wanted to run for governor of the state of California; Tim came up to our offices to get Jann's and *Rolling Stone*'s endorsement for his candidacy. In the US if you get a newspaper's endorsement then everybody reads

Timothy Leary, San Francisco, 1969

Oakland Raiders, Denver, 1974

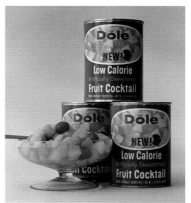

Dole Fruit Cocktail, San Francisco, 1965

about it and it more or less confirms you as a bona fide leader wannabe. But, no, Jann didn't give Leary the endorsement he sought. However, throughout the history of *Rolling Stone* Jann would endorse various presidential candidates, put the candidate's picture on the cover and explain to the readers why he thought they should vote for his choice. It was always an intelligent and rational presentation. Did it affect the individual voter? Who knows?

We ran stories on a myriad of other topics we thought might appeal to readers who were also interested in music. Hunter S. Thompson did a great piece about the Oakland Raiders and the National Football League. At the time the NFL had nothing to do with music, of course, yet professional football is such a powerful force in the US it was totally appropriate that we would cover that. The whole *Fear And Loathing In Las Vegas* thing (Thompson's book was first published in *Rolling Stone*) was also more political than musical, the ranting and ravings of those crazies exaggerated and reflected a certain ethic of the moment.

It was through photography that I learned about the world. I would become interested in a particular subject or movement or person then find somebody to give me an assignment to shoot a story. I was a photojournalist; I covered a topic and learned about it at the same time. The studio side of photography had its own technical challenges, of course, but in the studio you're not learning about the world, you're just creating beautiful static memorable images.

My first advertising job when I was in San Francisco – before *Rolling Stone* – was photographing fruit cocktail! The account director explained to me that for the photo they wanted an older woman to be holding a dish of individually perfect fruit cocktail. They sent over a case of it. I was instructed to open every can, put all the fruit into a big bowl, pick out only the absolutely perfect pieces and put them in the model's dish. That's what they wanted me to photograph. I thought, is this the way I'm going to spend my life as a photographer? No! I did the job, got paid and that was that, but it was an important lesson, an example of what I knew I *didn't* want to do.

I had a couple of shoots for *Vogue* magazine. By then my portraits were pretty well known, and *Vogue* asked me to do some pictures of Ryan O'Neal, Ali MacGraw's co-star in the hit

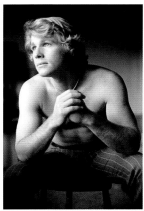

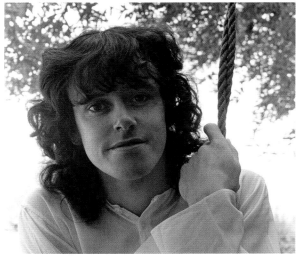

Ryan O'Neal, Los Angeles, 1971

Donovan, Los Angeles, 1969

movie *Love Story*. The *Vogue* assignment person called and said, "We want you to take a picture of Ryan O'Neal in LA, but you've got to get him to take his shirt off because these gay editors I work with told me, "Make sure Baron gets a picture of Ryan without a shirt." "Ryan," I said, "we need a picture of you with no shirt." "No problem, Baron!" and off it came. So I got this terrific picture of him without a shirt and the *Vogue* people came back, "OK, we like your pictures, now go shoot Donovan. We'll send you the clothes." "What do you mean 'We'll send you the clothes?'" I didn't realize that *Vogue* not only ran the portraits of the stars but would note on the page who designed and/or manufactured the clothes the stars were wearing and where the reader could buy those clothes. At that point it was an editorial etiquette which was foreign to me.

So I felt out of my depth when I photographed Donovan for *Vogue*; it was such a weird assignment. Sending clothes to me for Donovan to wear on the shoot was totally antithetical to the way I approached photography. I knew I wasn't going to be able to do what *Vogue* wanted to do; I knew I was going to fail. Donovan asked, "Hey, what's with you, man?" Because of the clothes I was embarrassed and very anxious in advance; I was nervous and it showed. I said, "This is what they want you to wear." They had sent a tweed jacket, leather shoes and some sort of designer shirt, garments that Donovan never ever wore. He said, "Baron you've got to be crazy." I answered, "I know, I feel like I've failed both you and the magazine" and he said, "No, no, no – come on, just take the pictures of what I'm wearing, my everyday clothes, and we'll have a good time."

He was so kind to me; he saw how exasperated I was and remained really cool about it. The irony is that he worked hard just to put me at ease; it was usually the other way around – me working hard to put my subjects at ease because I needed them to be relaxed in order to get the best pictures.

I had a few methods that usually helped me to get my subjects to loosen up. One that I had learned from my years of service in the Intelligence Corps is that pretty much everybody's favorite subject is himself or herself, so all you have to do is ask your subject a few personal questions, be seriously interested in the answers and focus the conversation on him or her. Because I wasn't musically trained and didn't play an instrument and therefore couldn't talk

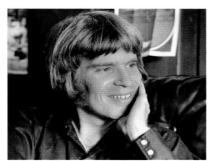

John Fogerty, Oakland, CA, 1969

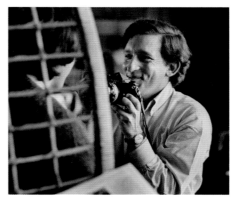

Baron Wolman shooting Jann Wenner, San Francisco, 1968

musicology with the musicians, I always felt at a huge disadvantage even when I was familiar with their music. So I had to take our conversations in different directions, usually focusing on the lives of my subjects.

They would relax and we'd talk about a million different other things, about their lives and careers. All the while as we chatted and as they became more comfortable with me I would be looking around the room to see where the best light was so I could find a good spot to pose them. Initially I'd hardly take any pictures because in the beginning of a session this was my only purpose: to put my subject at ease and to see what kind of natural light was available so that when I finally got around to taking pictures I would have an optimal photographic situation. Light is the key element to black and white photography, much more so than with color – the light and the shadows, the degrees of gray and black. I was always watching for one perfect spot to seat them; ok, I could move them around a little bit but if you move people around too much during a shoot you risk breaking the spell. I mean, you can do that up to a point but suddenly they remember they're being photographed and tighten up. I never wanted them to think about my camera; they knew they were having their picture taken, but I just didn't want them to be concerned about it.

I knew I wasn't going to be able to do what Vogue wanted; I knew I was going to fail.

Soon after I left *Rolling Stone*, Time-Life started *People* magazine. By then I was a pretty well-known photographer and *People* began calling me regularly to go shoot this story or that. There was one assignment I remember clearly. I attended a trial at which the defendant, an Hispanic woman, the subject of the story, had apparently been unfairly accused but was still found guilty. After the guilty verdict was handed down, the people left the courtroom and gathered in the foyer; everybody was crying, the family was crying, it was all very sad. I simply couldn't take pictures of their tears because I didn't want my flash to add to their discomfort or to insinuate myself into what was clearly a very personal moment.

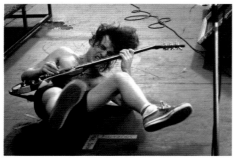

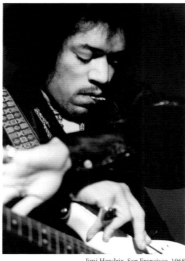

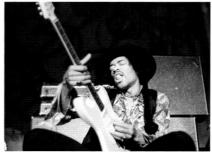

Angus Young, AC/DC, Oakland, 1978 Jimi Hendrix, San Francisco, 1968 Jimi Hendrix, San Francisco, 1968

I called the magazine and told the editors I got some good pictures but not of the family crying; they whined that the crying shot was precisely the photo they wanted. I answered, "I'm not a carrion bird and I'm not going to use my camera to increase somebody's misery." The editor said, "Well then, you'll never work for us again." And I replied, "I never fucking *want* to work for you again!" I knew what my conscience could handle and I didn't want to work for editors like that. When I discovered that what they wanted from me was basically inhuman and insensitive, without compassion, I turned and walked the other way. It felt good to tell the editor to go fuck herself; sometimes when you draw a line in the sand you know you've done the right thing.

The bands which had a discernable, visible "entertainment component" to their performance, those who moved around and did something other than just stand at the microphone were the easiest to photograph. AC/DC, for example, with Angus Young rolling on the floor or climbing up on top of the speakers – these were exciting pictures because visually you could see this guy going ballistic. Just look at Hendrix; Jimi would cross his hands over the neck of his guitar, he'd play it behind his back, he'd light it on fire, he'd go down on his knees, he'd simulate fucking his guitar – you always had something to photograph. It didn't necessarily have anything to do with the quality of the music but it had something to do with the quality of the pictures and the excitement of the show. The Grateful Dead, on the other hand, would stand there getting stoned on their own music and they wouldn't move – I couldn't stand there for three hours taking the same picture over and over again. But AC/DC: just fantastic.

> *His brother had actually chopped off a piece of his finger when they were both quite young.*

After the drug bust in 1967, the Grateful Dead had come to be considered San Francisco's own, the local heroes. Sure, there were many neighborhood bands which had achieved notoriety and attention but for most people in San Francisco the Dead was their band. For a long time we couldn't persuade Jann to do a story about them; he never explained why but he simply didn't want to put them on the cover. It wasn't until 1969, nearly two

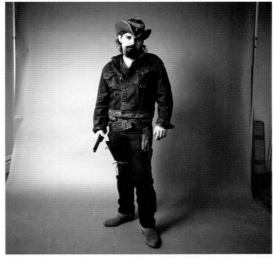
Pigpen, the Grateful Dead, San Francisco, 1969

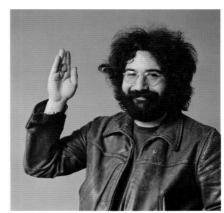
Jerry Garcia, the Grateful Dead, San Francisco, 1969

years after the birth of the magazine, that he decided it was time for *Rolling Stone* to do a major piece on the Grateful Dead. We talked about it at an editorial meeting and they asked how I wanted to shoot them. We knew it would be the cover story so I decided to take a more formal approach.

That was one of the few times at *Rolling Stone* when I chose to shoot the portraits in my studio, much like my heroes Avedon and Penn had done with their soulful portraits of the world's luminaries. I set up a single light, allowing a little bit of light to fall on the seamless background. The idea was to shoot each of the band members individually – isolate and give each equal importance, equal space. So I had them come over to the house; they didn't live very far away, right around the corner, actually. My studio was in my home. We had a three bedroom house, I had taken out a wall between two of the back bedrooms and combined them into the studio; the front bedroom was our master bedroom. Unfortunately, Phil Lesh was sick and couldn't come so I never completed the series in front of the seamless, which was too bad because that would have been a fabulous collection. I shot everybody else, though, even some of the crew members, guys who were part of the band then but not part of the band forever. Pigpen came fully armed. I didn't know him very well and was only slightly concerned that he was there packing heat in my bedroom, in my studio. He might be dangerous. As it turned out, of course, he wasn't – he was a sweet, shy man, but I didn't know him, didn't know what to expect.

Jerry Garcia, on the other hand, was as outgoing as could be; he was having a great time. You can see from the pictures he enjoyed the experience. What subsequently turned out to be the most intriguing moment, however, came when Jerry smiled and held up his open right hand, and I shot the picture I now call "Jerry Waving." I didn't think anything of it when I clicked the shutter but when I printed it I kept trying to do with my finger what he had apparently done with his finger; I thought he had just been fooling around, bending his finger backwards or forwards or something, but I couldn't make it happen on my hand. It was a long time before I learned that his brother had actually chopped off a piece of his finger when they were both quite young. Jerry usually kept that missing digit out of sight. Most people, even his fans, didn't know about it and here he was, holding it up for the world

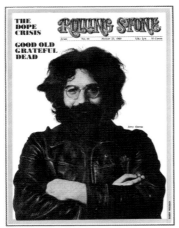

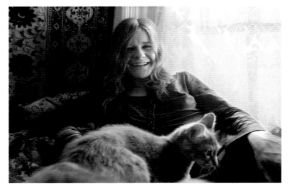

to see and for me to photograph. I remember that moment as another photographic gift, this time from Jerry Garcia to me.

I imagine this particular photo session was probably a big deal for the Dead. After all, it was a cover story for *Rolling Stone*. It was also important because there were still no other publications giving bands that kind of attention. So, yes, it was probably significant to be on the magazine's cover although not yet as noteworthy as it became when Dr. Hook eventually sang Shel Silverstein's song 'The Cover Of Rolling Stone.' Once that came out everybody acknowledged that being on our cover was something to aim for; if you had been on the cover of *Rolling Stone* then you had arrived.

People are always coming up to me, "Can I talk to you privately; I bet you have some great stories about what went on in those days?" I say, "Yeah I do," and they say, "Well, what went on?" and I answer, "What do you think went on?" And they come back, "Yeah, yeah," and I say, "Yeah!" I mean what do I tell them, that people were smoking pot? Of course they were smoking pot. That they were backstage making out? Of course they were. Did I see anybody destroy hotel rooms? No, and so what if they did, so what if I had seen it, what is there to see that I could tell them that they don't already know? One question that is continually repeated is, "Hey, can I talk to you privately, tell me – it won't go any further, just for me – did you sleep with Janis Joplin, just tell me, did you sleep with Janis Joplin?" And I always answer, "Well what do you think?" I either say it like this – "What do *you* think?" or "What do you *think*?" And they say, "Oh, man, thank you, thanks, I appreciate that, it means a lot to me."

...just tell me, did you sleep with Janis Joplin? And I always answer, "Well, what do you think?"

I let them use their imagination; I never say anything more, never go beyond that response! Never did and never will.

They all want dirt but what represents dirt? For some reason people seem to care who other people sleep with. Grace Slick was really upset with Marty Balin because of all the

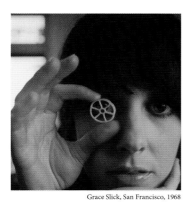

Grace Slick, San Francisco, 1968

Bill Graham, San Francisco, 1967

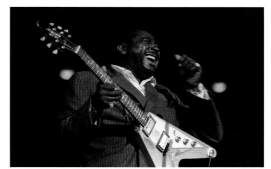

Albert King, San Francisco, 1969

Jefferson Airplane members only he wouldn't sleep with her. I guess that's an interesting story but how interesting? I guess it adds a little flavor. Is it interesting whether I slept with the people I photographed? Maybe that would be interesting – yeah, that Baron, he'd go out there, he'd photograph them and he'd fuck them. I think that's what people want to know, because they like to think that's what was going on in our world.

As far as I could see in the early days there was no rush for the money. Everybody was simply making music; the ones who were playing music cared about music, they wanted to play music because that's what they loved to do. I think many were surprised at their success. They also seemed to be surprised at the price of success because as soon as – the phrase I always say is – "the business of music became bigger than the music itself" a lot of things changed, and not just for us photographers. Our access changed, but it seemed to me that the musicians' approach to everything changed, too. Management was out there fighting for bigger contracts, bigger pieces of the action and the money became a larger component of the musical experience. Suddenly, you could no longer ignore the money.

Of course, everybody needed to make a living but that wasn't the issue in the early days; when I was taking their pictures they weren't playing for the money. However, over time, the bands did start playing for the money, too. And why not? Just as I shot for love and joy when *Rolling Stone* began, when we could finally afford to pay for the photos, it didn't seem wrong to accept the money.

Bill Graham quickly identified the popularity of the music and its business potential. No doubt there were also other promoters with his insight at the time. As Pete Townshend remembers, so much of what the British bands were playing at the time was blues-based; Pete himself discovered the blues through a college mate, the American photographer Tom Wright. And Graham understood that, too, which is why he'd bring the black musicians to the Fillmore. They were surprised to receive the sort of money they were getting from Bill Graham at the Fillmore concerts because his concerts invariably sold out and Bill was usually generous with the musicians. Too often the bluesmen had seen their songs ripped off and their money ripped off but from Graham they got a real payday.

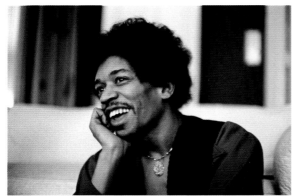
Jimi Hendrix, New York City, 1970

Eric Clapton, New York City, 1970

Before Graham most of the money went to the management or the venue or the record company; the artist was lucky to catch some of the leftovers. Very unfair. That was an education Bill Graham even gave to me, and I say "even" because I was one of the people to whom he introduced these blues musicians and helped to understand the connection between them and contemporary rock 'n' roll.

Everybody always says, "Oh, you're a great photographer!" But I don't look at it that way. Yes, I'm a good, competent photographer, but I'm just taking pictures of extraordinarily talented people who play music and whom the fans adore. Nobody would much care about these pictures if it weren't for the musicians I photographed and it's to them I owe a big share of my success. I could take the same good portraits of other anonymous people; you'd have them side by side, you'd say that's a nice picture, yes, that's a nice picture, but that Jimi Hendrix shot, wow! OK, I'll take credit for taking good pictures but I have to say it is the subjects of the pictures who have contributed to my success and reputation. I think a lot of photographers forget that; they begin to think that they are as important as the people they photograph. Not so.

Somebody had impersonated me and gone in earlier! I was flattered; by then my name had some clout.

Hendrix was a gentle guy, a very quiet guy… It was also very difficult to take a bad photograph of him. He was the most photogenic musician I ever encountered, whether he was in motion on the stage or at rest with his friends.

Once I went to the Fillmore East to shoot a show, I think Eric Clapton was playing with Delaney & Bonnie. I went to the stage door where my name was supposed to be on the list. "What's your name?" "Baron Wolman." "Oh, you're already here." Somebody had impersonated me and gone in earlier! I was flattered; by then my name had some clout.

In the Sixties I had a sense that I was part of something new, something that was destined to be successful. Everybody who was at *Rolling Stone* recognized that this was a

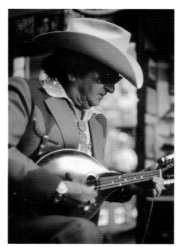

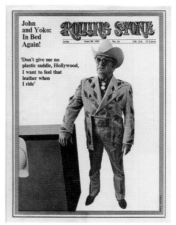

really cool endeavor. We had a freedom which up to that point was unknown to journalists – be they writers or photographers – a freedom to write and shoot the way we wanted to, to be eccentric, ironic or irreverent. Just consider the ad we ran to get subscribers – way back in 1968, we offered a roach clip to anybody who bought a subscription to *Rolling Stone*. Think about it – that was amazing. Those were remarkable days!

We didn't have a strict policy limiting ourselves to rock 'n' roll; we tried to cover all types of music, whatever we thought was important. There was a lot of good music coming out of Bakersfield, California so we did a big story about country and western music there. Many of those musicians contributed to the country and western scene in Los Angeles of which Gram Parsons eventually became a part because Gram felt that country and western was an under-appreciated art form.

I loved Nudie Cohn, tailor to the celebrities. I should have bought a "Nudie Suit" when I photographed him. At the time I probably felt his jackets were a little on the expensive side but had I only known! The pictures of Nudie were taken at his store in North Hollywood and appeared on the cover of Issue 36. His signature suits were covered with rhinestones and appliqués, often with distinctive themes appropriate to whomever was wearing one. His suit for Gram Parsons featured cannabis leaves, pill bottles, and naked women. Most famously, I suppose, was the $10,000 gold lamé suit he designed and produced for Elvis. He also drove customized Cadillac convertibles which sported guns and steer horns, some of which are in the Country Music Hall of Fame in Nashville. The suits are hugely collectible now. Nudie himself was an accomplished mandolin player and even released an album of country classics.

> *His suit for Gram Parsons featured cannabis leaves, pill bottles, and naked women.*

On the other side of the country we did a story about the music that was being made and recorded at Rick Hall's FAME Studios in Muscle Shoals, Alabama and at Capricorn Records in Macon, Georgia. I think the Georgia venue was called Redwal Studios or Redwal Music

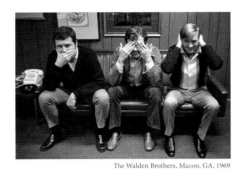

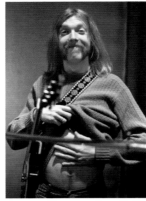

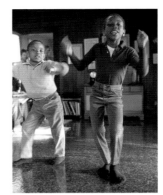

The Walden Brothers, Macon, GA, 1969 Duane Allman, Macon, GA, 1969 Otis Redding III, Dexter Redding, GA, 1969

because Alan Walden, who started Capricorn with his brother Phil, managed Otis Redding – "Red" for Redding, "Wal" for Walden. Phil signed and managed a southern rock band from Florida called The Hour Glass which he re-named The Allman Brothers Band, because the band included Duane and Gregg Allman. My photos of the Allmans at Capricorn were supposedly taken the very first time the band went into the recording studio as The Allman Brothers. While I was in Macon, the Walden's took me over to Otis Redding's house. We stopped first at Otis' grave site, then drove to his house and met his widow and his three kids. After a while his young boys put on some music and started dancing like their dad, dancing like Otis Redding.

I did not always sit in on the editorial sessions. If I had an idea the editors would often accept it but mostly, after they decided what stories they wanted to do, they would give me the assignment – "OK, we're going to do a story on Muscle Shoals, you need to go down there with the writer and make some pictures." The editors were always on top of the new music trends as they emerged but they would also look at the origins in order to present a story that explained the roots of a particular type of music that had become popular. The writers were all very intelligent, all thoroughly versed in music history. Many were graduate school journalists but even if they weren't they were accomplished writers who were deeply interested in the subject. I was the dilettante among them; I liked music but I didn't begin to have their extensive knowledge about music and I didn't know the musicians. The writers would be familiar with the musicians and often have a personal relationship with them. So I always felt at a distinct disadvantage. I didn't photograph photographers or I could have talked to them about photography; I photographed musicians who essentially spoke a foreign language.

The only time I photographed Dylan was at the beginning of the *Slow Train Coming* tour when he converted from Judaism and became a born-again Christian. The music and the album were roundly disparaged but I was moved by it because I could hear him struggling with his faith and struggling with the important issues of what it meant to be alive, issues that many people don't even think about. A lot of the *Slow Train* songs are pretty good, like 'You Gotta Serve Somebody' – no matter who you are, no matter what your status, you still must have some sort of faith. In a few of the pictures you can see that he's wearing a

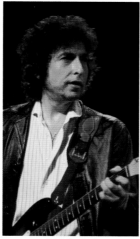

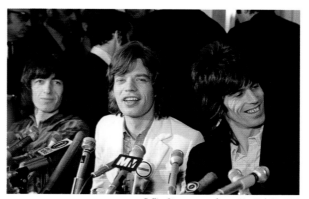

cross; kind of strange for a Jewish kid from northern Minnesota. I wish I could have photographed Dylan more but what can you do? We just pass through life; me, I felt like I was passing through and shooting what I could get along the way.

I was in New York when Mick Jagger made his announcement at a press conference in Radio City Music Hall that the Stones were going to play a free concert when they got to California during their 1969 tour. One of the shots I took of Mick that day was used on the cover of the next issue. We were all looking forward to the event but as we all know, it didn't end well. Everybody blames the disaster at Altamont on the Hells Angels but that's somewhat unfair. The Stones made a commitment to perform a free concert in the Bay Area, originally in Golden Gate Park, a perfect location, but at the last minute the City refused to issue permits. So they started looking around for another venue and found an ideal location in Sonoma County, the Sears Point Raceway, which had plenty of room and was a perfect outdoor venue. They had Sears Point all lined up but the owners of the track, a big corporation in southern California, backed out, supposedly because of liability issues. You can't blame

> *Everybody blames the disaster at Altamont on the Hells Angels but that's somewhat unfair.*

the Stones for the disaster either; there was nothing that could be done. It was all wrong, planned badly and if it was anyone's fault it was the City of San Francisco which said no in the first place and the LA corporados who said no in the second. Had the City said yes it would have gone forward like any other peaceful concert at Golden Gate Park. At the time, I kept wondering how the hell were they going to do this. They kept going from one venue to another. It wasn't going to work out well.

By then the Stones were down to the wire; they're coming to town for the concert but they've got nowhere to play. So this guy who ran the Altamont racetrack stepped up. "Come on out to Altamont; you can do your show here." They had only hours to construct the stage, to put the lights up, to build the sound system, hours to do something that

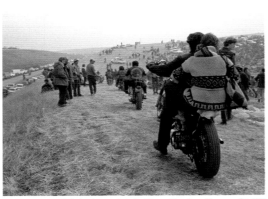

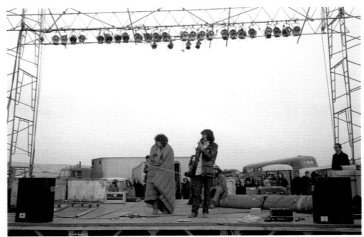

Hell's Angels en route to the Altamont Speedway, Livermore, CA, 1969

Michael Lang and Sam Cutler, Altamont Free Concert, Livermore, CA, 1969

usually takes weeks, at least days; they had to do that overnight. Their people struggled all night long to get the facility ready for the free concert. In the end they built a stage that was probably, at most, four feet off the ground. That's not very high; they had no perimeter space to keep the crowds away so the fans were able to push right up to and hang on, or even climb up on the stage. Either somebody wasn't thinking or there just wasn't time enough to put up fencing to keep the people back a little bit.

The Hells Angels had been hired to provide security. The promoters figured just by their sheer presence the Angels were going to keep people away. So they were put on the stage to keep people off and away, but the crowd didn't pay attention to them – wouldn't pay attention – and pushed toward the front. There was animosity between the crowd and the Hells Angels; it was like goading a lion who's sitting there minding his business and that's how that whole thing became a disaster. Everybody looks down at that guy who was killed and blames the Hells Angels but really, whose fault was it? It was a perfect storm that ended badly, that's all there was to it.

> *There was animosity between the crowd and the Hells Angels; it was like goading a lion who's sitting there.*

It was a horrible day, the weather was cold and damp, and everybody was so uncomfortable. I'd ridden out in the motor home the night before with the writers from *Rolling Stone* to cover the concert but I knew the moment I opened the door of the motor home in the morning that it was not going to be a good day. I looked out and I saw a Doberman run down a rabbit and kill it, and I thought that's the way this day was headed. In the middle of the afternoon I realized it was going to get bad and I didn't want to stay anymore so I hitched a ride out. Looking back I remember there were virtually no sanitary facilities, it was all very rudimetary; of all the concerts I'd gone to, nothing had been like that. The Stones were caught, they couldn't cancel, they couldn't *not* hold the concert, but just look at the weather, look how everybody was bundled up; it was miserable.

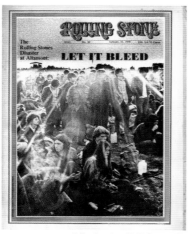

Rolling Stone Issue No.50, January 1970

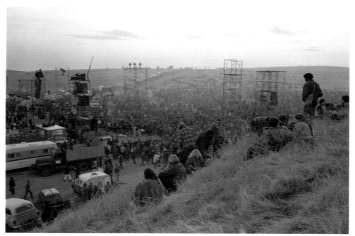

Altamont Free Concert, Livermore, CA, 1969

Jann was pissed. From his house he called, "You left, you fuck. How could you fucking leave? You're a photojournalist, you're supposed to cover this thing!" I said to Jann, "So where were you, Jann?" Jim [Marshall] stayed to the end but much of his film got messed up by his lab; bad vibes all around. (The only reason I was sorry I didn't stay is that I missed getting pictures of Gram Parsons who performed that day.)

The 1960's brought about dramatic social change in America.

The nature of relationships, gender, food, drugs, segregation was radically altered, and the bands and their music reflected these changes.

I was there with my cameras – photographing those important and exhilarating days.

I was worried about going to photograph Frank Zappa. I knew his reputation as a creative eccentric and I was like, "Oh shit how am I going to deal with this?" Because I didn't even know his music; I mean, of course, I was familiar with his music, he was brilliant. But only if you really knew music could you understand that brilliance; for the most part it wasn't listenable, at least to my ears. Besides, there was nothing I could say to Frank Zappa that would in any way make me his intellectual equal. I knew I could take great pictures but I knew that I couldn't keep up with his mind. (That was my biggest shortcoming – my inability to keep up with any musician when it came to talking about the music itself.)

We got up there and I said to the writer Hopkins, "You do the interview first then I'll do the pictures," but Zappa wanted to do the pictures right away so he and I went out behind his house and found all these bizarre photographic situations that were both wacky and fantastic. I didn't have to say or direct anything; he just started fooling around because he was having such a great time. Frank being Frank – performing for me and my camera without direction. I have one series where he goes into a cave and he comes out of the cave and he goes back into the cave. It was a little peek-a-boo thing.

Then he started climbing all over the construction equipment that was on the hill behind his house. Next to the house was a huge tree; for his kids he had tied a thick rope to a branch of the tree. He started swinging on the rope just like his kids. I didn't have to do anything; I hardly had to talk to him.

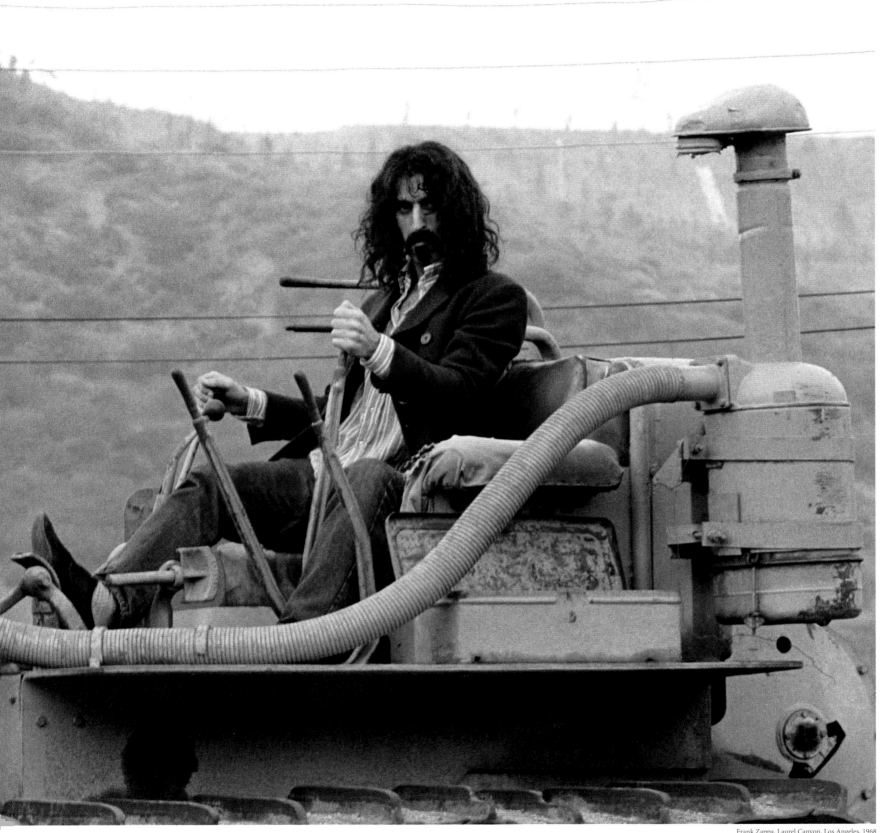

Frank Zappa, Laurel Canyon, Los Angeles, 1968

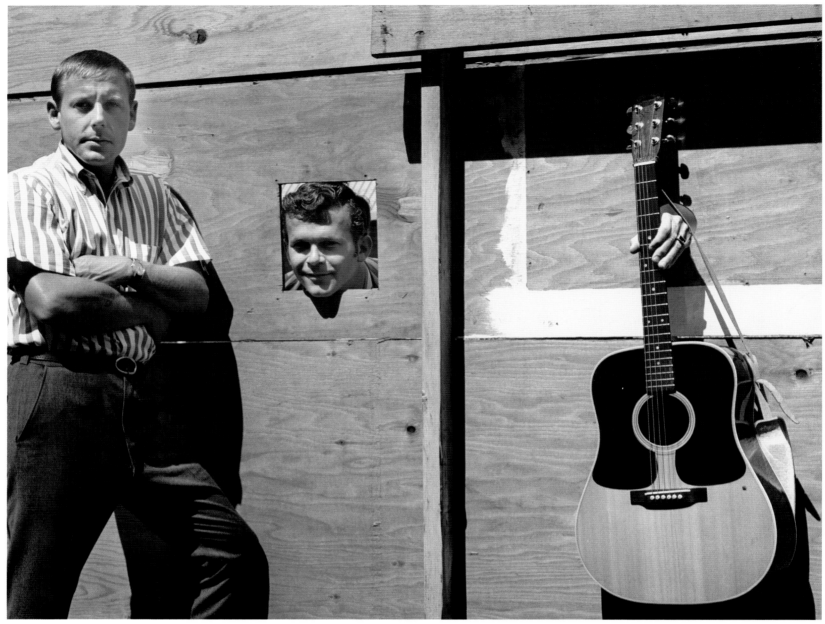

Kingston Trio, Los Angeles, 1963

The first music photo session for which I was ever paid was with the Kingston Trio, my college idols. Those guys were so good, I loved their music, had listened to them at Northwestern, had sung along with their records. Interesting that I wasn't starstruck or even had "celebrity nerves" when I shot these photos; it was just a fun afternoon. And little did I realize that with the Kingston Trio I had taken my first step into my new profession, into the fascinating world of photographing musicians. One of the Trio's hit songs was called 'Scotch And Soda'. For university students in the late Fifties, early Sixties it was one of the anthemic songs. "Scotch and soda, mud in your eye. Baby, do I feel high..." One night I was feeling oh so cool and decided to head down to Rush Street in Chicago where the clubs were, wanted to listen to some music. The band was playing 'Scotch And Soda' so I ordered one, wanting to get "high", hoping to find a "baby" to get high with. Know what? I couldn't drink the stuff.

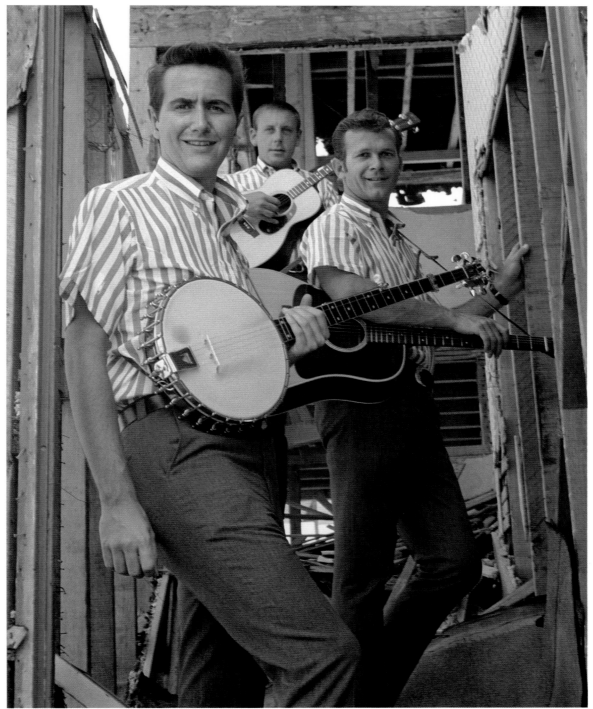

Kingston Trio, Los Angeles, 1963

It tasted horrible, bitter, nothing like I imagined when I heard the song. Indigestible. Did somebody actually like this stuff? Soda is bad enough, good Scotch, great Scotch, is memorable. But at that bar the Scotch was not good, and mixed with soda, it tasted like medicine.

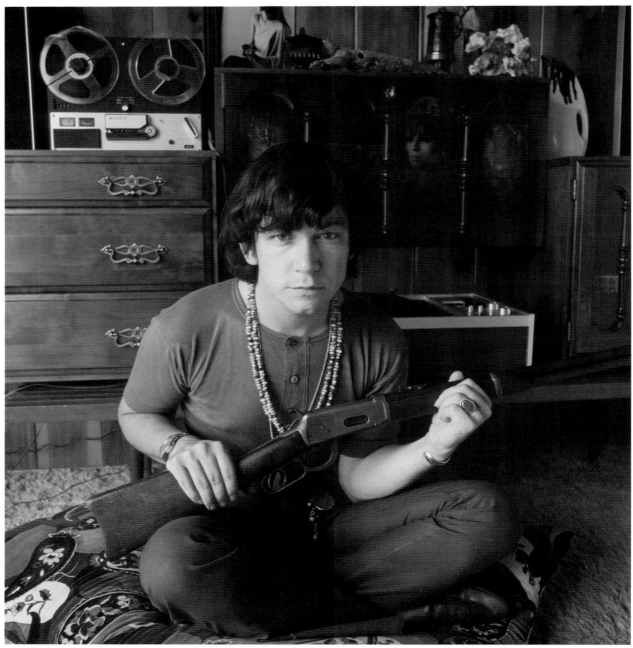

Eric Burdon at home. Los Angeles, 1968

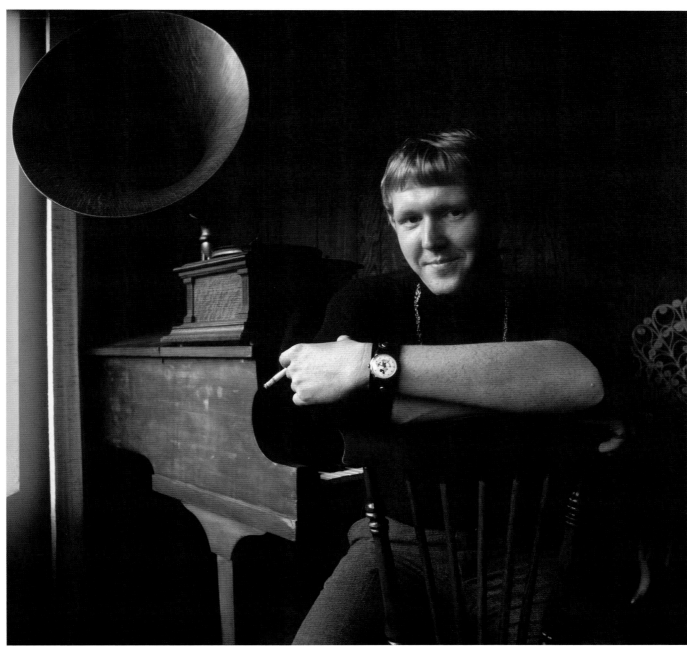

Harry Nilsson, Los Angeles, 1970

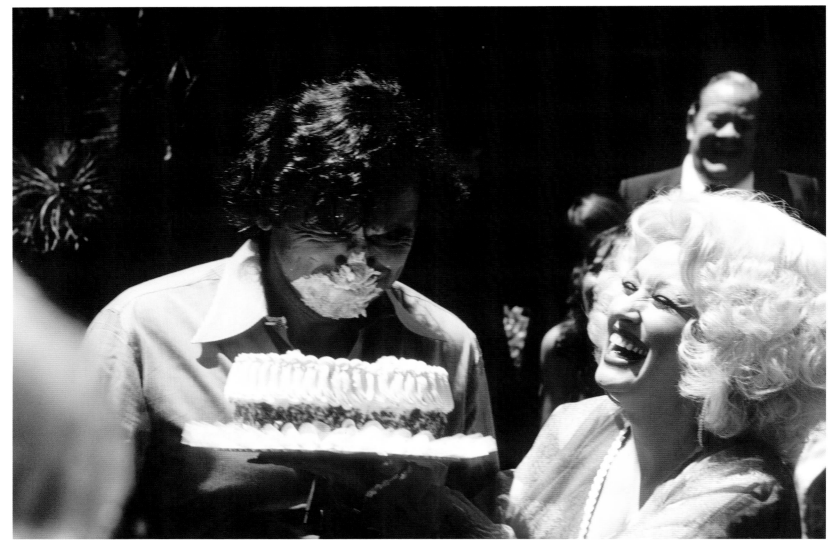

Bill Graham and Dolly Parton, Oakland Coliseum, CA, 1978

On Bill Graham's birthday Dolly Parton presented him with a cake. He was all smiles as she held the cake in front of him… and then proceeded to push it into his face, icing and all! Thinking back to the Day On The Green (DOG) concerts, a series of shows presented by Graham at the Oakland Coliseum, I chide myself for not taking advantage of the extraordinary opportunities given me. I look at the list of musicians I didn't shoot, the DOG concerts I didn't attend even though I could have – even though all it took was a call to Graham's office to get my pass and the drive from Mill Valley to Oakland. I look at that list and to this day I regret my laziness.

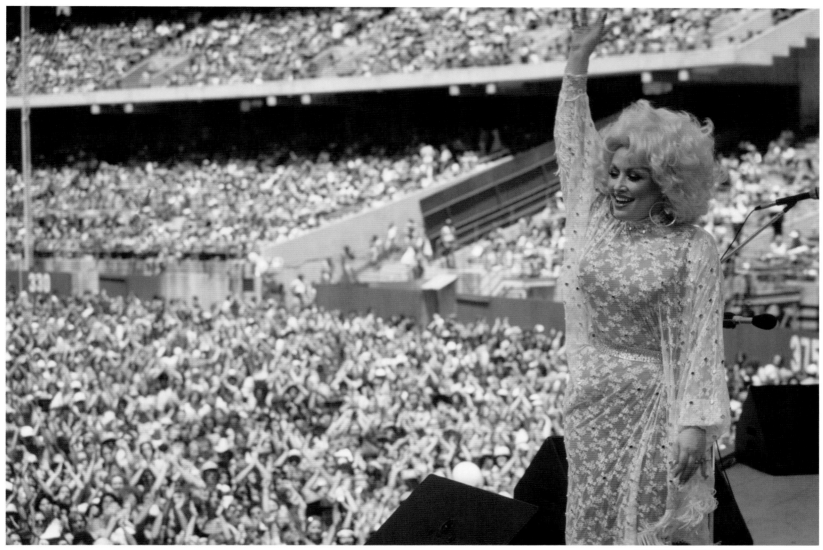

Dolly Parton, Day On The Green, Oakland Coliseum, CA,1978

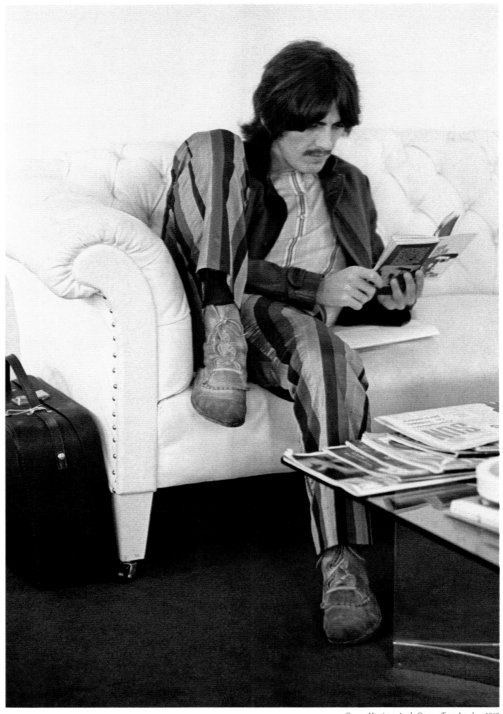

George Harrison, Apple Corps offices, London, 1968

The writer and I were sitting in the reception area of the Beatles' Apple Corps offices on Savile Row in London, waiting to interview and photograph George Harrison. He appeared a few minutes in advance of the interview, plopped down on the couch and started reading a copy of Bob Dylan's book, *Don't Look Back*. I wanted to shoot some pictures of George but didn't quite know how to begin. Yes, I was somewhat intimidated by him; after all he was a Beatle. I was conflicted: should I ask him if I could make a few pictures, ask him to pose? Or would I simply allow him to be himself while I clicked off a few frames surreptitiously? I didn't want to insinuate myself upon him. In the end I just took some photos while he was reading his Dylan book and waiting for the interview to begin. Although I quite like this one picture, in retrospect I would have liked to have posed him a little bit and said, "Hey, George could you look here for a second," or something like that. But he didn't

Yoko Ono's Apple Sculpture, Apple Corps offices, London, 1968

volunteer; he knew I was taking pictures and continued to read; there was no collaboration. We all went inside for the interview with him, he knew who I was, we were introduced, but I truly didn't take advantage of the situation in the way I should have and normally I would have. Ah, the missed opportunities…

Before George arrived I spent a little time wandering around the Apple building. The Beatles hadn't been there that long, a couple of months, I think, and they were in the process of getting the place set up. There was still not enough office furniture but there was lots of *stuff* everywhere. In the corner of one room against a wall

were different pictures and illustrations of apples as well as what I later found out to be a piece of artwork by Yoko Ono, also featuring an apple, of course.

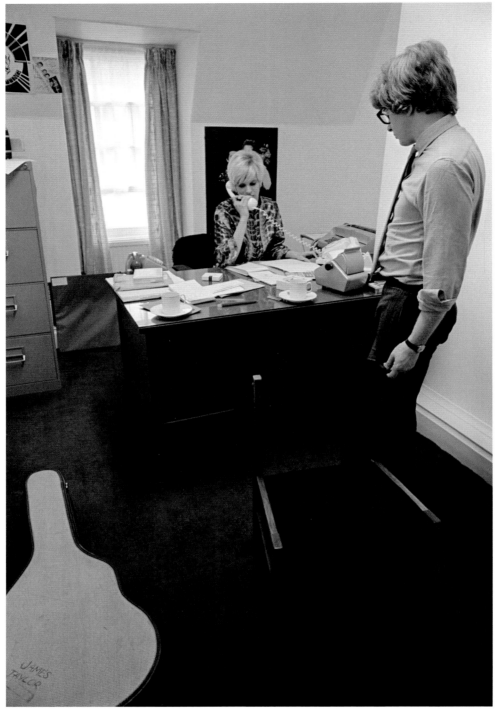

Peter Asher in the offices of Apples Corps, London, 1968

Workmen were putting together what appeared to be a recording studio of some sort in the basement. James Taylor was newly on the Apple Corps scene. George had signed him to the label, or was still trying to, and there was his guitar, laying on the floor in the office of Peter Asher, Apple's A&R man. Asher was the older brother of Jane Asher, the girlfriend of Paul McCartney; he eventually became Taylor's manager and over the years produced many of his records. The Savile Row building had 'cool' written all over it! Even the rooftop is legendary, the spot where the Beatles performed for the very last time together; altogether quite an historic place!

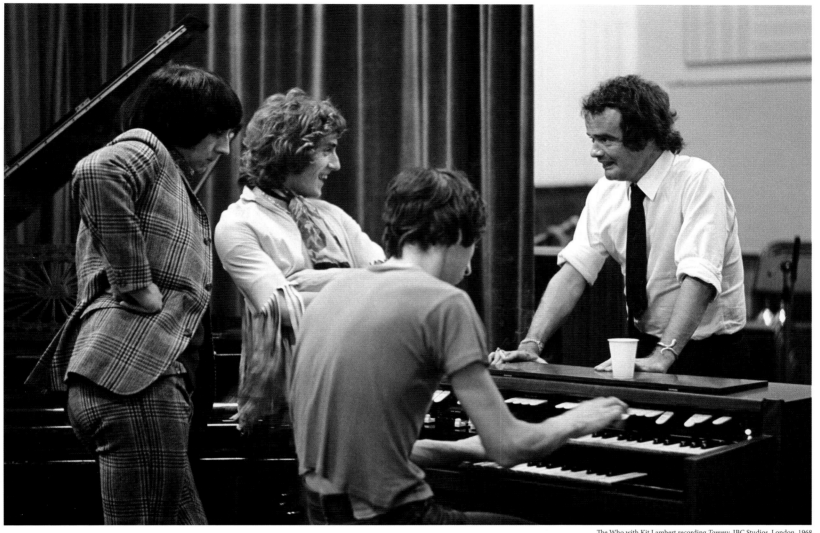

The Who with Kit Lambert recording *Tommy*, IBC Studios, London, 1968

On that same trip to London I was scheduled to shoot The Who; the band was in the famed IBC Studio recording what would soon become their *Tommy* album. Up until that time I had been in very few recording studios, certainly not when such a celebrated band was laying down tracks. I remembered the studios as being pretty tense places with musicians, engineers and producers always deep in concentration, but everybody seemed to be having a great time that day. Even though the band members were "at work," I was struck by their dress. Keith Moon sported black pants, a black jacket, a black vest, a shirt with French cuffs and what appeared to be a silk foulard. John Entwistle wore an Edwardian flavored suit, and Roger Daltry was dressed in what appeared to be a Chamois leather shirt with some sort of neck scarf. Townshend was under-dressed in a T-shirt, khaki pants and desert boots; I guess he earned it…

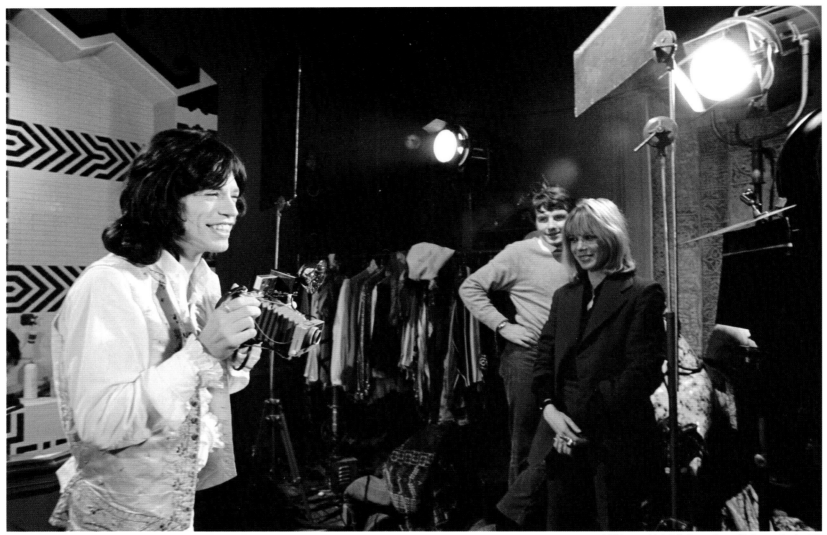

Mick Jagger and Anita Pallenberg on the set of *Performance*, London, 1968

Juliana was with me on the 1968 trip to London. After The Who finished work in the studio Pete invited us for dinner and later decided we should go over to the film set in which Mick Jagger was shooting his new movie, *Performance*. According to IMDB, the Internet Movie Database, the actual location was 23 Lowndes Square, Knightsbridge, London, which would explain the relatively short drive. Dropping by the movie set had nothing to do with my *Rolling Stone* assignment; this was just Townsend's suggestion. I mean, I *think* it was his idea that we go over there; at least, that's how I remember it. So we just showed up, and, as you can see, the photos were very informal. I love the classic Polaroid camera Mick is holding and Anita Pallenberg was gorgeous. The relationships were all a little complex; Anita was Keith's girlfriend who had been with Brian Jones before and was now in a movie doing love scenes with Mick! Without realizing at the time what a big deal it was, not only

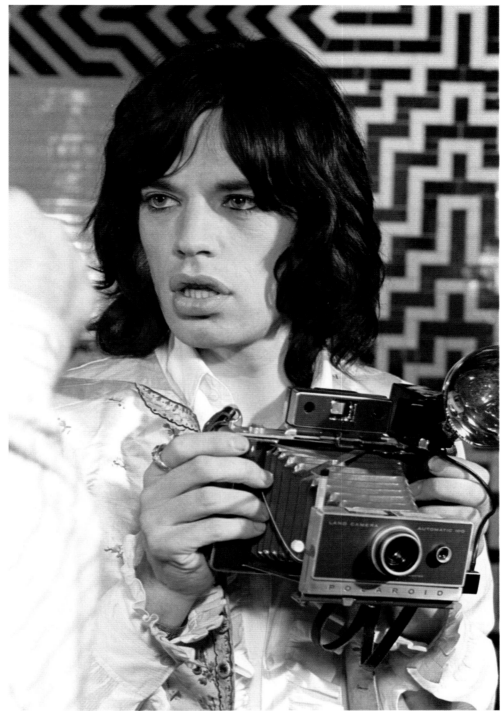

Mick Jagger on the set of *Performance*, London, 1968

was I in "swinging" London but I had
photographed The Who, a Beatle and a
Rolling Stone. Not bad for a few days work.
Looking back, I wish I had been living in
London during those times – there was
clearly a society of musicians and other
creative artists of which I would have
happily been a member.

I myself didn't realize that this line-up of guitars belonged to the illustrious guitarist Jimmy Page. Embarrassingly, I didn't even know that much about Led Zeppelin when I photographed them. I simply liked that they were a hugely photogenic band; to me that counted for a lot. Sure, I was familiar with 'Stairway To Heaven', watched the crowd go crazy yet again when the band played it. But when Zeppelin showed up to a thunderous welcome I was surprised because once again I didn't appreciate they were such a big deal to so many people, and that's true of so many musicians I photographed.

Looking at the dearth of pictures in my files I think, damn, I could have, should have, taken so many more photographs. I never quite understood the wonderful opportunity I was given to document and make a record of these people who were to become so important to the history of music as well as the history of our society. I guess I should have known; I just couldn't see that far into the future. Who could? So many others apparently did – certainly David Gahr did. He documented virtually all of the original great blues, folk and country artists. If I could only turn back the clock...

The Day On The Green concerts produced by Bill Graham were incomparable; nobody produced concerts like Graham. He was, hands down, the best. Over the years and after I left *Rolling Stone* I shot several DOG concerts for Bill; I wish I had attended more. Every Day On The Green line-up included the best, most popular musicians of the day. I look back on the series and wish that I and my camera had been at every one; I should have just moved to Oakland because every band you'd ever want to see or photograph performed for Bill and the DOG fans.

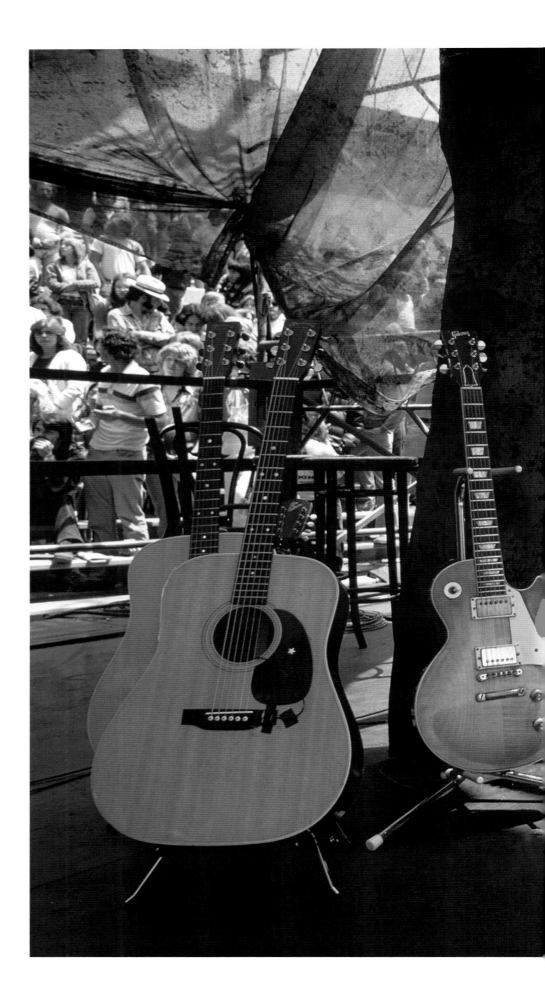

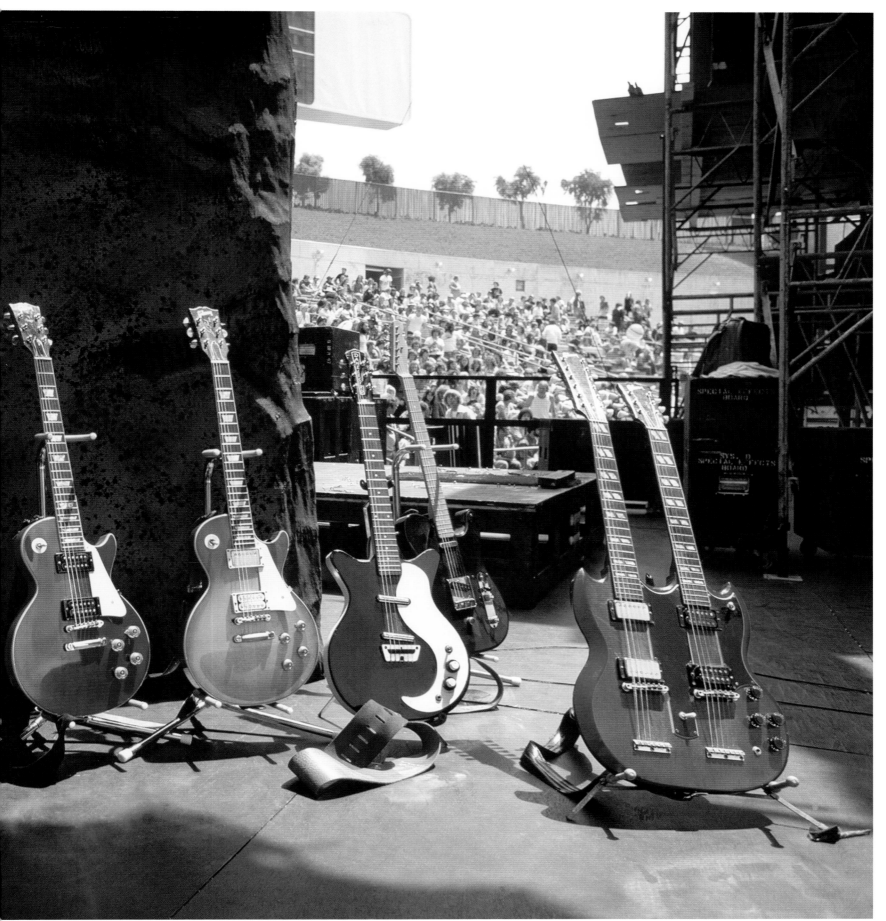

Jimmy Page's "heavy artillery," Led Zeppelin, Day On The Green, Oakland Coliseum, CA, 1977

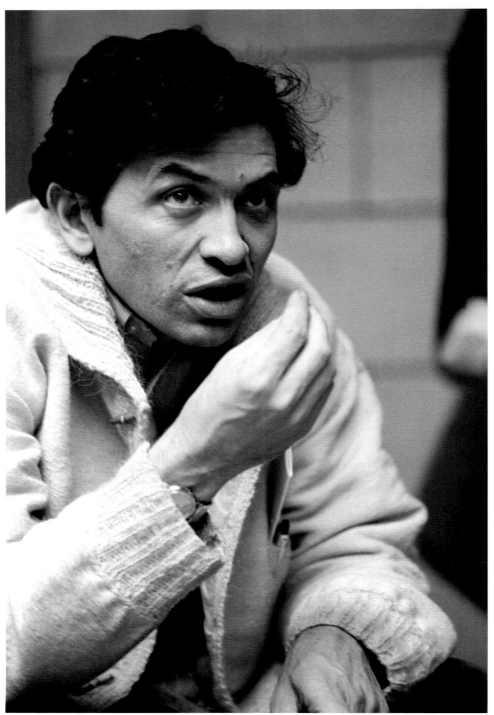

Impresario Bill Graham, San Francisco, 1967

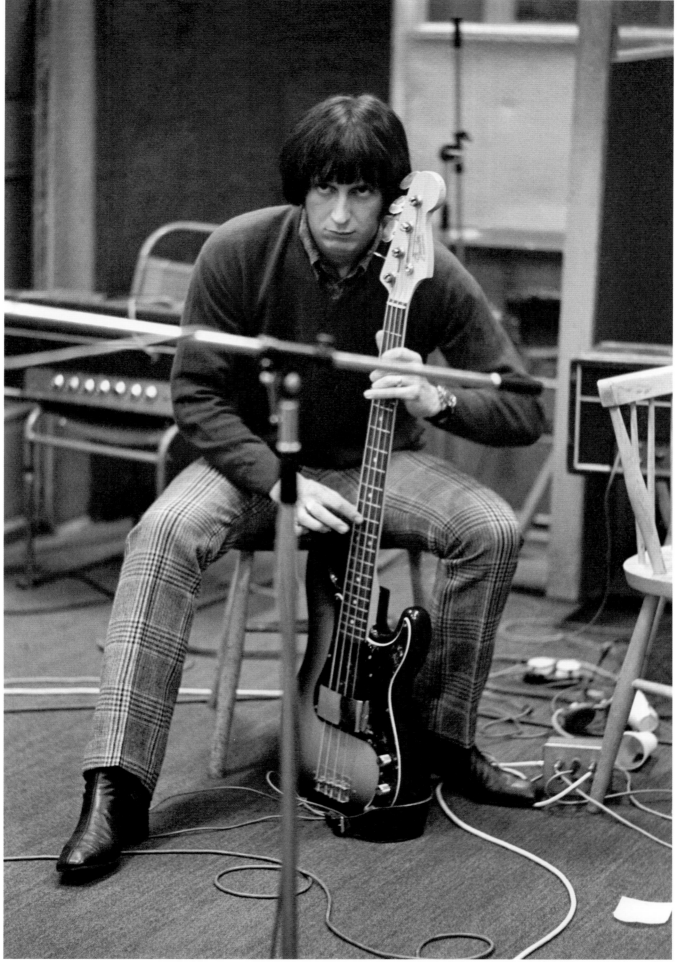

The Who bass player John Entwistle, IBC Studios, London, 1968

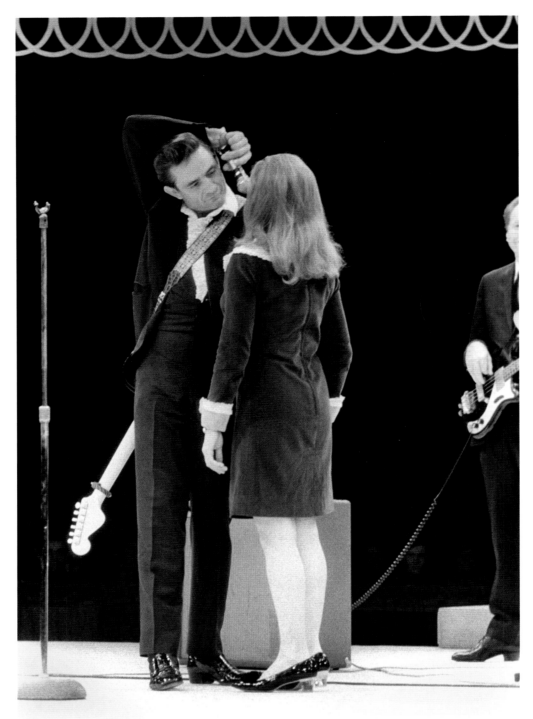

Johnny Cash and June Carter Cash, Circle Star Theatre, San Carlos, CA, 1967

Backstage Johnny Cash sure didn't look as though he was anticipating a happy performing experience that night. In all of the pictures that I took backstage that evening he's somber, and not the kind of somber or nervous anxiety that precedes a show. It was something else – you look into his eyes and you don't see a whole lot of

joy in there. I don't know much about him during that period (it was 1967) or what was going on for him personally, so it's impossible to speculate what was on his mind. Although before the show both Johnny and June looked as if the last thing they wanted to do was get on stage, they put on a very very good show; the audience

clearly got its money's worth. Backstage somber, onstage smiling. What can I say? The Cash photos are some of the first I took on assignment for *Rolling Stone*. We started publishing in October of 1967; these were taken in December of that year at the Circle Star, a popular theater-in-the-round south of San Francisco. I am quite

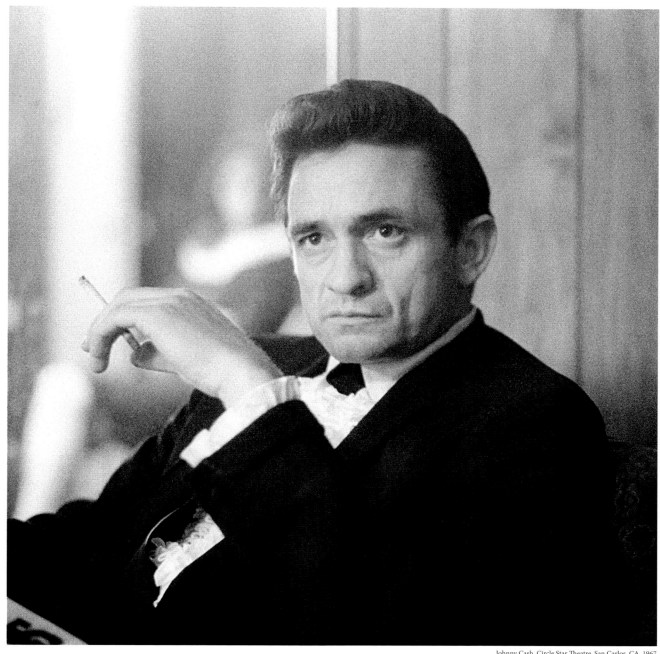

Johnny Cash, Circle Star Theatre, San Carlos, CA, 1967

fond of this particular backstage photo I made of Johnny – his body language, the seated pose, the look in his eye, that fake wood background, the grain of the film I was using that night. Everything about that photo is really great. In 2007, the Morrison Hotel Gallery on Prince Street in New York City exhibited a collection of my music

photographs. Included in the collection was this same photo of Johnny Cash, of course. During the opening a woman came up to me and said, "I love your photo of Johnny Cash and June Carter Cash." I thanked her for the compliment, but asked, "Where is June in the photo?" She replied that June was in the background, and pointed to her.

She was right; June was, indeed, in the photo, out of focus, reflected in the mirror behind Johnny. I had taken that photo in 1967; it took 40 years before I "found" June in the picture – that is, until she was found for me. We think we know everything about the pictures we've taken until something new is revealed. I love this profession!

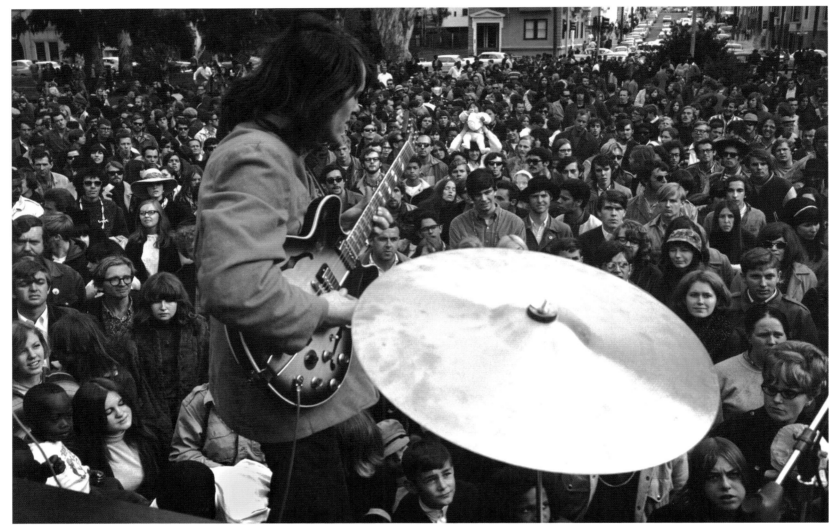

Quicksilver Messenger Service, Golden Gate Park Panhandle, San Francisco, 1967

I was a big fan of small concerts, nothing larger than the Fillmore West. So it was with considerable dismay that I watched Graham move his concerts into the Oakland Coliseum, the home of the Oakland Raiders professional football team and the Oakland Athletics professional baseball team. Who would come to a concert in an outdoor sports arena, I wondered? Well, of course, tens of thousands did, week after week, for Bill Graham's Day On The Green (DOG) concerts.

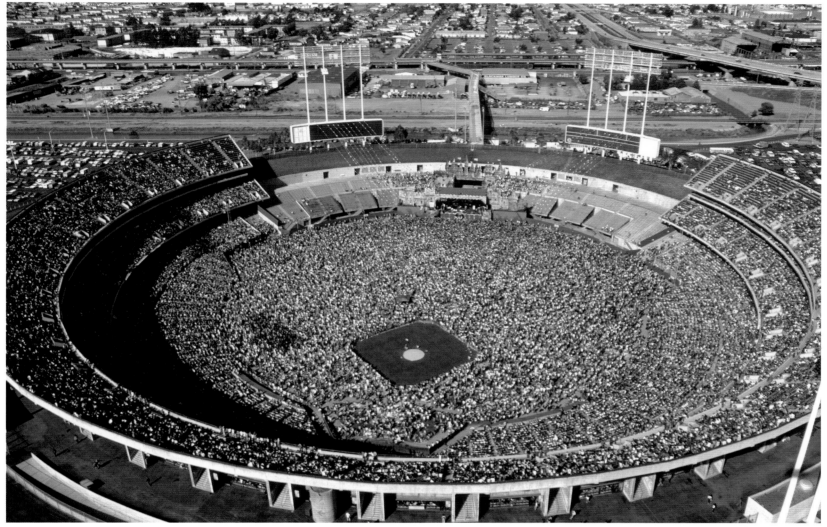

Day On The Green concert, Oakland Coliseum, CA, 1976

After I left *Rolling Stone* and started making aerial photos I would still do an occasional music shoot. I kept in touch with Graham and his people. They knew I was shooting aerials and they knew I loved music so they told me to charter a helicopter and shoot Peter Frampton's "The British Are Coming" show – one of the early DOG concerts – from the air. I could not believe the thousands of fans who packed the stadium, nor the amazing set Graham had built for Frampton's performance. It was only the first of many DOG concerts I photographed for Bill and to this day I believe that taken as a whole, the DOG concerts that ran from 1973 to 1991 comprised the best series of outdoor performances this country has ever seen. The groups were incredible, the sets were incredible, and the production values were incredible. Everybody who was anybody appeared at Day On The Green. A look at the DOG Wikipedia entry is like reviewing a *Who's Who* of popular music.

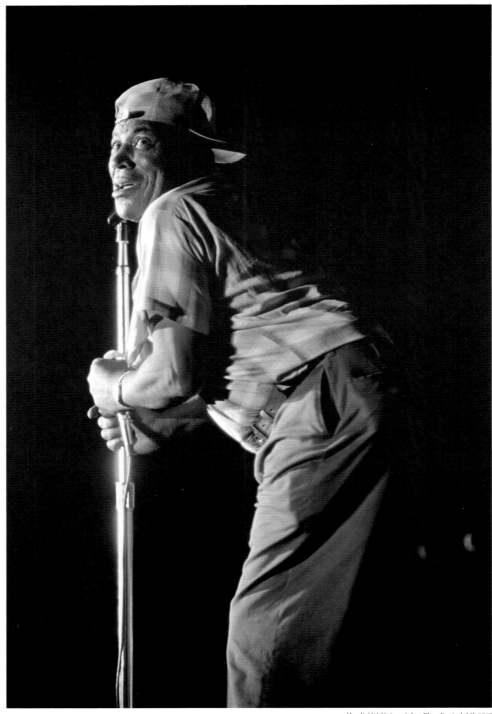

Howlin' Wolf, Ann Arbor Blues Festival, MI, 1969

Howlin' Wolf was scheduled to perform at the Ann Arbor Blues Festival, another one of our stops on the *Festival* book tour. I photographed him backstage in the afternoon. He was already "two sheets to the wind" and by the time he climbed on stage he was wasted; he had been drinking all day. Blues legends Mississippi Fred McDowell and Roosevelt Sykes performed at Ann Arbor, as did Muddy Waters, Luther Allison and Willie Mae "Big Mama" Thornton. I remember being surprised to see cops at the entrance searching backpacks and confiscating bottles of wine and beer then emptying them into a big steel drum. Perhaps that was one of the reasons why the festival was such a laid-back and totally enjoyable two days of music.

Not far down the road – and concurrent with the blues festival – another musical gathering was taking place, The Mt. Clemens [Michigan] Pop Festival.

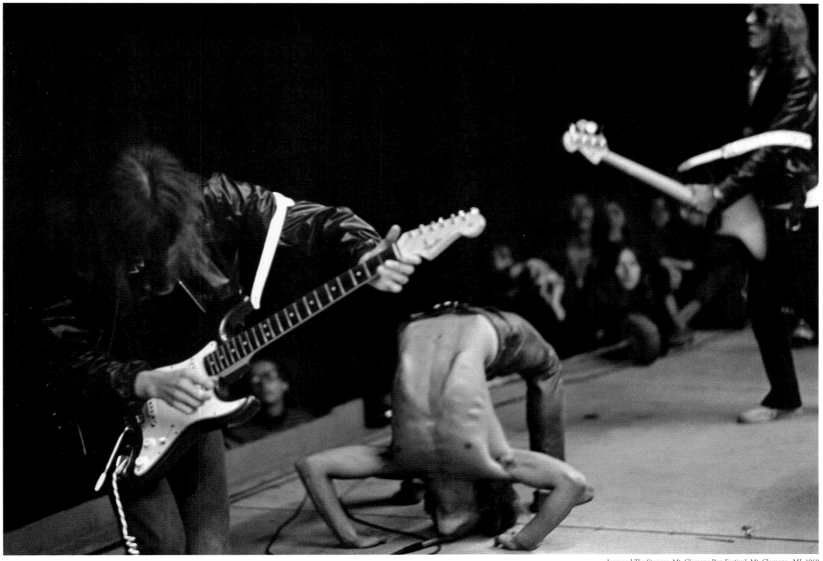

Iggy and The Stooges, Mt. Clemens Pop Festival, Mt. Clemens, MI, 1969

It was there I had my first and only encounter with Iggy and The Stooges. I had no idea who they were, and was not prepared for Iggy's on-stage gymnastics. Man, he bent over backwards almost in half, still wailing into the microphone: he was hardcore. But he was great to shoot and definitely met my "photogenic test!"

That small festival took place in some kind of a bog, it was so uncomfortable – hot, humid, swarms of mosquitoes – I couldn't wait to get out of there. And now again the self-chastising – had I known more about Iggy, understood who he was, especially in the Detroit music scene, I would have shot a whole lot more film;

hell, I only took a total of 10 frames or so. Unforgivable! Nevertheless, Mt. Clemens Pop was one of those small concerts where it wasn't about famous bands; these were kids who loved to play music and it didn't matter to them that the crowd was small. This was pop music at its most innocent, fresh and compelling.

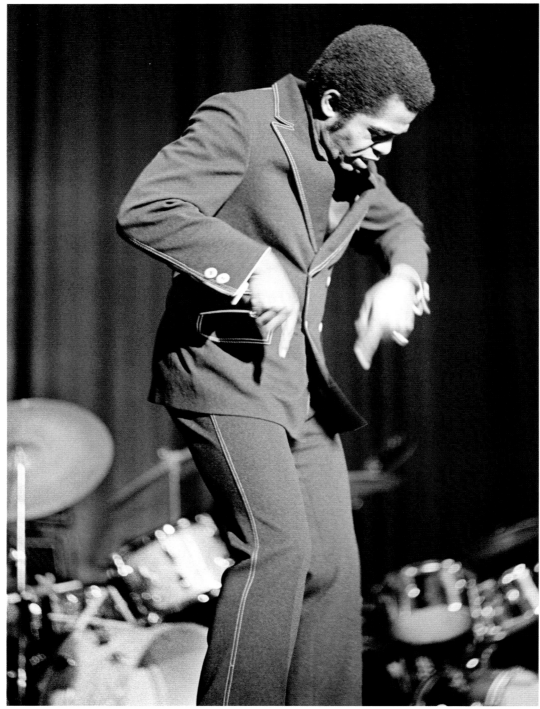

James Brown, San Francisco Civic Auditorium, 1970

These shots of James Brown were made at a 1970 New Year's Eve concert in what was then called the San Francisco Civic Auditorium. After Bill's fatal accident in a helicopter crash in 1991, it was renamed the Bill Graham Civic Auditorium to honor his extraordinary contribution to the San Francisco music world. Getting backstage was always a challenge, but in this case it was a particularly unique one. Back then Brown had a security team that resembled the squads surrounding rap stars these days – large black men and lots of them. I'm a small white man and, evidence to the contrary, it's not difficult for anybody to intimidate me. It's never been easy for me to be cool and justify myself, explain why I was here or there in order to get past security so I could just do my job, take my pictures and not bother anybody. I kept thinking about how Jim (Marshall) would have handled the situation. Jim grew up in a mostly black neighborhood so he knew how to behave, or not to. My pal, the tall white

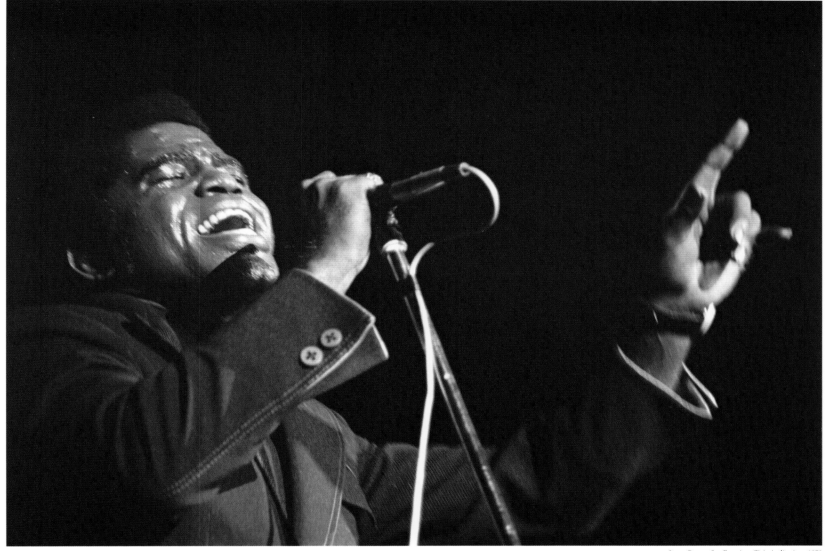

James Brown, San Francisco Civic Auditorium, 1970

photographer Michael Zagaris, thinks he's black and can talk to anybody like a "brother." I, on the other hand, was a little white guy from the suburbs trying to hide his discomfort. Security had been given their marching orders to keep everybody out and they were doing their job well. As usual, however, in the end I was passed.

Once I had made it through the layers of armor I was treated very well by Brown and his people and was given total access.

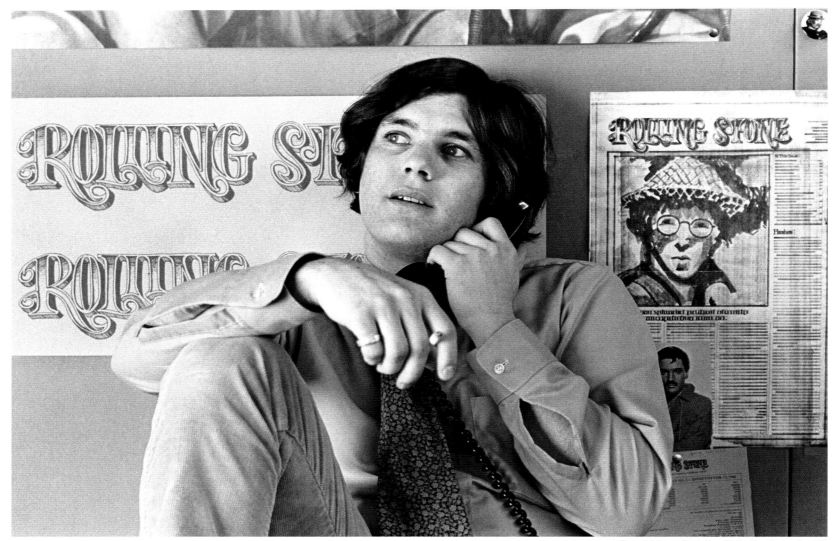

Jann Wenner in the original Brannan Street offices of *Rolling Stone*, San Francisco, 1968

These two pictures of Jann were taken early in the history of the magazine, shortly after publication of *Rolling Stone* Issue No. 1. On the wall is the layout dummy of the first issue. I recall some debate around the design of the logo; I'm pretty sure Rick Griffin played a role in the design – they may have done a bit of work on Griffin's initial interpretation but the details escape me. In the dummy for Issue No.1 you can see the illustration of the photo of John Lennon in the movie *How I Won The War*. All the early layouts were done this way, by hand. This must have been a sample layout; the actual issue didn't end up quite like that – similar, but not the same.

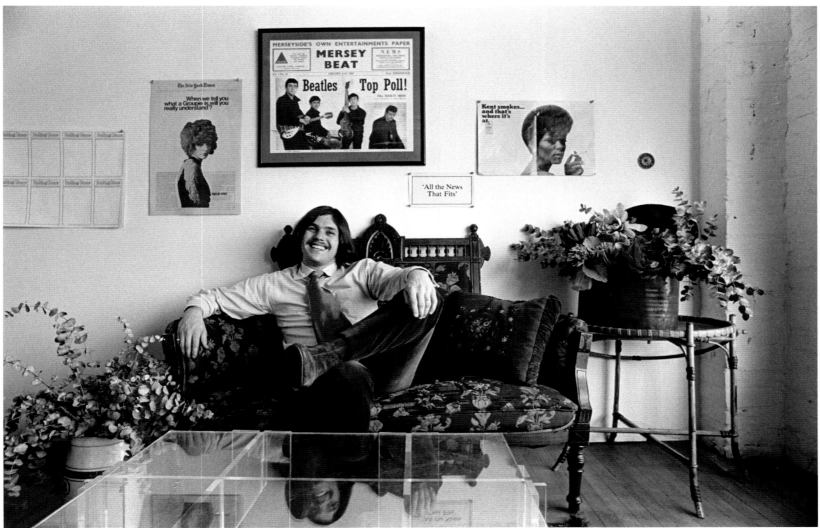

Jann Wenner in his personal office on Brannan Stret, San Francisco, 1969

always admired Jann's taste. He had great taste in household and office furnishings, great taste in design, great editorial taste – the man had taste in spades. I mean, when do you walk into the office of a 22 year old and find a carved antique love seat or an expensive Plexiglas table? Who would decorate with such elegance? Any other start-up company would more than likely have had a table made out of cinder blocks with an old wooden door on top. A couple of years after we began publishing, *Communication Arts* – the highly respected publication dedicated to excellence in graphic design – did a piece on *Rolling Stone* which praised our magazine for its design and photography but made little or no mention of its editorial content. Although Jann was not happy about the omission, I think he knew intuitively that how the magazine looked played a major role in getting people to pick it up and take it home. It had to look good in the first place; if it reads well, too, they'll come back for more.

Ted Nugent, Day On The Green, Oakland Coliseum, CA, 1978

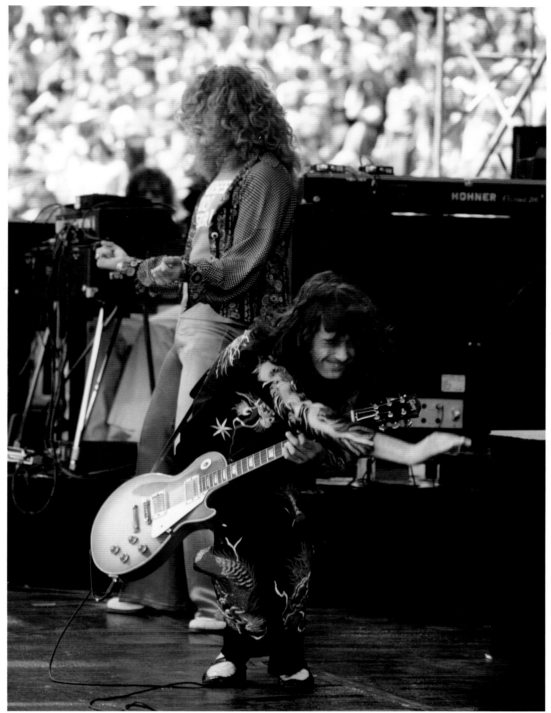

Robert Plant and Jimmy Page, Led Zeppelin, Day On The Green, Oakland Coliseum, CA, 1977

My friend Phil Carroll, the art director at Fantasy Records, phoned one day and asked me to fly to LA to photograph Duke Ellington and his band for an album Fantasy was about to release. It was so exciting to be in a gorgeous show-room with a big band; for years I had been enjoying Ellington's music but I had never actually seen him or his band – or any "big band" for that matter.

Duke was another one of those absolutely wonderful, hospitable celebrities I would occasionally encounter. For all of his many talents and accomplishments – he was a bandleader, a pianist, a composer – Duke had no big head, no ego issues, none of that stuff which became so much a part of the rock 'n' roll scene. I sat with him for a long while in his dressing room and we talked while I shot some informal portraits; he was a gentleman, the man had class. The day I photographed them the band was performing at the legendary Ambassador Hotel on Wilshire Boulevard, the same hotel where Robert Kennedy had been assassinated in 1968.

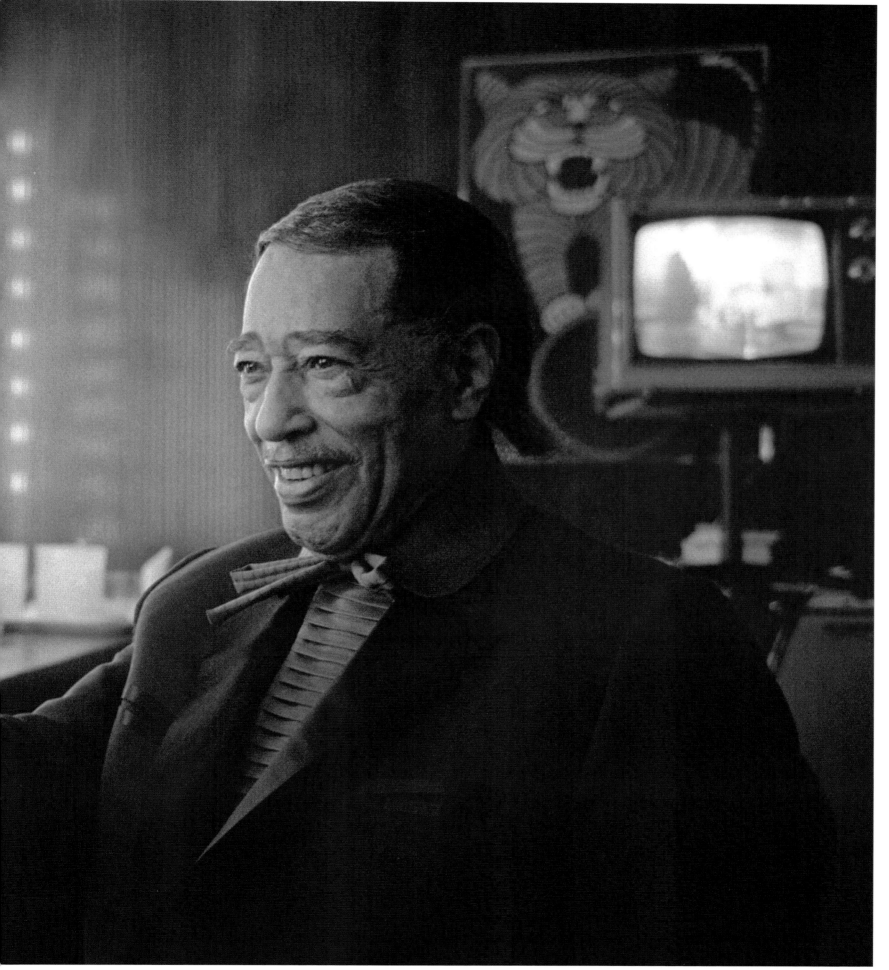

Duke Ellington, Ambassador Hotel, Los Angeles, 1972

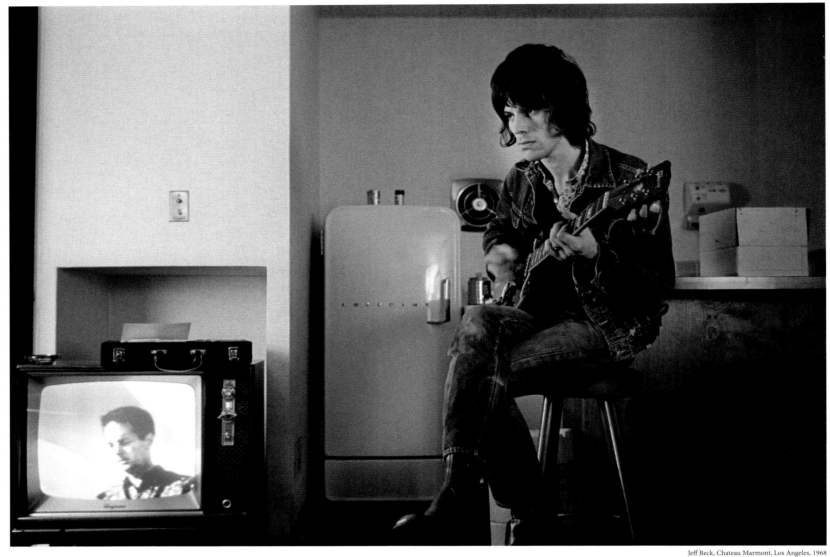

Jeff Beck, Chateau Marmont, Los Angeles, 1968

In 1968, for *Sunset* magazine, I shot a story about a cruise ship sailing from San Francisco down to LA. When we got to port in Los Angeles I hustled off the boat to the Chateau Marmont to meet up with Jeff Beck and his band. We sat around the rest of the day before heading back up to San Francisco where they were performing next at the Fillmore. It was the only occasion that I hung out with a band over a period of time, did nothing but sit and talk and take pictures. It was nice, it really was nice, and I can see why a lot of photographers like to do that; without the pressure of a gig we can get great pictures like the ones I took of Jeff in his room at the Marmont, sitting there playing his guitar with the silent TV in the background; you don't get that unless you're on tour with a band.

Jeff Beck, S&C Ford, San Francisco, 1968

...isco ...ith the ...ood, Rod Stewart, Mickey Waller and Nicky Hopkins. I acted like a tour director, showing them my city, explaining to them how to ride the cable cars, taking them across the Golden Gate Bridge to the famous No Name Bar in Sausalito (where they started hitting on the chicks, of course). In those days Jeff travelled with a 45rpm player and a stack of 45s. He would put on some music and practice alone in his motel room. Beck was also a car guy. He asked me if I knew where he could buy an American hot rod so I took him to the showroom of a car dealer who had one which was for sale. Jeff was immediately fascinated with the car and decided to buy it on the spot. I photographed him writing a check to the dealership. I later heard the car never made it to the UK – something about shipping or permit issues. I also heard that he regretted not figuring how to get that car home.

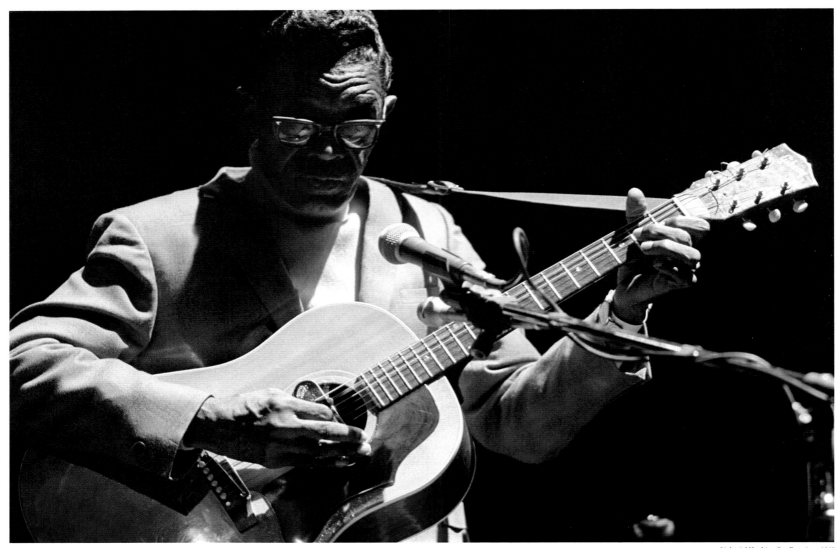

Lightnin' Hopkins, San Francisco, 1969

I was decidedly unlearned when it came to the blues itself and the musicians who played it. Even though I photographed and enjoyed the music of many of them, by the time my knowledge had caught up with my pictures, many had passed away. This photo of Lightnin' was taken in San Francisco in a small club on Divisadero Street.

It was when Jim [Marshall] and I went to those blues festivals in 1969 – Memphis and Ann Arbor – that I truly began to understand the hugely significant role these musicians played in the history of American and British popular music. At the festivals when I listened to the old guys playing the decades-old blues I came to understand in a

much more visceral way that this was the origin of much contemporary music, especially the popular music coming from the UK, played by the Stones, The Who and the others.

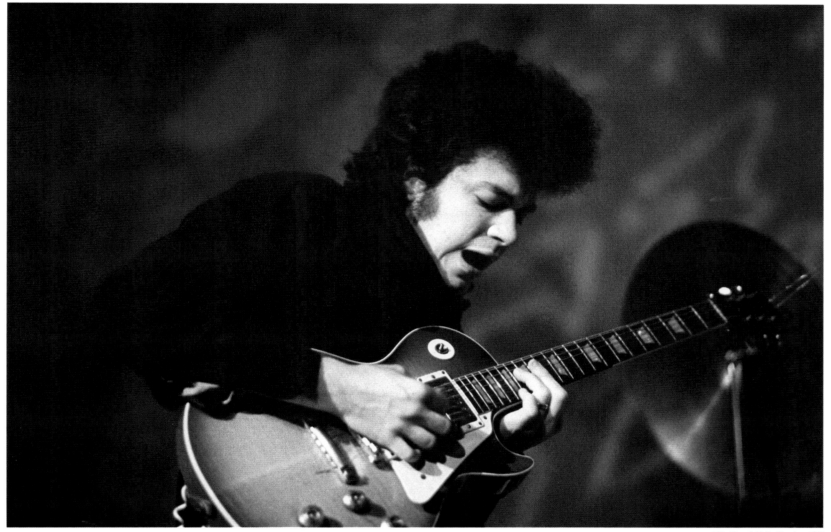

Mike Bloomfield, San Francisco, 1968

Mike Bloomfield was a white, black blues player – no other way to describe him. He was born into a wealthy Jewish family on Chicago's North Side, near Northwestern where I attended college. Bloomfield's interest in and commitment to blues began as a teenager and he spent hours at the blues clubs on the South Side of Chicago.

When *Rolling Stone* ranked him as number 22 of the top greatest guitarists, it wrote, "Bloomfield's reputation as the American white blues guitarist of the 1960s rests on a small, searing body of work: his licks on Bob Dylan's *Highway 61 Revisited*, his two LPs with the Paul Butterfield Blues Band and his sublime jamming with Al Kooper

on 1968's *Super Session*." It's significant and not widely known that Bloomfield was one of the members of the band which backed Dylan at his controversial first live electric appearance at the 1965 Newport Folk Festival.

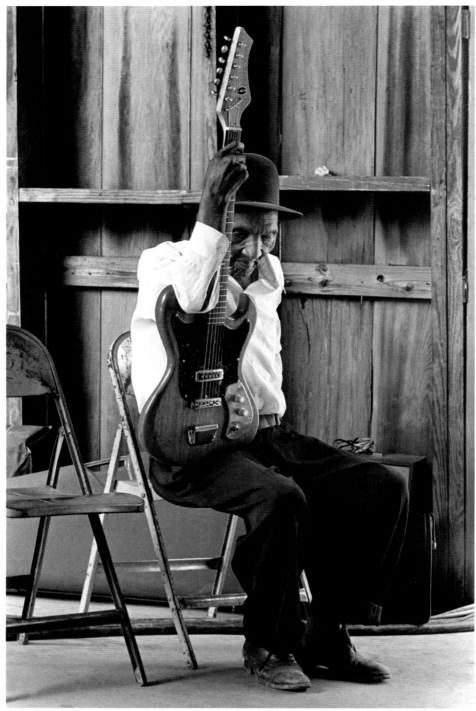

Nathan Beauregard, Memphis Blues Festival, TN, 1969

When I photographed Nathan Beauregard at the Memphis Blues Festival in 1969, I had yet to learn that he was blind at birth, was probably already few months or years beyond his 100th birthday and had been singing for decades. He was led on to the stage by his 73-year-old nephew, Marvin, and according to some reports, at least one of the songs he sang was 'Highway 61 Revisited.' He had a high-pitched voice, more or less consistent with his age, I guess, but his diction left something to be desired. His performance was exceptional in that he sang the true roots of the blues; if you wanted to know where the Delta blues came from, this was it.

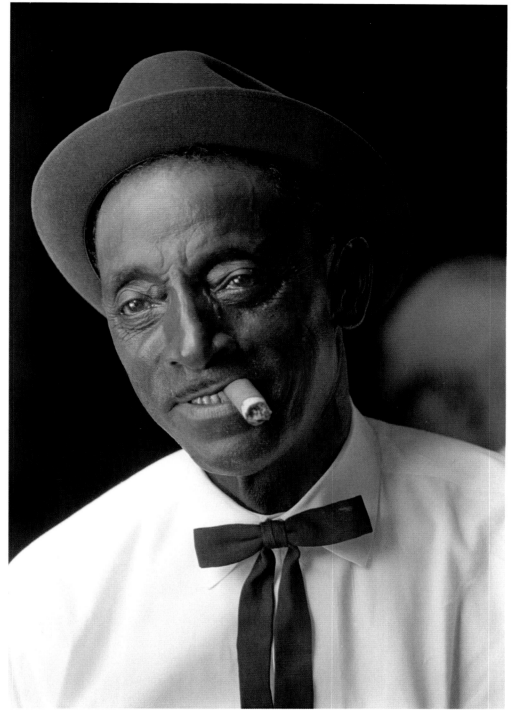

Mississippi Fred McDowell, Memphis Blues Festival, TN, 1969

On too few occasions in the late Fifties, when I was in college in the Chicago area, did I wander down to the South Side where so many of the icons of blues were playing in the clubs. I always enjoyed these "white boy expeditions," always enjoyed the music, always enjoyed being in the clubs. At the time, I had temporarily put aside my cameras and hadn't thought to document my club visits – another one of my major regrets.

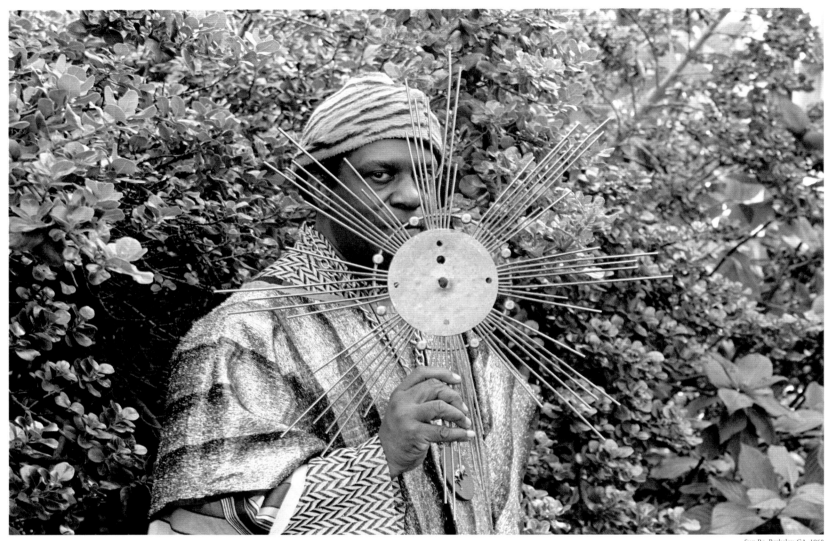

Sun Ra, Berkeley, CA, 1968

When I went to Berkeley to photograph Sun Ra for Issue No. 31, I had no idea who he was or what sort of music he and his Arkestra played. The man was a remarkable and somewhat obscure musician – both he and his music were other-worldly, controversial and difficult to grasp. Sun Ra died in 1993, but his music – an amalgam of jazz, electronic and improvisation – has been rediscovered by a new and younger audience and is widely sampled by DJs around the world. According to one source, Sun Ra "was a prolific jazz composer, bandleader, piano and synthesizer player, poet and philosopher known for his 'cosmic philosophy', musical compositions and performances." He was also enormously photogenic, meeting all my material criteria for the making of a good photograph.

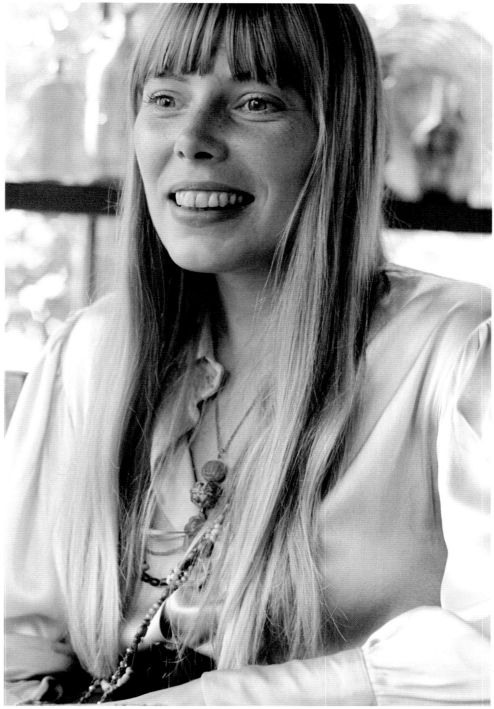

Joni Mitchell at home, Laurel Canyon, Los Angeles, 1968

Occasionally, when my friend Jean and I have "deep meanings" to share we'll send song lyrics to one another. Our feelings and "deep meanings" are not so unique; others have had similar experiences, and for ages songwriters have penned words of joy and sorrow and desire. Jean will invariably send me Joni Mitchell lyrics and they're usually spot on and poignant. Joni's lyrics are neither simple nor simplistic; they're complex and soulful and usually reach the heart of the matter. I have a much greater appreciation for Joni Mitchell now that I've been introduced to her in this manner. Joni is also a skilled painter; you can see her work on her website. But unlike other would-be musician-painters she refuses to market or sell them at all. I admire her for that although I would love to publish a book of her paintings; that would be one good way to share them without selling them.

I photographed blues musician Taj Mahal a few times, mostly at or around his home, seldom in concert. Like Jimi Hendrix, I found it difficult to take a bad picture of Taj. There was something about the man which was fundamentally photogenic. My friend Jim Marshall often spoke about the trust that can exist between photographer and subject, a necessary component to a successful photographic experience, one that provides an opportunity to create intimate and meaningful portraits. Perhaps that trust existed between Taj and me. In 1974, Taj was living in Oakland when Columbia Records asked me to make some new pictures of him – this is one from that session.

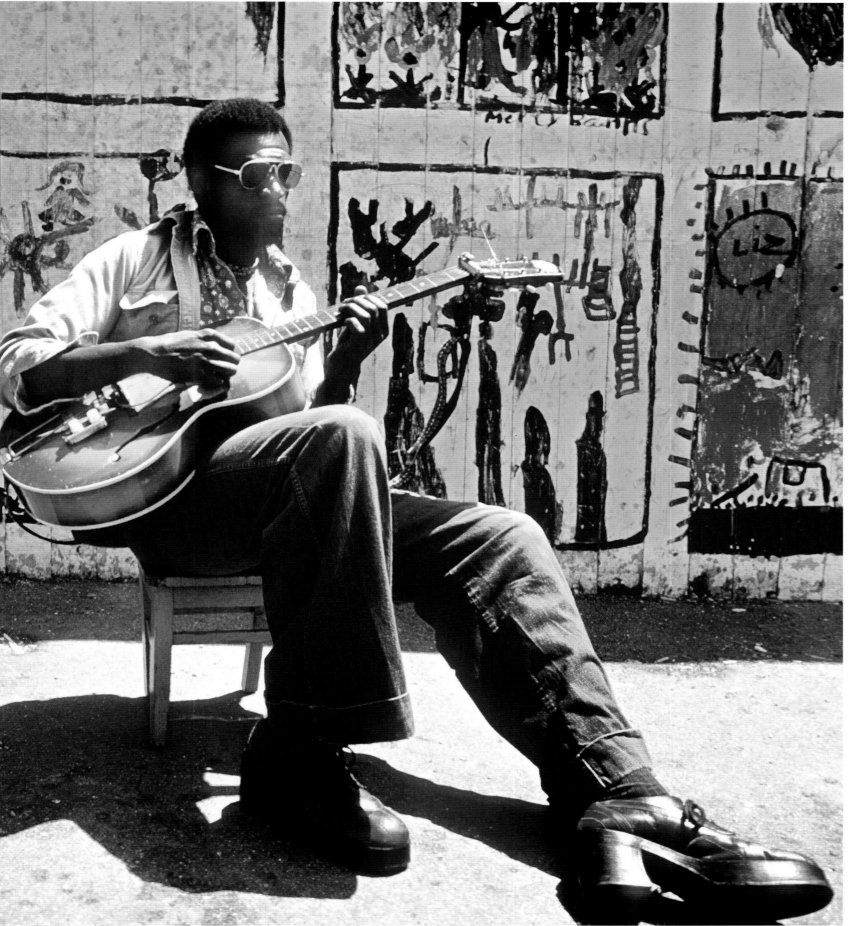

Taj Mahal, Oakland, CA, 1974

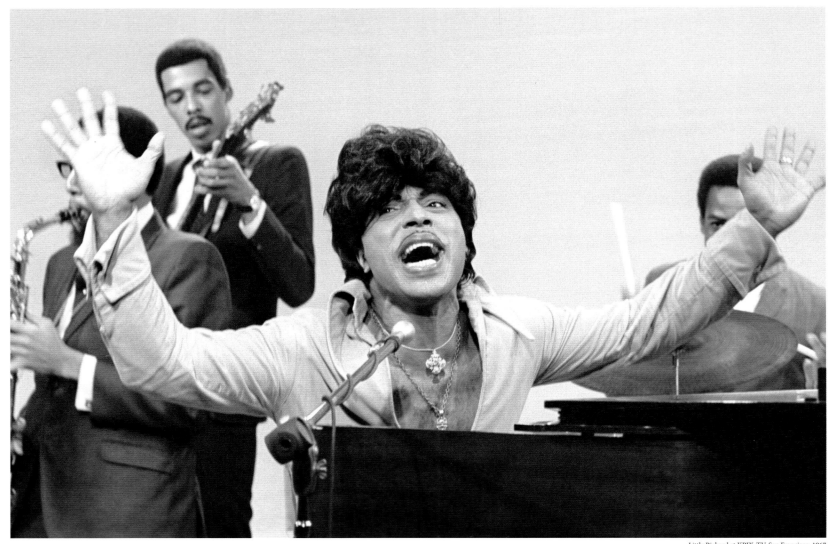

Little Richard at KPIX-TV, San Francisco, 1967

In December 1967, Little Richard and his band played a concert in the TV studios of KPIX in San Francisco and I was there with my cameras. His ever-expressive face was a photographer's dream. He was widely acclaimed by his musical peers – James Brown said that Little Richard was the "first to put the funk in the rock 'n' roll beat". I photographed him twice; the other time was in concert for Bill Graham.

A rarity for me at the time, I photographed Richard (or is it "Little") in both black and white and in color.

The Straight Theater, Haight Street, San Francisco, 1967

I find it hard to believe that in the five years I lived in the Haight-Ashbury, I attended so few of the myriad of concerts held at the Straight Theater, a renovated vaudeville movie theater on Haight Street. Embarrassing because the Straight was only a five-minute walk from my house. A glance at the musical talent which played there from June 1967 through April 1969 included all the Bay Area bands of note and then some: the Grateful Dead, Janis Joplin with Big Brother, Santana, The Charlatans, Blue Cheer, Country Joe McDonald, Quicksilver Messenger Service, Steve Miller – it was a long and impressive list. There were dance concerts, poetry readings, and fund-raising events at the Straight. Many local bands made their first (and often only) appearance at the theater on Haight Street. On September 17, 1967, Little Richard was scheduled to appear. Apparently, he didn't...

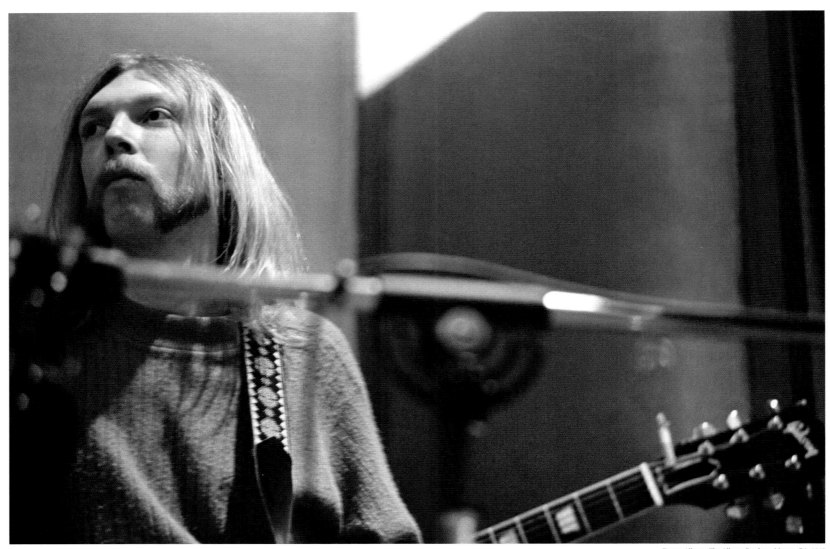

Duane Allman, The Allman Brothers, Macon, GA, 1969

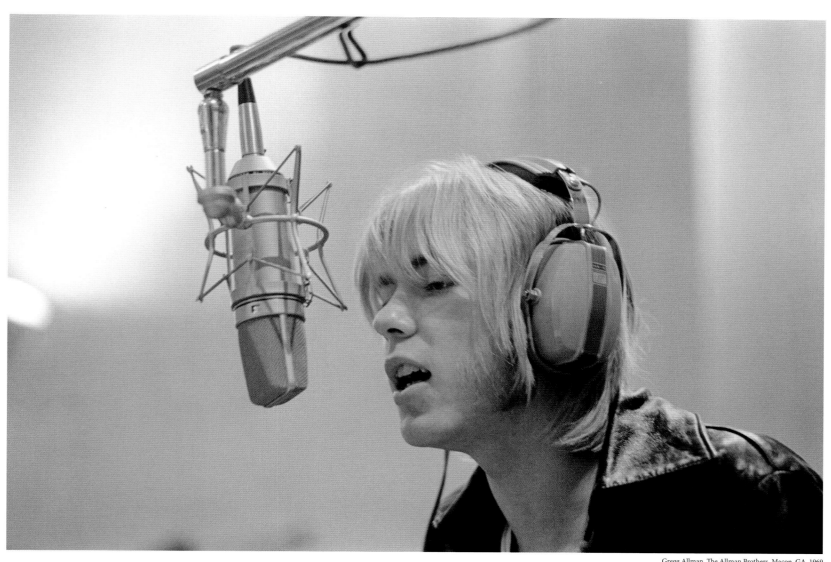

Gregg Allman, The Allman Brothers, Macon, GA, 1969

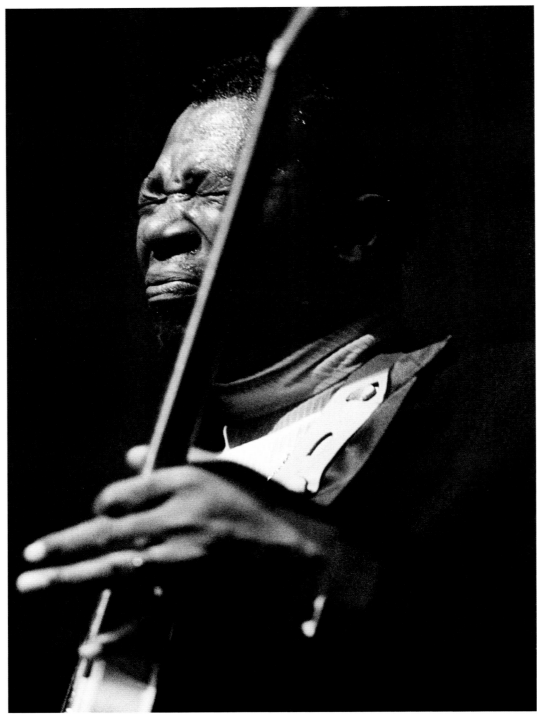

B.B. King, Fillmore West, San Francisco, 1968

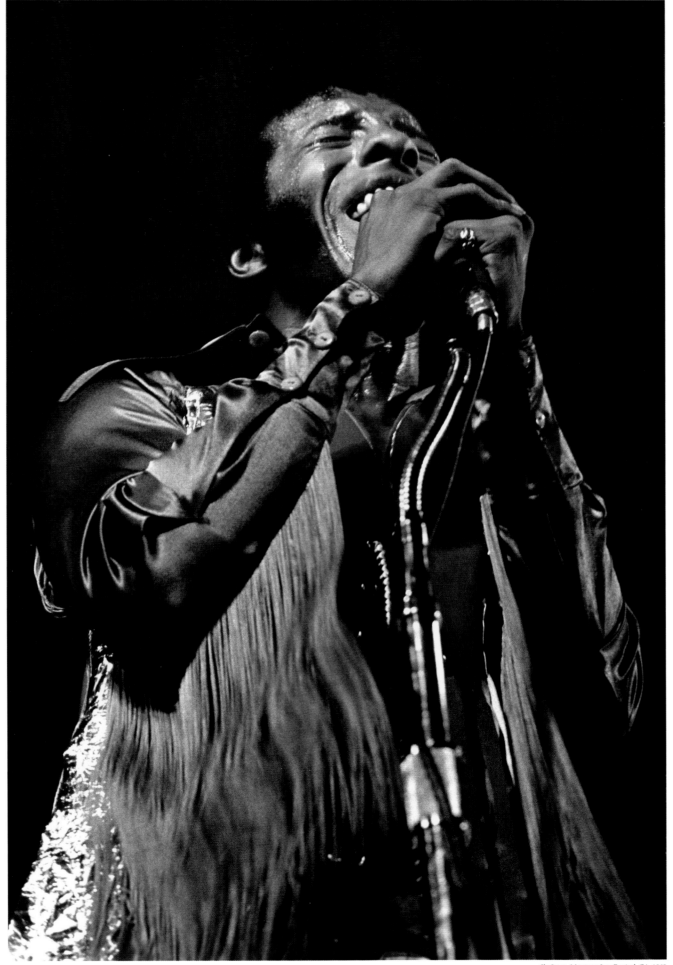

Sly Stone, Monterey Jazz Festival, CA, 1969

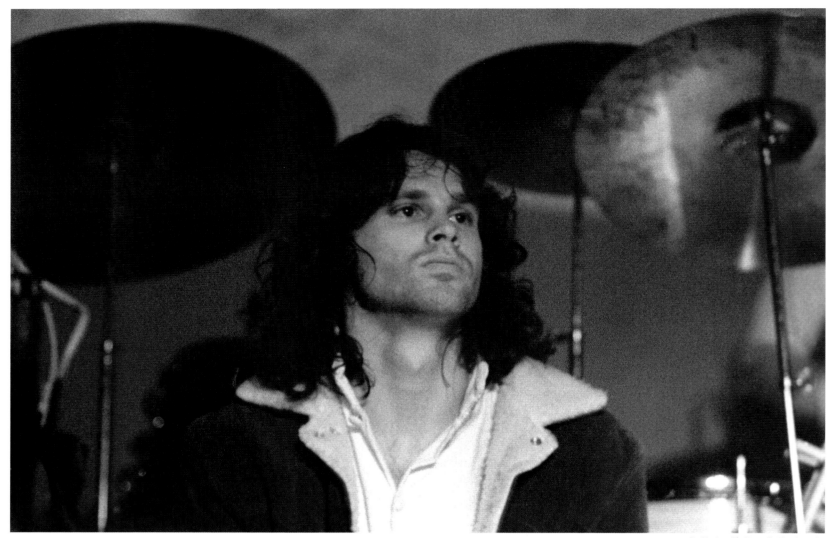

photographed The Doors at Bill Graham's Winterland, a huge San Francisco venue with a bigger capacity than the Fillmore. I decided that night I would try to shoot the concert from the audience to see what it was like from that perspective. The main problem at Winterland was they didn't have a row of security studs or a photo pit, so in order to get to the front I had to push through all the people who themselves were shoved up against the stage. I had my camera bag and a couple of cameras and if you've ever been to a large concert you know that in the front people are always pressing forward to get closer, ever closer to the stage. The crowd was reasonably polite and accommodating and they let me squeeze in because I told them I was from *Rolling Stone* and I needed to get the pictures. But I'm short and had to drive my way through all these bodies with heads towering above me. I needed to get in front so I could get the shots of the band without those heads in the picture.

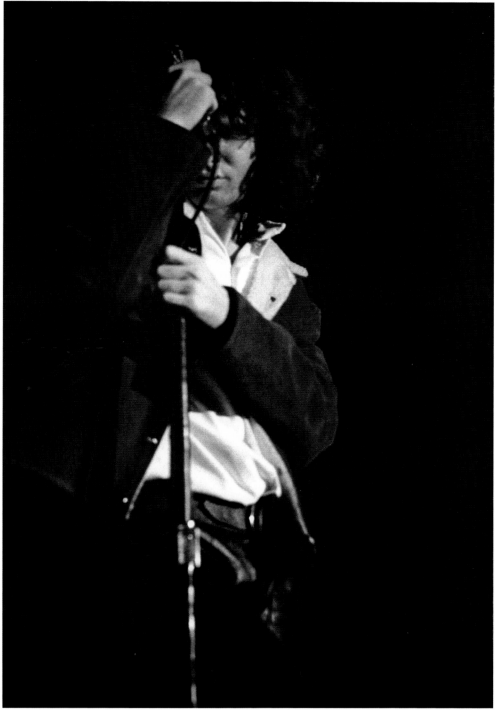

Jim Morrison, The Doors, San Francisco, 1967

Soon everybody was pressing so hard against one another the way they do at the front that I began to feel like a fish packed into a sardine can. In that situation it was extraordinarily difficult to change lenses or change cameras. It became impossible to move my position; there I was, stuck in one place and had to make the best of it.

Those who study Jim Morrison pictures, women in particular, tend to look at his package. He always wore those shiny leather pants and they were clearly filled. I don't know if he packed them or whether that was Jim himself, but that's where women always look. Hey, they love him so why not? I have trouble understanding celebrity worship. Some people care more about celebrity news than about the real news. Maybe it's because celebrity adoration is such a simple concept in a world that's filled with intricacies, intrigue and corruption. In a world in which there are so many enormous problems we can't even begin to solve, we might as well talk about celebrities.

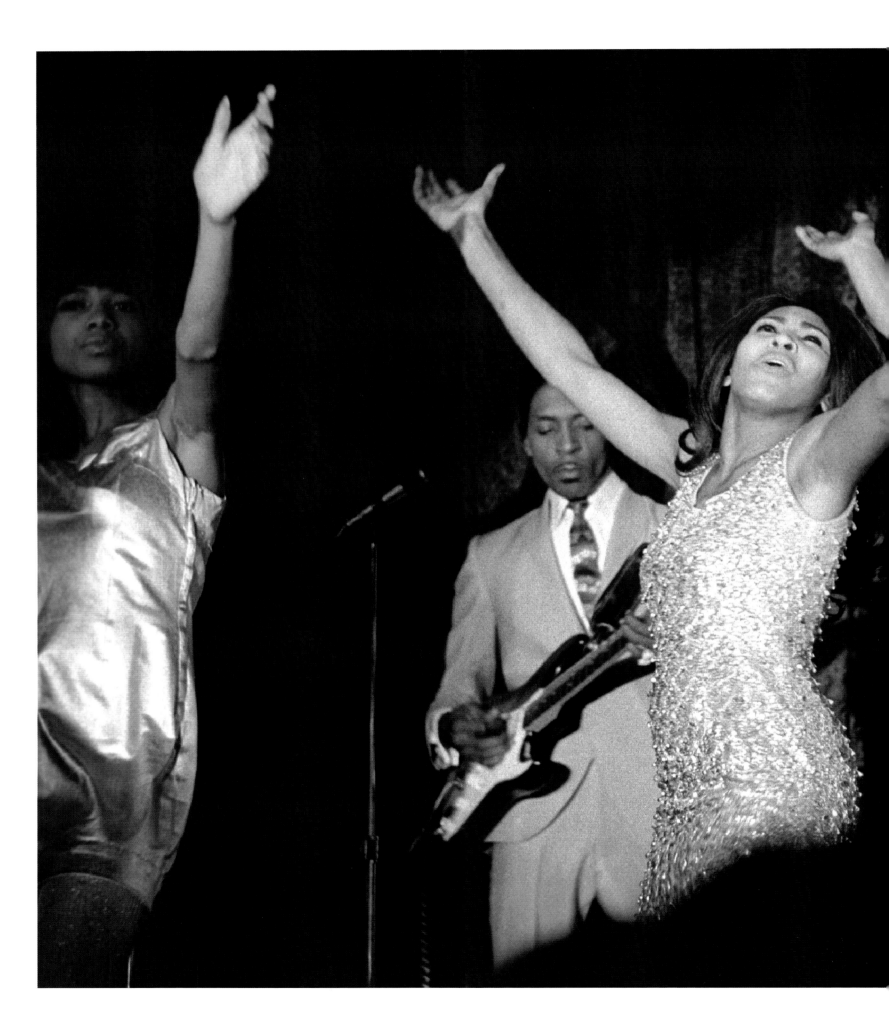

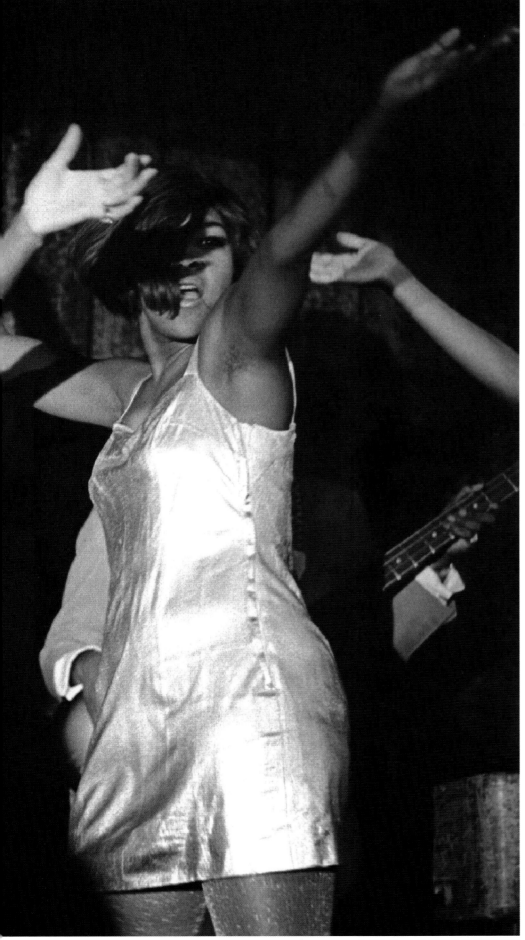

Ike & Tina Turner with the Ikettes, San Francisco, 1967

One of the early assignments I had for *Rolling Stone* (Issue No. 2) was to photograph Ike & Tina Turner in a little San Francisco club, a very well-known club called the hungry i. At the hungry i the stage was low, no higher than a table, around three feet. Guests could slide right up to the front of the stage as I did, with nobody hassling you, no "two song minimum" or any of that nonsense. This was what was so important in those early days; having this kind of intimacy and access – not just backstage access. I'm not talking about big stage access, but in the small clubs you could walk right up to the stage.

Bill Cosby was on the program that night and I was chatting with him before the performance. As I like to do, I had brought along a really beautiful woman to be my "assistant." Before I knew it Cosby started hitting on my date. "How fucking dare you, this is not fair, I know you're famous, I know you're making a lot of money, but she's mine." I took one look at her and immediately knew that she would soon be his – the power of celebrity is so great! And I wasn't one. Yet. The hungry i was a great club, an intimate venue which was instrumental in the careers of many performers, Cosby included.

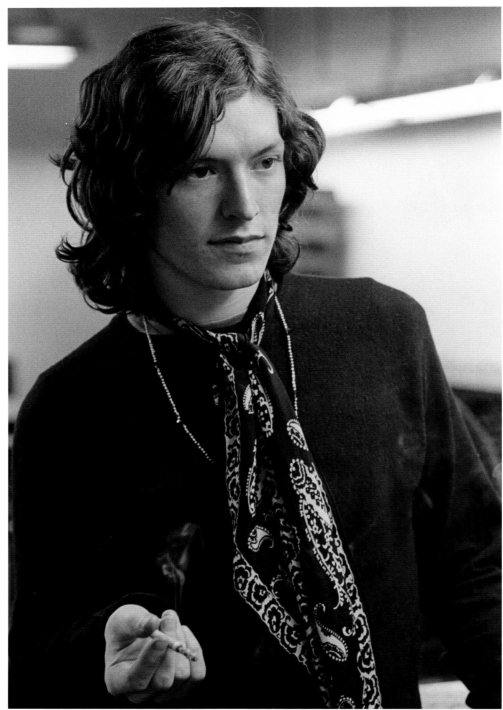

Steve Winwood in the original *Rolling Stone* offices, San Francisco 1968

Kris Kristofferson on the set of *Cisco Pike*, Los Angeles, 1970

I didn't shoot Kris Kristofferson for *Rolling Stone*. After I left I would do an occasional shoot for another publication or record company – by then I was a known quantity to editors and art directors. I shot Kris for *High Fidelity* magazine. These were taken on and around the set of *Cisco Pike*, a film about a musician who had a drinking problem; it was at the time that Kris had a drinking problem so for me this picture is much more than just a movie still because it really did represent what he was going through at the time. Kristofferson is so talented and so photogenic; another musician of whom it's impossible to take a bad picture.

Strolling down Haight Street, San Francisco, 1967

While the *San Francisco Examiner* writer Michael Fallon was the first to name the counter-culture Haight Street crowd "hippies" (from "hipster"), *San Francisco Chronicle* columnist Herb Caen continued to use the term regularly, popularizing it more than ever during 1967, the "Summer of Love" in San Francisco. The national media picked up the term and ran with it.

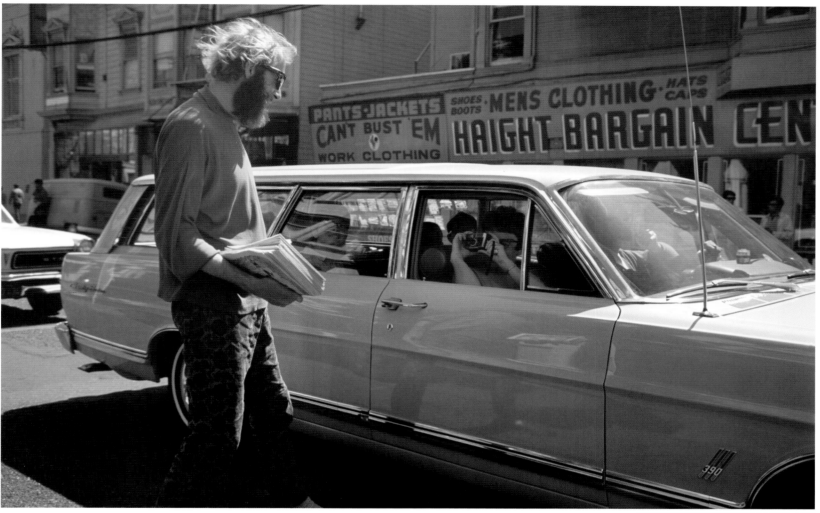

Hippie posing for tourists, Haight Street, San Francisco, 1967

During the time we lived in the Haight my camera and I spent hours watching the tourists watch the hippies watch the tourists. Once America heard about the hippies, people came from every corner of the country. Haight Street was often an eight-block traffic jam – on any given day there were more tourists on the street than hippies.

They would come with their Instamatics to photograph – maybe even be photographed with a hippie, maybe even touch a hippie. To earn a few dollars the hippies would sell the various counterculture papers which tourists would buy as souvenirs or as "ransom" in order to have their picture taken with the strange-looking (to them) newspaper vendor.

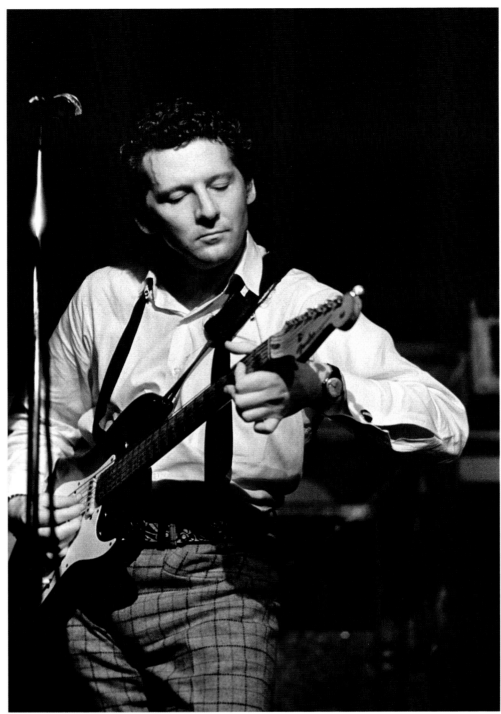

Jerry Lee Lewis, New York City, 1969

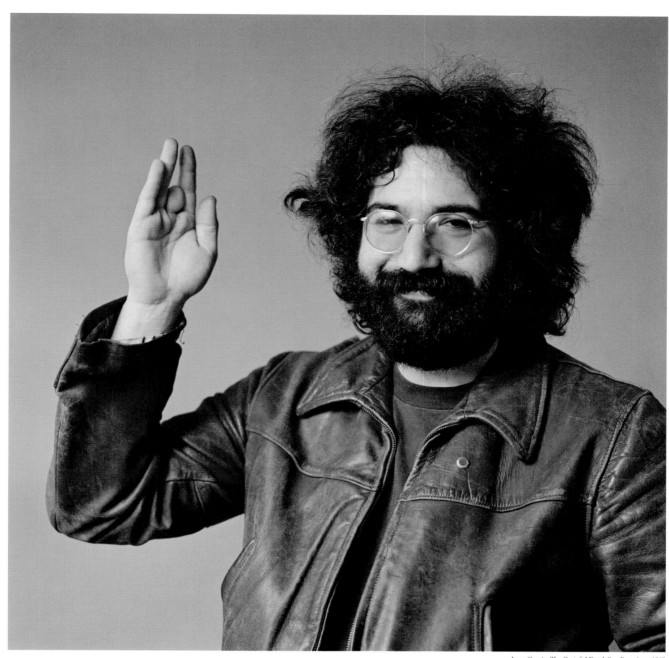

Jerry Garcia, The Grateful Dead, San Francisco, 1969

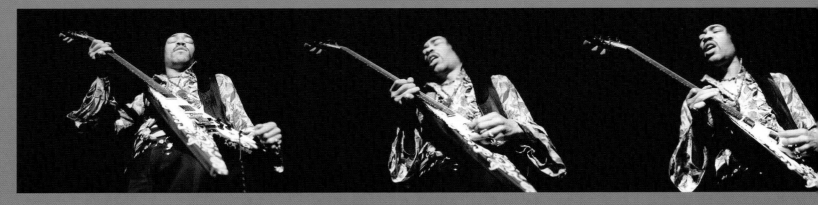

Jimi Hendrix

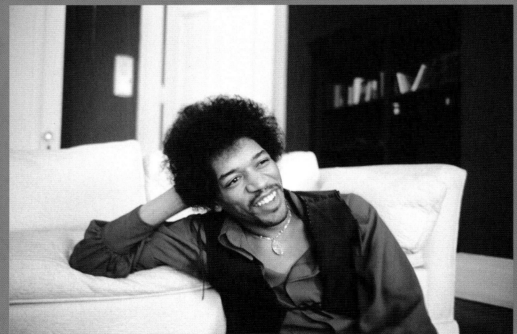

Jimi Hendrix, New York City, 1970

Jimi Hendrix was one of my absolute favorite photographic subjects; he dressed well all the time. Even when he was at rest, between his clothes and his looks, he was photogenic. When Jimi was on a stage he was such an incredible performer. The genius of his musicianship aside, he just looked so good on the stage – his facial expressions, the way he would cross his arms to play, he'd play behind his back, he'd play with his teeth, he'd make love to his guitar. For a photographer, shooting Jimi at work was like hitting the mother lode... or, as they say, shooting fish in a bowl.

In the days of film if you shot a roll of 35mm and you ended up with two or three great shots on that roll you felt you nailed it. But I look at the contact sheets of Hendrix and on a contact sheet of 36 exposures there'll be 20 great shots minimum. Guess that says something about him or me, or a little bit of both.

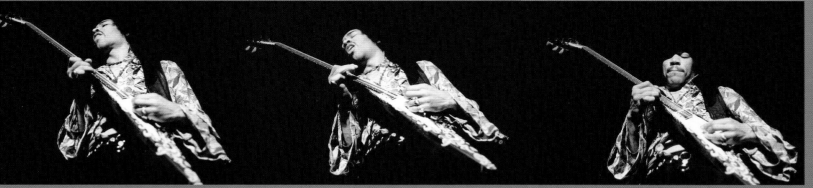

Jimi Hendrix, San Francisco, 1968

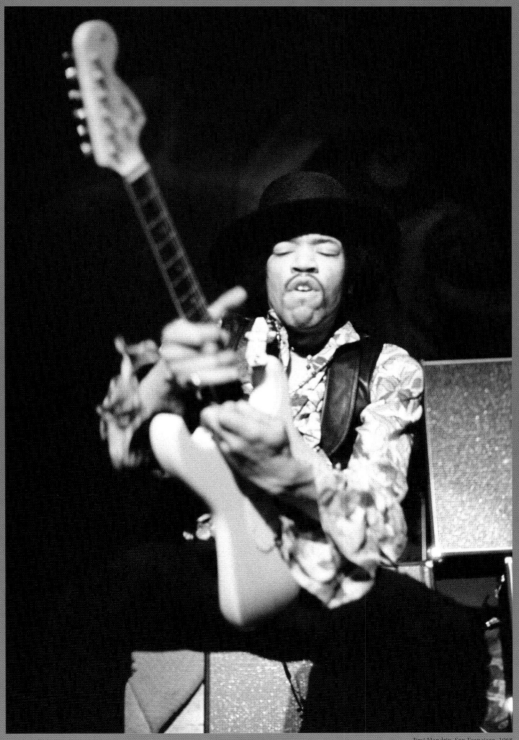

Jimi Hendrix, San Francisco, 1968

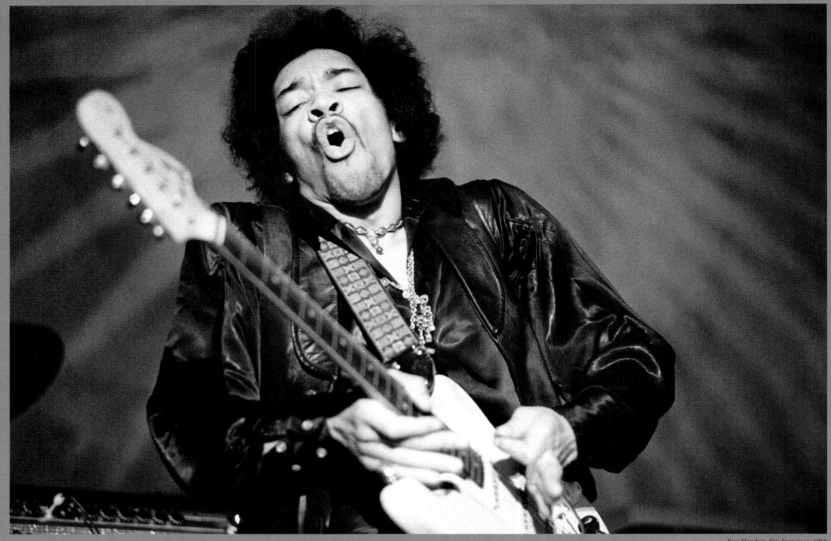

Jimi Hendrix, San Francisco, 1968

What I learned in shooting Hendrix – and this is really the first time I understood this, something that became so clear to me – is that musicians repeat themselves. Not only do they repeat musical phrases but in repeating the phrases they repeat their body moves. So if you pay attention and you see a move you like, you can be sure that the same musical phrase with its companion move will come back and you'd get another shot. So you had to listen carefully, anticipate its arrival and start shooting before it got there because if you saw it in the viewfinder the moment had passed – you couldn't catch it. By the time you had seen it, it had gone on to something else. We had to be aware of the music without actually listening to it; we had to anticipate. Anticipation was the key. That's why this picture is so great because it couldn't have gone any further, become any better; there's no way you could improve upon this image. This is "the" exact moment we all shoot for, anticipate and hope to catch. What I also love about the photo is how it reflects the ecstasy a musician must feel as he or she is playing, the exhilaration of performance – it's all there and you don't always capture that in a photograph. Jimi was at a peak moment. Peak moments are what we were always aiming for but mostly didn't achieve.

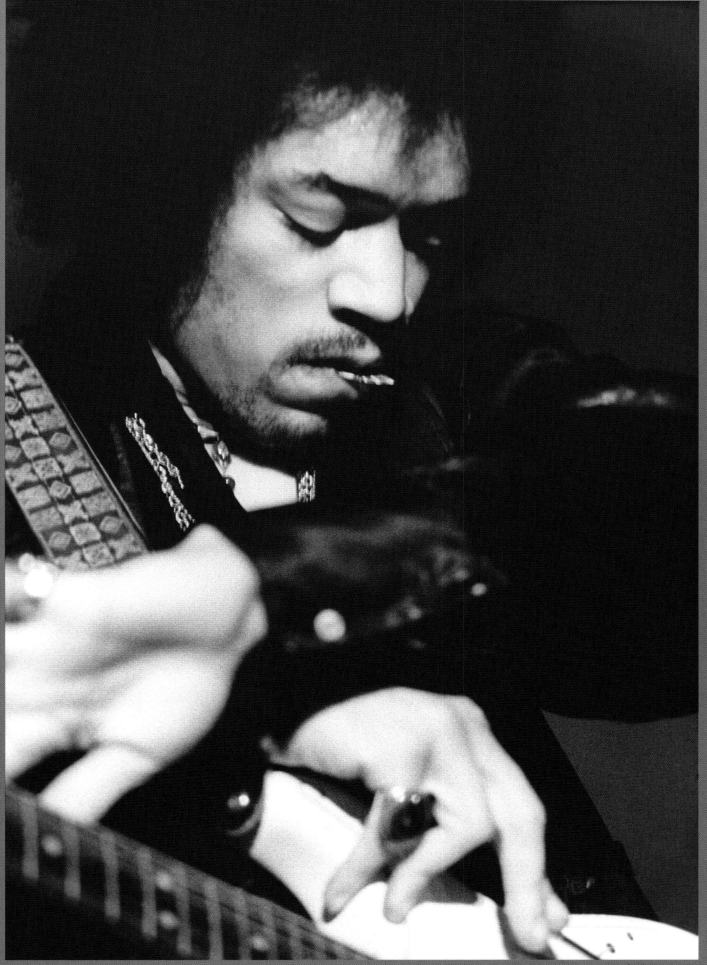

Jimi Hendrix, San Francisco, 1968

Miles Davis

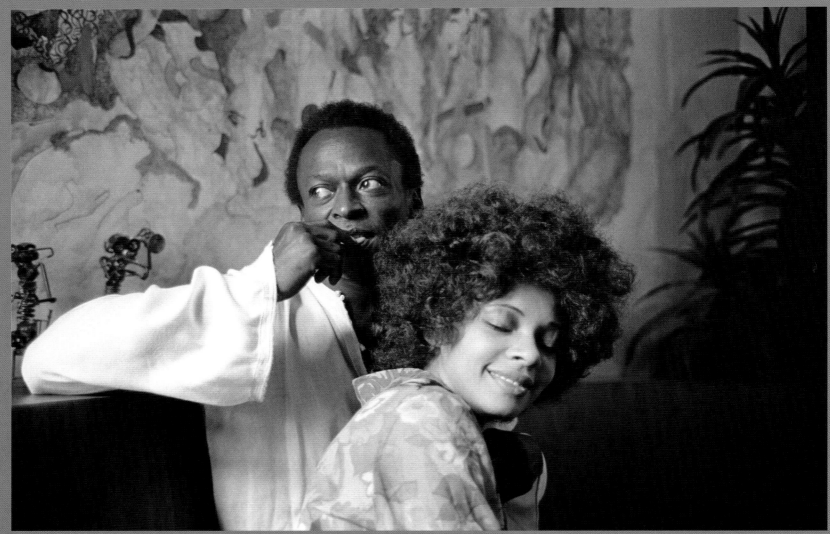

Miles and Betty Davis at home in New York City, 1969

There were moments when I was indeed intimidated by my subject or was nervous about taking his or her picture. Miles Davis was a perfect example. I had been told that Miles could be really difficult, especially if you're white, so I didn't know what to expect when I went up to his house on the west side of Central Park in New York City. There had been no need to worry, we got along well both times I photographed him, although it was the same day – first together with his then-wife Betty, afterward alone, just the two of us. At least, I think this was

the timeline; after all, this all took place more than 40 years ago. Betty had set up the session with her and Miles. I knew her because we did a big photo fashion shoot with her for *Rags*; she was a first class "fashionista" who knew clothes, had great taste and was instrumental in getting Miles to change the look of his wardrobe. She said, "Baron, come on up and photograph me with Miles." I had always wanted to take portraits of Miles and was not disappointed with the outcome. We were at his home in his New York City brownstone.

Preferring natural light as I did (still do) I left the strobes at home and ended up making what I think are some amazingly soulful portraits of both him alone and him with Betty. For the photos of the two of them I shot both black and white and color. The intensely colored painting behind them was one of Miles' own – like many multi-talented musicians, by then he had become creative in yet another field. (And like Jerry Garcia, his artwork was later transferred to commercially available neckties.)

Miles Davis with his 275 GTB Ferrari, New York City, 1969

After the portrait session was finished he said, "OK, let's head over to the gym." We climbed into his red Ferrari and sped down the West Side Highway toward the famous Gleason's Gym. Along the way I asked him to pull over for some more portraits, not with his wife but with his beloved Ferrari.

When we arrived at the gym, he growled, "Baron, you are totally out of shape. You're getting in the ring with me for a serious workout." Fortunately for my body and posterity the only workout I did was

with my cameras, following him as he warmed up, worked out on the heavy bag, and sparred with a friend in the ring. My only regret is that I didn't actively pose him in the ring or at the gym, the way Jim Marshall did for his great shot of Miles sitting on a stool in the corner of the ring. We talked about his love of boxing and how it related to the way he played. "Listen carefully to my music; I play like I box. You can 'hear' the jabs, the feints, the crosscuts, the uppercuts. You can imagine that I'm boxing when I'm playing."

My sense is that boxing was also a reflection of his personality. Miles was an angry guy – in a way, maybe his music was too – but to me it seems as if boxing may have been another way for him to deal with his many hostilities, to release them in the gym.

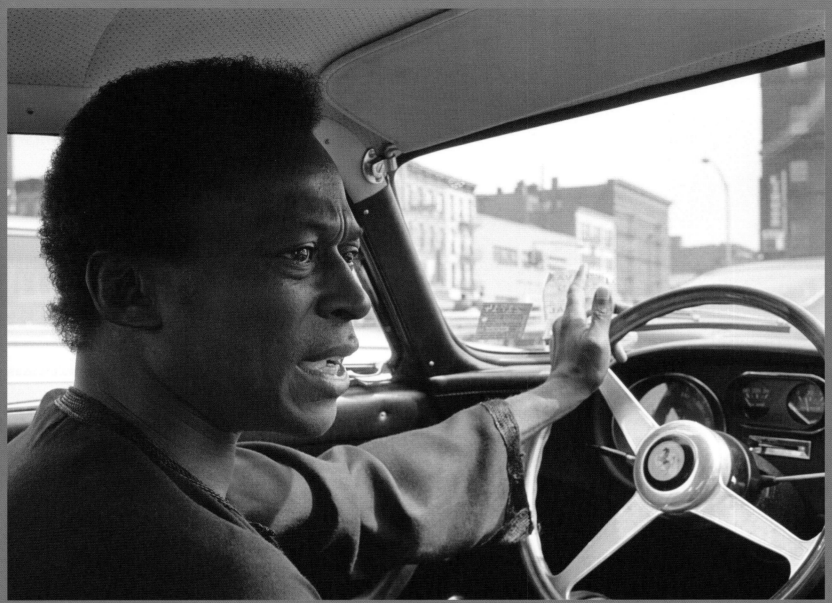

Miles Davis behind the wheel of his 275 GTB Ferrari, New York City, 1969

After the workout I made some more photos from the passenger seat as Miles piloted his Ferrari home. In one frame you can see the classic Ferrari logo on the steering wheel. Very large prints of this photo and another were featured both in an exhibit in the Ferrari museum in Maranello, Italy, as well as in a major exhibition in Paris called "We Want Miles." On display in the Paris exhibition was the journal of Baroness Nica de Koenigswarter, an heiress who supported many jazz musicians – Miles, Charlie Parker, Monk and the like. During the jam sessions she held in her New York hotel suite she would ask each musician to write in her journal his or her three most important wishes. Miles wrote only a single wish: "To be white."

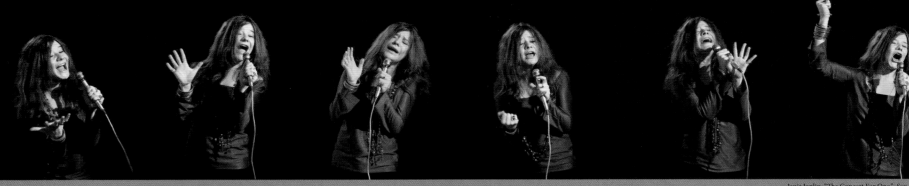

Janis Joplin

I always liked photographing Janis and Big Brother; they were fun to hang with, more fun to photograph. I'm fond of Big Brother; they still play often and well. I remember once encountering them on a plane back to San Francisco; they had just been headliners at Nudestock, an annual "naturist" convention in the Midwest. I even hired the band to play at "Winestock," an event I produced on the occasion of the 25th anniversary of the Woodstock festival. It took place at Markham Vineyards in the Napa Valley. The invitations read "Black Tie-Dye Optional." We even auctioned over-sized bottles of the finest Napa Valley wine, bottles on which my photos of iconic musicians had been etched.

Janis Joplin was another one of my favorite photographic subjects. She had such an expressive face; she was such an animated performer. Janis had two distinct sides to her personality: dark and light. Both were there on stage, both were there off stage. Both comprised the real Janis and the more I knew her – the more I knew about her – the more it all made sense. She could go from dark to light, from light to dark so quickly. Jim Marshall's two famous backstage shots of her with the Southern Comfort bottle confirmed the duality most clearly.

When Janis smiled, her face lit up, her body relaxed and she glowed. I always went for the light Janis; she was in her early 20s and I knew there was still a little girl inside – it was that little girl I wanted to photograph. During a photo session I would say, "Janis, this is not like going to the dentist," – a phrase which would always elicit her award-winning smile.

The only time I chose to photograph the "dark Janis" was when I was shooting pictures in her bedroom. Acclaimed Sixties photographer Bob Seidemann had done a semi-nude photo shoot of Janis; one of the frames was a lovely image which was made into a poster. Janis said, "Hey man, like I'm the first hippie pin-up chick ever!" When I went to her flat to take some of my own pictures of her I noticed she had one complete wall of her bedroom papered with these posters, directly across from her bed. I simply had to pose her in front of those posters. Although I always preferred to capture the light side of Janis, I let her get a little dark at that moment to match the mood of the poster.

I loved it when Janis broke out into a big smile – I mean, look at my photos of her, just so ecstatic, the way I liked to shoot her. I took a lot of photos of Janis in her bedroom, on her bed – Janis with her dog,

Janis with her cat, Janis posing with her custom-made cape. The picture on page 34 was taken in her home; she was living in at least one room – I don't remember whether there was another. But for sure in one room was her bed; she had all the hippie material draped everywhere, those ubiquitous Indian prints – everybody was flying over to India to visit an ashram then importing

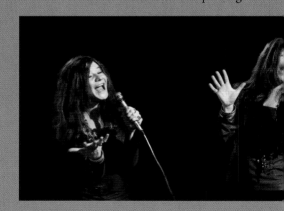

that stuff when they returned. Her drapes and many of her clothes – performance and otherwise – were handmade by her friend Linda Gravenites, ex-wife of blues musician Nick Gravenites.

Nick wrote the song 'Buried Alive In The Blues' for Janis but she died the night before she was scheduled to record it and the song appeared simply as an instrumental on her album. Linda was a clothing designer who I think created a garment, one which became Janis'

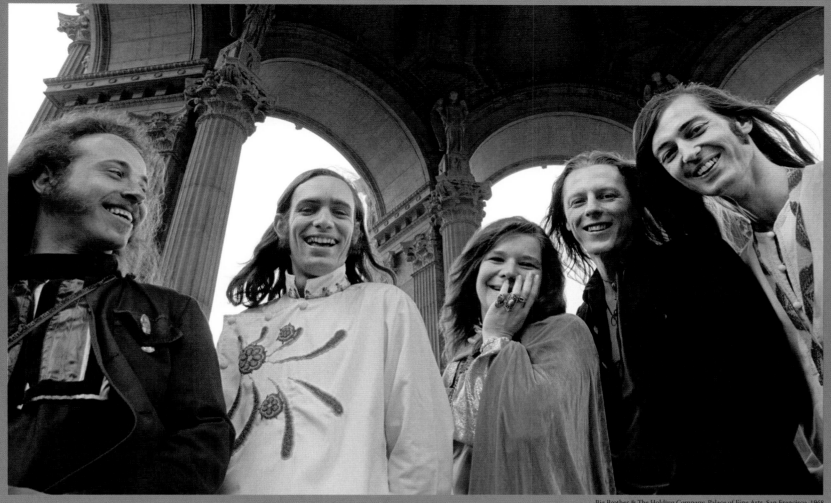

Big Brother & The Holding Company, Palace of Fine Arts, San Francisco, 1968

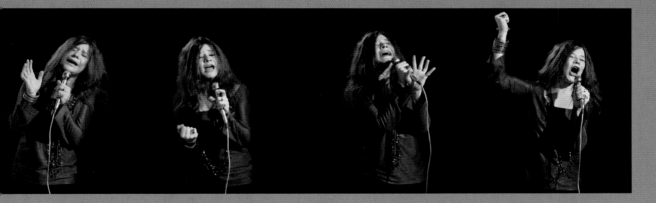

signature cape; it was apparently stolen and has never been found.

We needed a group shot for CBS Records – one of this series actually ended up on a Big Brother record album cover. I remember that particular day Janis was not in the mood to be photographed because she had just come back from the dentist and she felt as though her cheek was swollen huge, that sense you have before the Novocain wears off. She did a lot of posing with her hand over her cheek and for the first time I couldn't use that line which usually evoked a smile from her, "After all, getting your picture taken is not like going to the dentist." "Fuck you Baron, I just went to the dentist. I'm doing this for you!"

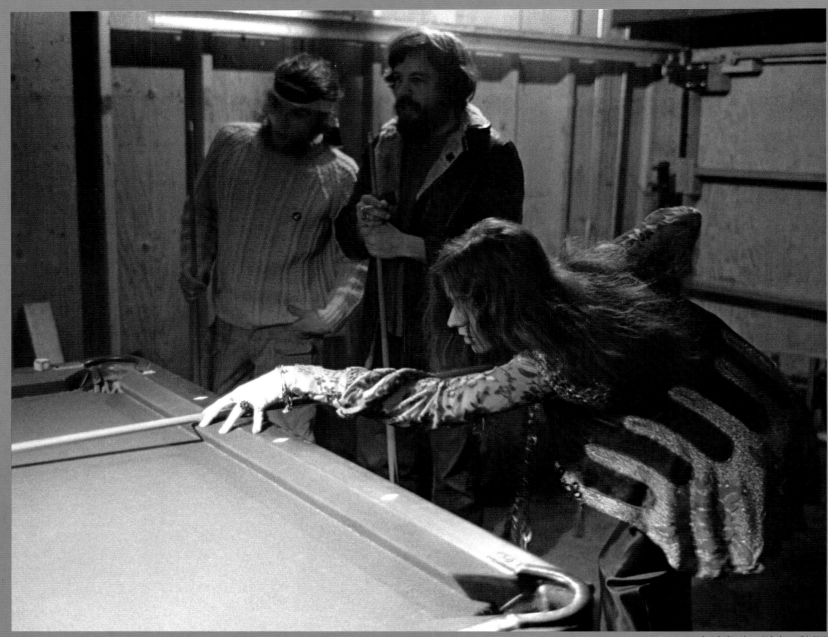

Janis Joplin at home in Larkspur, CA, 1969

In the late Sixties, Janis moved from San Francisco into a wood-shingled, creekside house in Marin County in a town called Larkspur. I attended one of her many parties at the house. She had a pool table there in the basement and I shot a few pictures of her playing pool. A while ago a stranger contacted me, said he had bought the house and that the pool table was still there. He wanted to sell the pool table and needed some pictures to give it provenance.

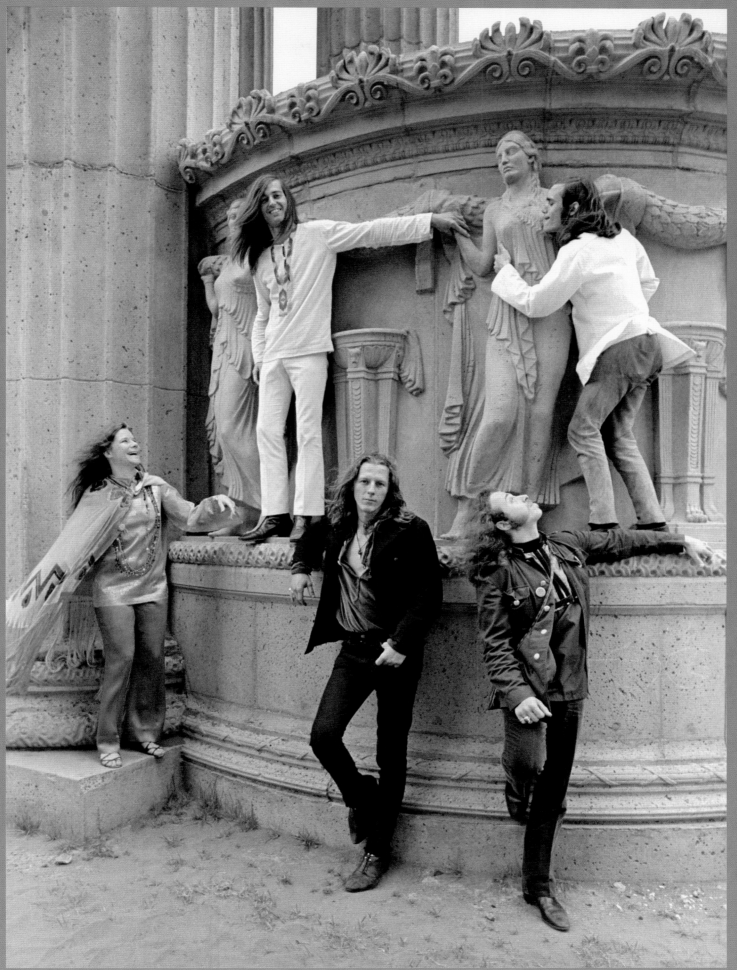

Big Brother & The Holding Company, Palace of Fine Arts, San Francisco, 1968

The Groupies

I loved the "groupie issue", mostly because I love women and am always looking for an excuse to photograph them. Here's how the issue came about. Women hung out with the bands backstage. Nothing new here – a lot of women were back there ready for action, sexual and otherwise, I guess. But those aren't the ones about whom I'm talking.

The ones who caught my attention were young women who had obviously spent an inordinate amount of time and effort putting themselves together for their backstage appearance; these were not just chicks coming to hang, they were back there strutting. This was something else – style and fashion mattered greatly, were central to their presentation, and I became fascinated with them because these were obviously not just girls in jeans looking for guys to take home. I discovered what I believed was a subculture of chic and I thought it merited a story. These ladies were different from all the girls I knew – all the women I knew – and Jann agreed it was a good idea for a story so he put Jerry [Hopkins], John Burks, and me on to it; a story which ultimately became so interesting that it became an entire issue.

Not only did it become an entire issue, it became a milestone issue. Jann and I were in New York on business. We went over to CBS Records, one of our advertisers and biggest boosters, and explained that we were about to publish a very important (to our way of thinking) issue and we wanted to introduce it with a splash. We talked to the CBS creative director Arnold Levine – great guy, by the way – and asked for his help in designing an ad for the back page of The New York Times. The back page of the second section of The New York Times is where publications promote themselves in order to get media attention and therefore more advertising – look here, look at us, look how cool we are. And in 1968, the back page – mind you we were struggling financially – the back page of The New York Times was priced around $10,000 which was a huge chunk of change for us. (I don't think Arnold ever charged us to design the ad.) For our page, Arnold put the cover photo of Karen on it and ran the line, "When we tell you what a groupie is will you really understand?" The not-so-subliminal suggestion was that we at Rolling Stone can tell you what's happening – without us you won't get it, Mr. Jones, because there's something going on here and you don't know what it is...

Jann and I were staying at the Warwick Hotel around the corner from "Black Rock," as the CBS building is, or was then, known. The early edition of The New York Times comes out around midnight, so we sat around waiting and waiting and waiting for it; I'll never forget when we finally held copies of the Times, of our ad, in our hands. Once again, the thrill of going from idea to reality. It goes without saying that we received a lot of attention over that issue. I worked very hard on the "groupie issue." I shot it like I did the Grateful Dead cover story – seamless, single light – two lights actually – very simple photographs of all these girls. One of the women said, "Oh I'm not a groupie." "But you're a beautiful woman who hangs around musicians; call yourself what you want, but that's why we're featuring you." And she agreed to be included.

One collection of groupies we decided to photograph was the GTOs, a Frank Zappa project. Some were beautiful, some were exotic, some were eccentric. They were the Girls Together Outrageously or Occasionally or Orally, pretty much anything starting with an "O." Zappa put them on stage and he produced an album with them (Permanent Damage) that is almost impossible to endure. There were seven GTOs: Miss Pamela, Miss Mercy, Miss Cynderella, Miss Christine, Miss Lucy, Miss Sparky and Miss Sandra.

The GTO's, (Girls Together Outrageously), Los Angeles, 1968

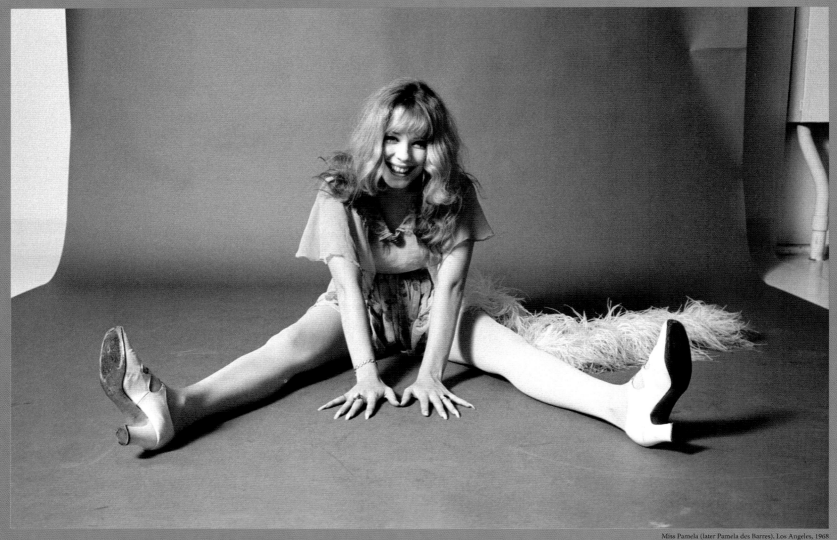

Miss Pamela (later Pamela des Barres), Los Angeles, 1968

Miss Pamela, or Pamela des Barres as she became, was the super groupie who wrote the book *I'm With The Band* and who slept with everybody and went on to tell about it. To shoot the GTOs I borrowed the photo studio of A&M Records; I shot each one individually then I shot them as a group. In one of her photos Pamela sat on the seamless with her legs spread wide. When I saw that picture I realized how symbolic it was because that's pretty much how she spent her life as a groupie, but no disrespect to her because she was a talented writer and incredibly accomplished when it came to getting the guys she wanted. No, she never targeted me. I've often wondered how the guys about whom she wrote felt when they saw their dalliances with her so well described.

Lacy was also in the "groupie issue." All I remember is she was gorgeous, she really was; for the shoot she wore a very loosely knit top with nothing underneath. I couldn't stop staring and shooting.

She arrived at the studio with one of her friends, another groupie who wasn't nearly as striking or sexy. Anyhow, we all sat around smoking and Lacy was toking this perfectly rolled joint while I took her picture. For another shot I arranged all the current issues of *Rolling Stone* in front of her. This was early 1968 and I don't know how many subscribers we had – there were more newsstand sales than subscribers – but this portrait of Lacy became the picture we sent as a Christmas card thanking them all for subscribing to *Rolling Stone*.

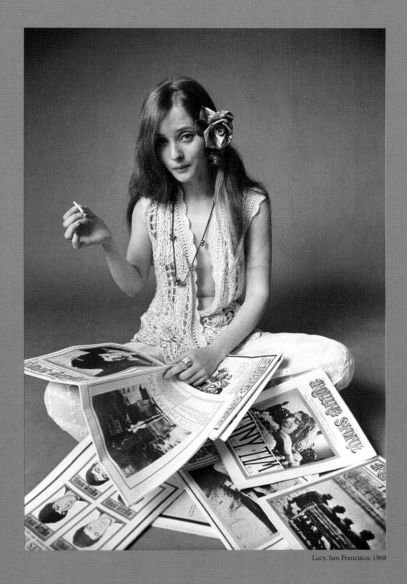

Lacy, San Francisco, 1968

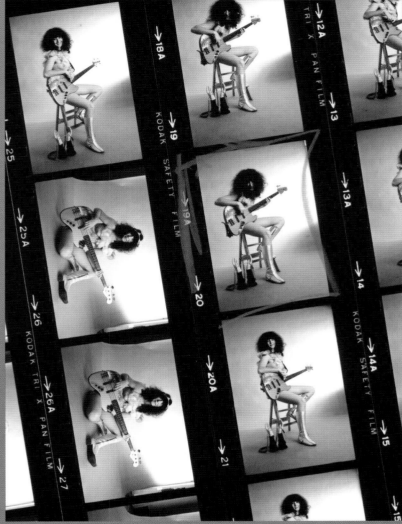

Trixie Merkin, San Francisco, 1968

It was also made into a big poster that we sent to all the head shops which were selling the magazine. Like *Rolling Stone* itself, it was printed on newsprint with the logo strung across the top.

The bass player in the photos is Trixie Merkin. (A "merkin" is a pubic wig for those not familiar with the term, although Trixie writes she took the name from President Lyndon Johnson's reference to "my fellow 'muricans".) Trixie had been a student at Stanford then dropped out and joined a "salon for the art and fun crowd at Stanford" called the Anonymous Artists of America: "They terrorize the countryside. Riding from town to town, painting the center line on all the highways in America red." Trixie posed topless in the "groupie issue" photo session to further a myth perpetuated by musician Al Kooper that she played topless in the band. Now she's living in Santa Fe and still playing music; she recently started a music festival called Med Fest – music for the Medicare generation. In her 60s, she's currently playing with local bands, still having a great time making music.

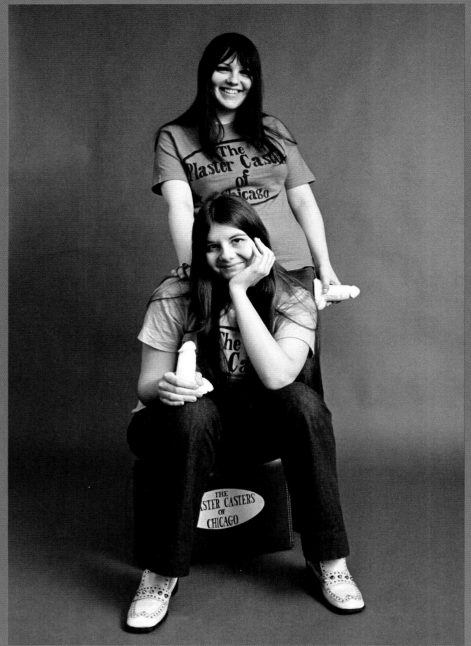

The Plaster Casters of Chicago, Chicago, 1969

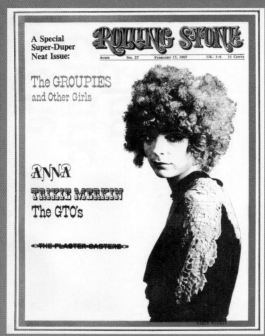

Karen, *Rolling Stone* Issue No. 27, February 16, 1969

We included the Plaster Casters of Chicago in the issue. I went to Chicago to photograph them; borrowed a friend's studio. They were so excited that they were being recognized. They had even produced a T-shirt with their logo; they were pretty clever, they already had a brand! (I'll never forget the shirt they gave me; Juliana wore it regularly to ballet class, then somewhere down the line she gave it away. I was devastated, wish I had it still; it's gotta be a collector's item.) Anyhow, after we took the pictures, the two women – teenage girls, actually – suggested they cast me. It was an "honor" to be asked, I guess, but I thought, "This is kind of weird, I don't know if I want to be immortalized in that way." They made the first move and I was flattered but I wasn't sure I wanted to be remembered like that, even though I would have forever been side by side with stars like Jimi Hendrix. In the end, I declined and opted to take them out for burgers. What I tell people now, "Yeah, they wanted to cast me but I refused because I didn't want to put all the musicians to shame."

Some of the groupies did very well for themselves. Karen, who was on the cover of the "groupie issue," married a Kuwaiti sheik with whom she had three children. She recently contacted me and started buying prints from our photo sessions; she's collecting them for her children – part of her family jewels, I guess. About a year after the "groupie issue" appeared I was driving along Venice Boulevard in LA; somebody had even painted the cover photograph of Karen on the side of a house – the ultimate compliment.

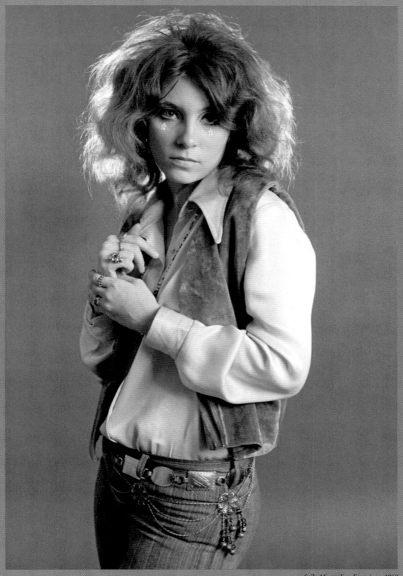

Sally Mann, San Francisco, 1968

Another groupie, Sally Mann, married Spencer Dryden of The Jefferson Airplane. She went on to have a bad heroin addiction and was busted for dealing or holding or something, and thrown into jail. While she was in prison she began studying law, and was such a model student and prisoner that she was given a full scholarship to Emory University School of Law in Atlanta after she was released. Now she is a successful lawyer in Texas. Here she was, one of the better known and respected groupies of the San Francisco scene who then went on a whole other life journey. Other groupies had drug problems, too; some never recovered from them. Drugs were so much a part of the scene back then… During the groupie interviews we learned how they would chase after a rock star and get into his bed in his hotel room or wherever he was staying when he was on tour. For the groupies that was, of course, a central step in the chase, but the most important element – and they almost all admitted this to us – was when they would pick up the phone in the hotel room, call their friends and say, "You'll never guess where I am." It was not the guy, but the moment; it was being able to talk about it and brag about achieving another notch in their belt. For them it often had little to do with the musicians themselves because they were all moving on anyhow.

The Grateful Dead

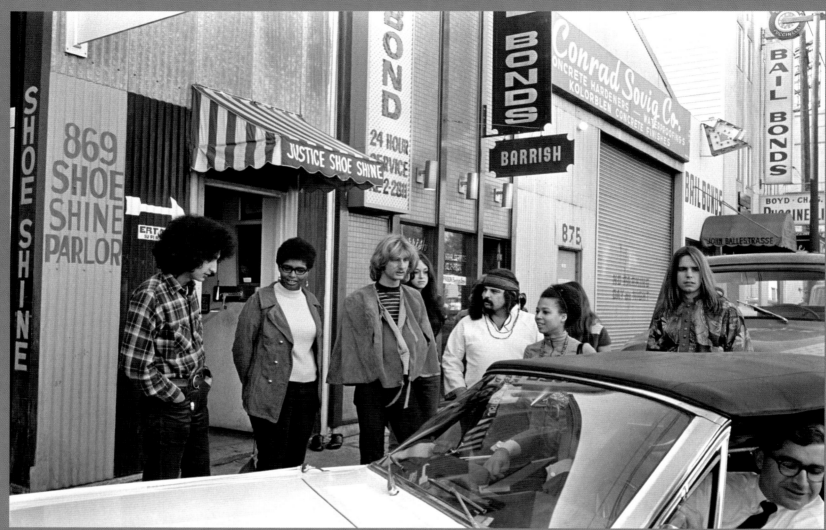

The Grateful Dead posting bail, San Francisco, 1967

My first story for *Rolling Stone* was the Grateful Dead bust. The cops came into the band's house and arrested several of them. The entire band wasn't at home at the time so the police couldn't bust them all, or they would have. And that bust was one of the lead stories in the first issue of *Rolling Stone*.

I remember being in our office which was right around the corner from the San Francisco Hall of Justice. I was told to cover the story and I approached it as the photojournalist I was. The band had to post

bail to get out of jail; they were down the street with the bail bondsmen and their lawyers. I think it was Pigpen and Bob Weir and some others who were also living in the house. They posted bail and then held the famous press conference.

I attended along with the rest of the San Francisco press. Remember that in those days people still weren't sure what *Rolling Stone* was, whether we were *Rolling Stone* or The Rolling Stones. Indeed, it took many, many months before some people were able to distinguish between The

Rolling Stones the band and *Rolling Stone* the magazine. That was the first time I made an appearance as a member of *Rolling Stone* so of course nobody knew or cared who I was because there had been no issues published yet.

The Dead put on this great press conference held appropriately where they lived and where they had been arrested. The band members sat across a table from the media. Along with the microphones, which were arranged between the band was a great big bowl of whipped cream which is

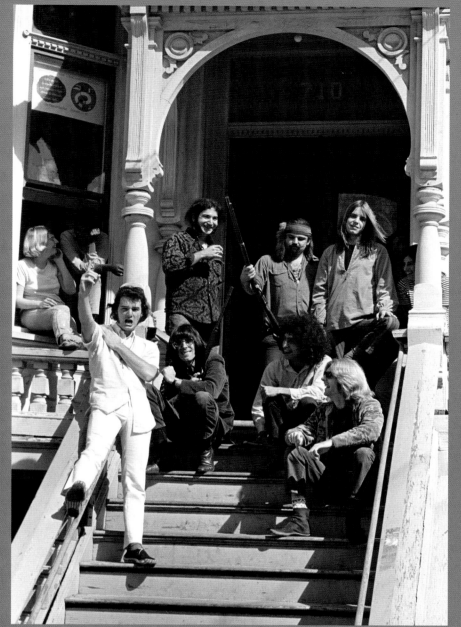

The Grateful Dead at home, 710 Ashbury, San Francisco, 1967

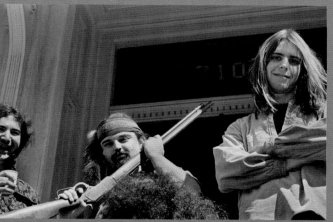

Jerry, Pigpen and Bob, 710 Ashbury, San Francisco, 1967

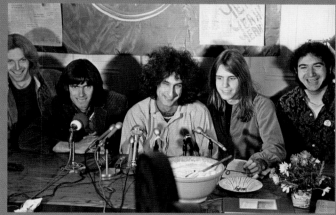

Grateful Dead press conference, 710 Ashbury, San Francisco, 1967

visible in the pictures and which they threatened to throw at the media if any of them asked a stupid question. If you read the first issue of *Rolling Stone* you understand the band was making the point: "Why are you busting us? If you busted everybody who smokes pot in San Francisco you're going to have no lawyers, you're going to have no doctors, and you're going to have no professionals of any kind because everybody smokes." The band was quite adamant about it, and they were right of course.

After the press conference I had to get the band to come out of the house for a group shot. Jann told me to get a picture of them on the front steps of the house since it was there the bust had gone down. They all became so wired during the press conference, they were having such a good time – if you look at the pictures they've got big smiles. They were taking it seriously, of course, but in their own Grateful Dead way, so when I was finally able to get them out on the steps they were like fireworks going off in 50 different directions. I needed to get that shot and they didn't know who I was,

they didn't know what *Rolling Stone* was (there was no *Rolling Stone* at that point) so it was really hard to get them to cooperate.

When they came out, they wouldn't settle down, pointed their guns this way and that, flipped me the bird, threatened to kill me. It was all great fun for them but at that moment not for me. In the end I did get one great shot. I call it "Dead On The Steps." And so ended my first real assignment for *Rolling Stone*.

Woodstock

Woodstock was not on our schedule of festivals when Jim and I started around the country in the summer of 1969, but when we found out about it, of course, we couldn't *not* go. Michael Lang had produced a festival a year earlier in Miami. All he did was rent two huge flatbed trucks, back them up to each other and that was the stage. He put the trucks in a park and delivered a relatively successful show; that was his entire festival experience up until Woodstock. What a leap!

The fact that it even came off is kind of a miracle. Consider the story about them forgetting to put the ticket booths in and by the time they realized they had not been taking tickets there were something like 100,000 people in front of the stage. Someone on the staff suggested they send them all out, take their tickets and bring them all back in! Wavy Gravy or someone answered something like, "Do you want to have a successful festival or do you want to have a disaster? They're in and they're staying in."

I was there when it rained, but I took shelter. You've got to understand I'm a total wimp. I didn't stay up all night, I went back to my hotel. I could get to my hotel through the back road, have a good night's sleep, and come back in the morning. Why would I be out in the fucking mud and living like a hippie, which I wasn't? I was never a hippie even though I lived in Haight-Ashbury.

There are so many Woodstock stories it's hard to sort out the accuracy of each. The fact of the matter is they had a damn good musical line-up. For me the Santana story was the best – the tale of Carlos being backstage where he and Jerry Garcia got loaded before their performances. It was Jerry's idea to get high. The way I originally heard it was that they dropped acid, but Carlos now says it was mescaline. Maybe it was both. I don't know which was correct but Carlos talked about being high on stage, about looking out into the crowd and seeing only eyes and teeth looking back at him, so then it would have been 600,000 eyes and 300,000 sets of teeth. He said his guitar was like a steel snake in his hands that wouldn't stop moving. "I would follow the note, I could hear the note leave the guitar, go through the wires, into the monitor, come back, go out into this crowd, and then come back to me and I was like I can't control it." I don't know how he did it, how he played stoned the whole time, because it was a great set and it turned out to be Santana's breakthrough moment. Until Woodstock his was just another band. Afterward his career took off and over the years he has become a superstar.

I spent more time photographing the festival "experience" than I did the musicians. I had shot most of the bands before so I thought why would I want to photograph them again? I didn't need any more band pictures. But all those people... that was something else. I had never seen anything like this before in my life. The one musician I wish I had shot, wished I had waited for, was Jimi Hendrix, but he didn't appear until Monday morning and I didn't realize it would happen like that. I and pretty much everybody else had gone home by then too, but it was in Hendrix's contract that he would play last; it just turned out that "last" was on Monday morning.

A young kid by the name of Dan Garson got some fabulous pictures; he was covering the festival for his high school newspaper. He was a born photojournalist – that's the only way to describe him. When I look at his photos now I see images I should have taken; he was shooting with a fresh, un-jaded eye. He captured very unique Woodstock moments that reflected what it was like to be at that concert in ways that even I didn't see, and I was working hard to get the good photos. It's a shame he died so young.

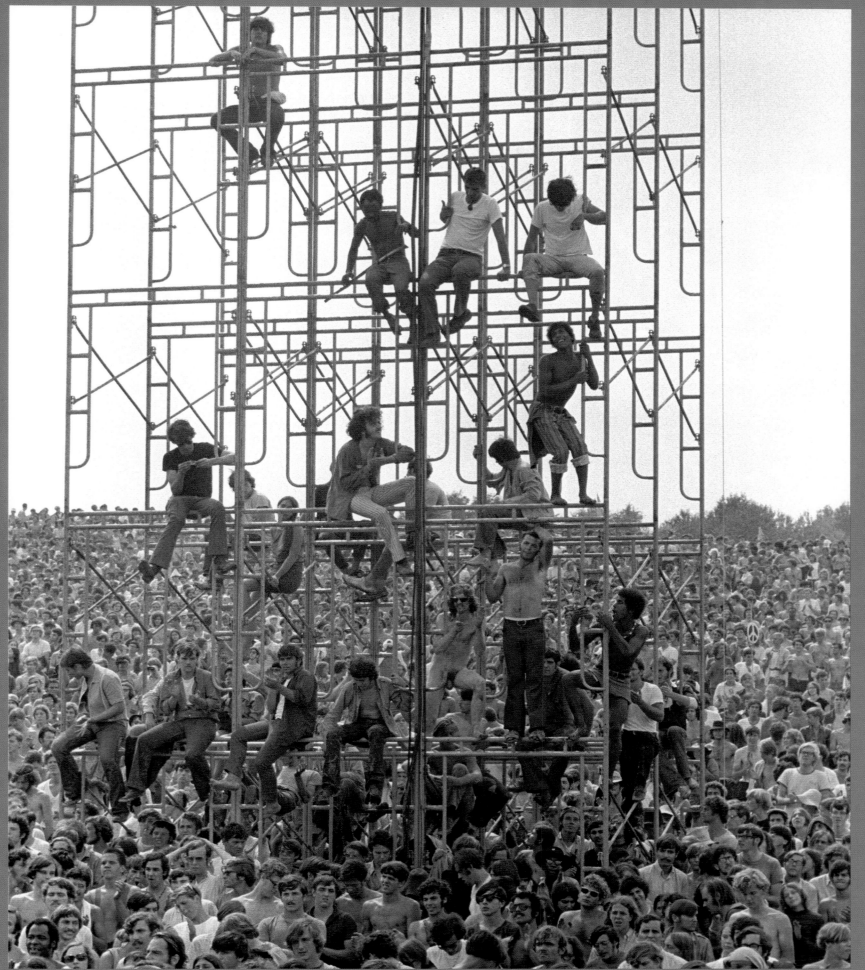

Lighting scaffold, Woodstock Music & Art Fair, Bethel, NY, 1969

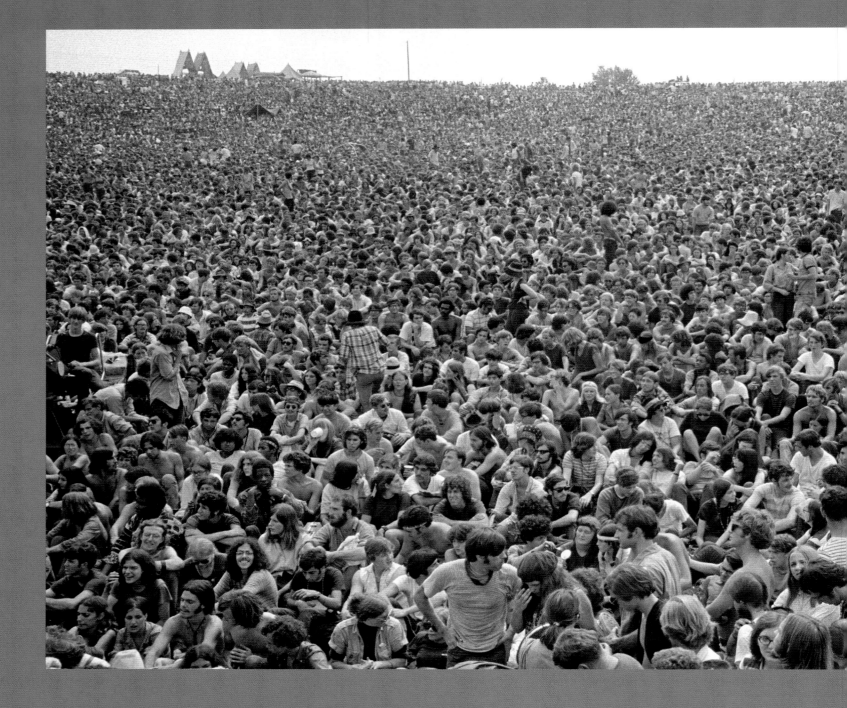

At Woodstock I was among the royalty, it was the ultimate all-access experience – we could go anywhere. Jim, Henry Diltz and I all had carte blanche, the group of us could move around without restriction. I remember seeing a picture of a bunch of photographers down in the pit in front of the stage. Jim and I felt like kings of the hill; the stage was enormous – huge– and we wandered freely around on it for three days. It was like roving around the Lincoln Center opera house stage, it was so big. We would walk from one end to the other and look out at the crowd and get a view of them from every perspective – people as far as the eye could see. I was overwhelmed just looking at all those people. Then I'd go out into the woods where the people had their encampments, tee pees and little shelters, stuff they'd be selling from little hippie stores and that's where all the drug dealing was going on. Everybody defines Woodstock by the phrase "sex, drugs and rock 'n' roll." I saw a lot of drugs and I saw a lot of rock 'n' roll, and I even saw some intimacy but I didn't see anyone actually having sex. After Woodstock the music industry came to understand the economic possibilities of the mega concert. When they saw all those people gathered to hear music the corporados started drooling dollar signs.

When I photographed the big mega concerts I would often stop the kids and ask, "OK, look you can't see the musicians, you're halfway across a fucking football field. Why are you here when you are so far from the bands? This is such a distant experience, so different than being

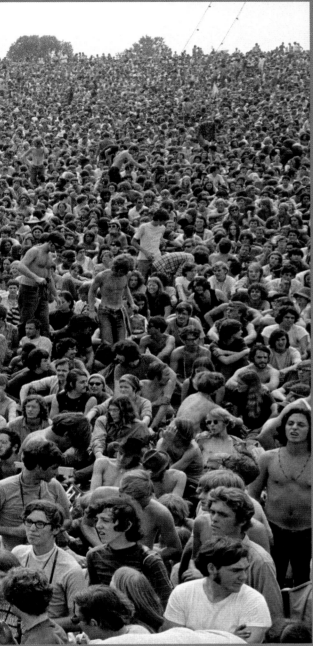

View from the stage, Woodstock Music & Art Fair, Bethel, NY, 1969

Bill Graham, on stage at the Woodstock Music & Art Fair, Bethel, NY, 1969

"Eat & Toke," Woodstock Music & Art Fair, Bethel, NY, 1969

close to the musicians and seeing them and experiencing them." The answer was always, "We're here to be with our people." There was something obviously satisfying in being a part of a community. I don't want to put down the stadium concert experience; why should music be restricted to venues the size of the Fillmore, which was at best a couple of thousand? Keeping the venues small would be a very elitist decision. For whatever reasons these big musical experiences turned people on. There was the Miami Pop, Monterey Pop, Atlanta Pop – this big

festival and that big festival – and now they're everywhere. The fans are not there just for the music, they are there for the overall vibe. They all tell you that music is the catalyst for some greater human, tribal experience…

Above is Bill Graham sitting on stage playing a cowbell, with Santana and the crowd in the background. I took Bill's picture and then he told me to sit down, "I'm going to get a shot of you." I did and he

did, and not only did he get a great moment in the history of my career (!) but Santana was perfectly posed right between the speakers, the amps, the monitors and me.

The picture at bottom right I call "eat and toke" because on the right they're feeding their bodies and on the left they're feeding their heads. Years later, the guy toking saw his picture in my book, *Classic Rock And Other Rollers*, and contacted me to buy a print.

125

Tearing down the fence, Woodstock Music & Art Fair, Bethel, NY, 1969

National Guard MEDEVAC helicopter, Woodstock Music & Art Fair, Bethel, NY, 1969

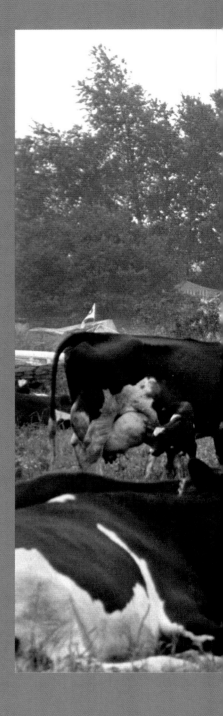

This picture of the fence coming down is not the exact moment the festival became free, but it is one of the reasons they ended up making it free – so many people who wanted to go to Woodstock couldn't get tickets but decided to show up anyhow. There was a very temporary cyclone fence put around the festival area and it took nothing to break it down, and the more that happened the more the promoters realized there was no way they could keep the fans out. Their security was the Hog Farm which was fundamentally a peaceful organization, "Hey don't do that, that's not cool. Don't break the fence down, man; the fence is there for a reason." "Fuck you, we're coming in." Quite rightly the promoters decided to make the festival free, which is one of the main reasons Woodstock is remembered as the legendary Aquarian age event it was.

I got there on Friday. Jim and I were still coming from other festivals. Had I known what it was going to be like at Woodstock I would have been there a week in advance like Henry [Diltz] and taken pictures of the transformation of Max Yasgur's dairy farm.

The symbolism of the cows in this photo is that Yasgur's farm was a dairy farm, one of several in the vicinity of the festival site. It turns out the cows in the area stopped giving milk for almost a month after because they were so disturbed, not just by the music, but the whole disruption of their routine. Some of the dairy farmers sued Woodstock for loss of earnings.

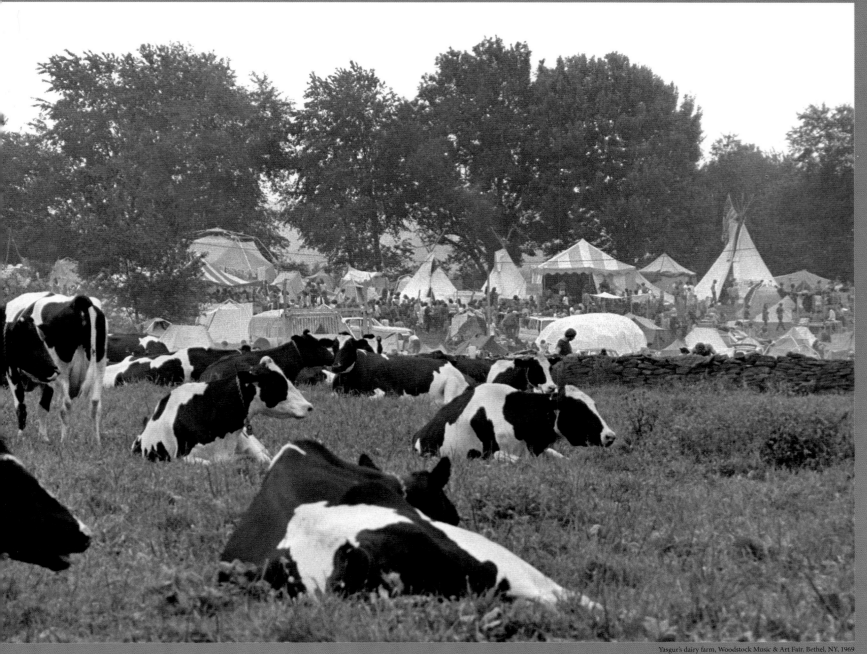

Yasgur's dairy farm, Woodstock Music & Art Fair, Bethel, NY, 1969

In one particular photo of the crowd, there is a totally naked guy hanging on the light stand; you can see his penis, his pubic hair, everything. After Woodstock a photo editor from the *Encyclopedia Britannica* called me; the *Encyclopedia* wanted to use one of my photos to illustrate their entry on Woodstock, so I sent them a few pictures. In the days before digital delivery we still sent prints. They published the crowd shot with the naked guy. (p.123). When they returned the picture they had airbrushed underpants on him!

The photo of the National Guard helicopter is for me an important picture because this was 1969 and the Vietnam War was still raging; there was constant stress and dislike between the counterculture and the military. "I'm not fucking fighting the war, I'm going to Canada; it's a bad war." "You're an unpatriotic hippie," they said. But here was the hated military and the despised people of the counterculture working together at Woodstock, which is the way it should have been all along because we're all Americans.

Lang had hired a bunch of off-duty police to work security but they were apparently scolded by the New York police department for joining the party and didn't do much to keep the peace. Maybe that was a good thing. Lang had also made a deal with the New York State Highway Patrol to assist in traffic control, but in the end they also didn't do much to help, which is one of the reasons these horrible traffic jams occurred. The officers were supposed to direct cars to the designated parking places and when they didn't, it just became a disaster.

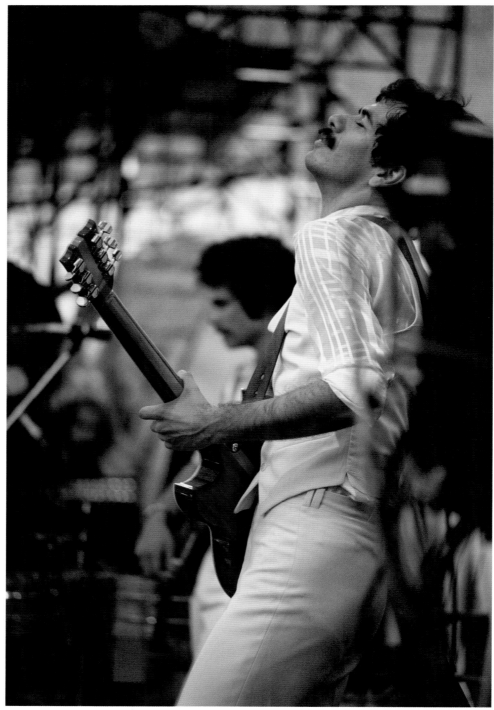

Carlos Santana, Day On The Green, Oakland Coliseum, CA, 1977

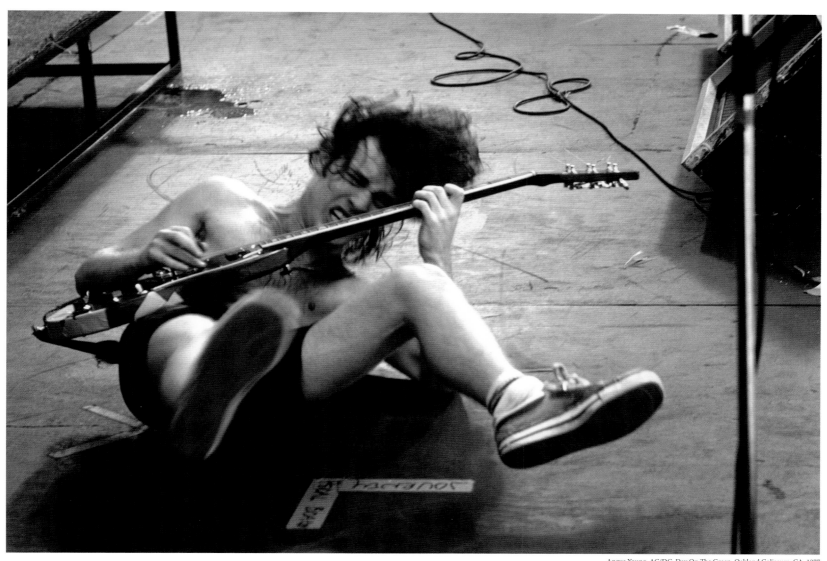

Angus Young, AC/DC, Day On The Green, Oakland Coliseum, CA, 1977

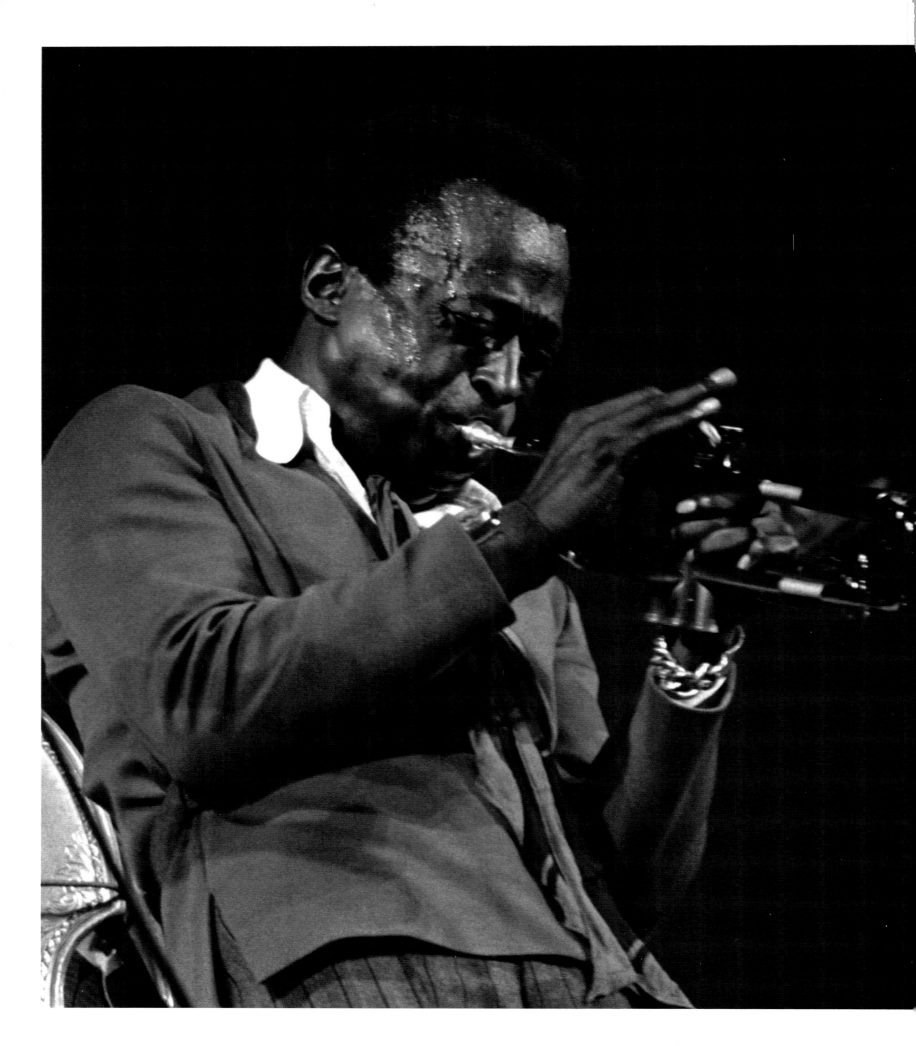

Miles Davis, Monterey Jazz Festival, CA, 1969

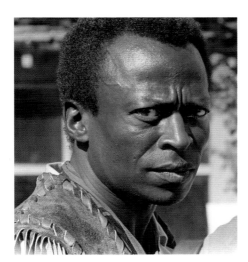

"Listen carefully to my music; I play like I box. You can 'hear' the jabs, the feints, the crosscuts, the uppercuts. You can imagine that I'm boxing when I'm playing." 131

Rod Stewart with The Jeff Beck Group, San Francisco, 1968

Rod Stewart appears to be looking longingly at Margaret (opposite) undressing. Talented and prolific Stewart obviously goes beyond the look. In August 2010, he and current wife, Penny Lancaster, announced the imminent appearance of Stewart's seventh child.

Margaret, 'It's All About The Next Moment' San Francisco, 1973

In San Francisco where I became acquainted with her, Margaret was a muse and friend to many. Touching upon the emotional power of fantasy, where a photo engages the mind of the viewer and takes reality to the next level, she titled this picture, "It's All About The Next Moment."

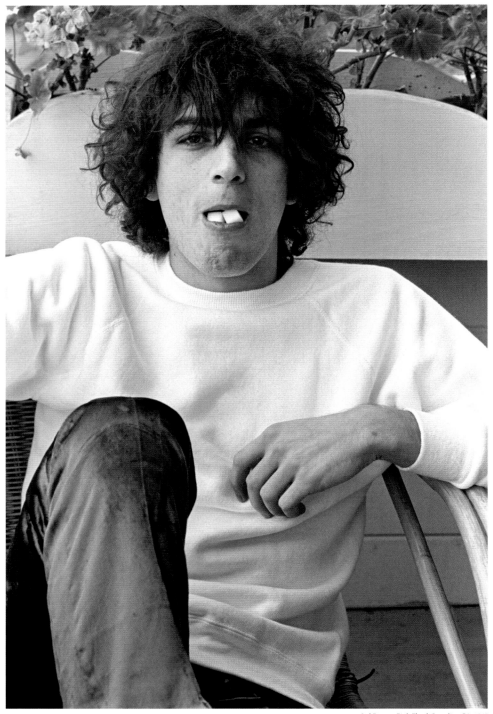

Syd Barrett, Pink Floyd, Sausalito, CA, 1967

photographed Pink Floyd's first visit to the US. They played the Fillmore for Bill Graham, but I didn't go to the show; it's embarrassing. Again in hindsight everything's so clear: the band photos I didn't take, the women I didn't sleep with. Hindsight is so gentle and so cruel. I love this shot of Syd. He was fooling around at the table while we were sitting on the veranda of their hotel having coffee. On the table was a little dish of sugar cubes for the coffee. I don't recall if it was his idea to put the sugar cubes in his mouth or if one of his mates called out, "Put the sugar cubes in your mouth Syd, show them what it's really like." One of the popular ways of starting an LSD trip was to suck on a sugar cube laced with high-grade acid, and Syd was a devotee. It's quite sad how it turned out for Syd; he looks so joyous and full of life here.

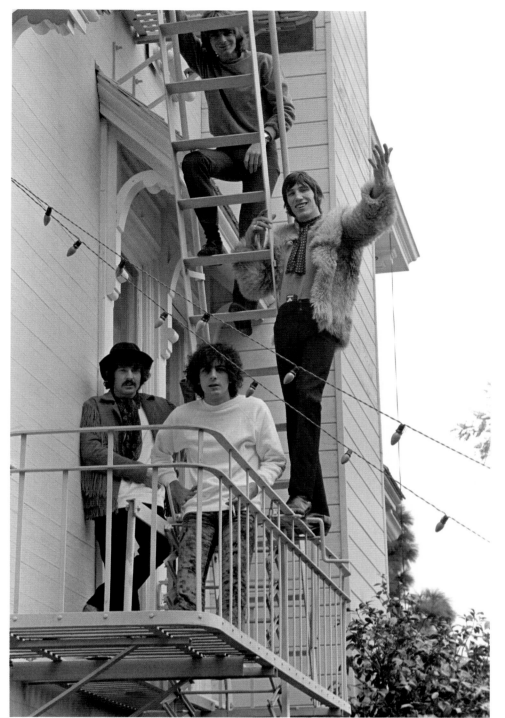

Pink Floyd, Casa Madrona Hotel, Sausalito, CA 1967

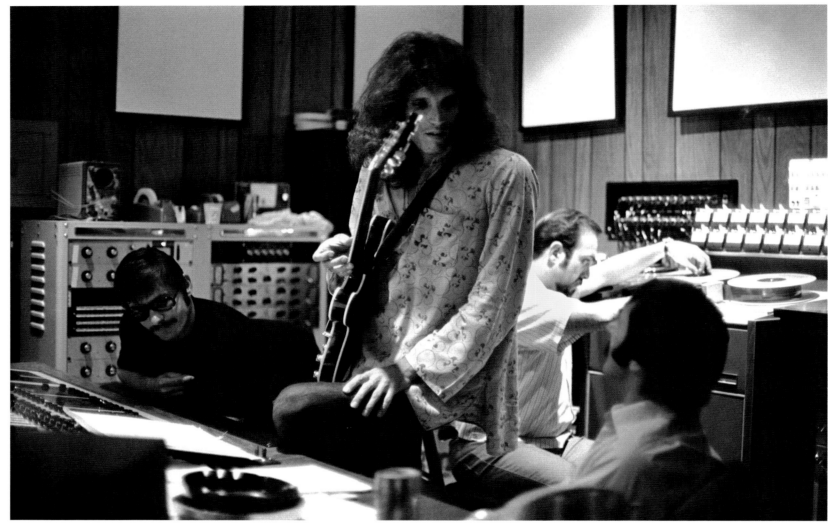

Jorma Kaukonen, Wally Heider Studios, San Francisco, 1969

In many respects, a music recording studio is hallowed ground where few non-musicians are permitted. It's where the final pieces of an individual song or an entire album are stitched together and prepared for release to the fans. Occasionally, it's also the scene of heated battles between producers and/or band members as each pushes for his or her vision of how the final product should sound. Recording studios come in various sizes and shapes, some as simple as the garage of a band member, some as elegant as a movie sound stage, each unique in size, shape and design. Here at Wally Heider's Hyde Street studio in San Francisco, Jorma Kaukonen, of The Jefferson Airplane, works on the Airplane's *Volunteers* album.

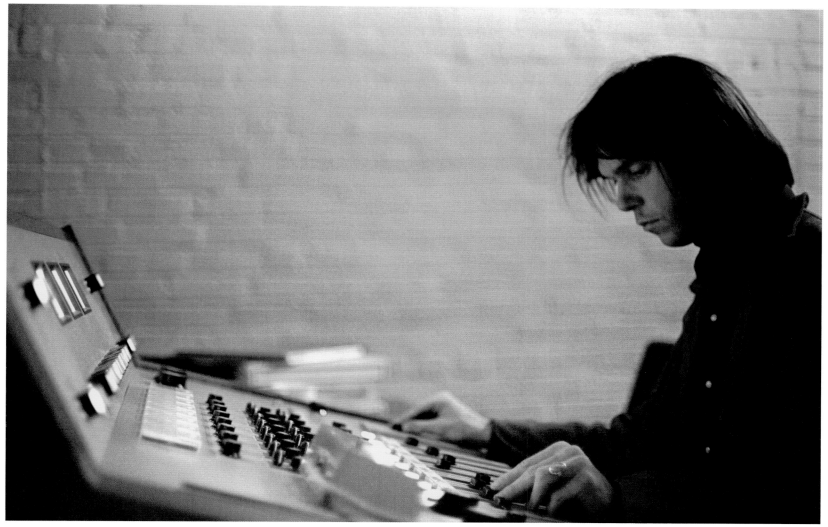

Neil Young, Los Angeles, 1969

In June 1969, I headed over to a recording studio on La Cienega Boulevard in Hollywood. All I remember is that I had been assigned by *Rolling Stone* to take some shots of Neil Young in that studio but I don't even remember what story we were doing about him at the time. Because I hated flash I neglected to bring along a strobe of any kind; the studio was surprisingly dark and I had no lights, so I ended up shooting a single roll of film at a very slow shutter speed and with the lens wide open. The results were barely adequate but Neil was enormously cooperative and allowed me the freedom (and privilege) to shoot as he worked at the mixing board.

Steven Tyler, Aerosmith, Day On The Green, Oakland Coliseum, CA, 1978

Bootsy Collins, Bootsy's Rubber Band, Day On The Green, Oakland Coliseum, CA, 1978

Because Graham gave me all-access to all the Day On The Green shows, I amassed an important – at least to me – collection of images. I shot on the stage and from the stage, from behind the stage, from the top row of the Coliseum looking back at the stage. I shot some of the most significant performers of the day, from AC/DC to Fleetwood Mac to the Rolling Stones to Santana, even Dolly Parton. Bootsy Collins performed once; now that guy was photogenic, how could you not photograph him well? For a photographer to make compelling pictures he or she must be able to shoot a musician who not only plays good music but knows how to present him/herself on stage. You get great performance photos if they know how to move or if they are dressed, well, weird. I don't know what you call the outfit Bootsy was wearing but it sure was colorful and he sure looked amazing. I will always believe that Tyler's gesture was simply one of true affection toward me...

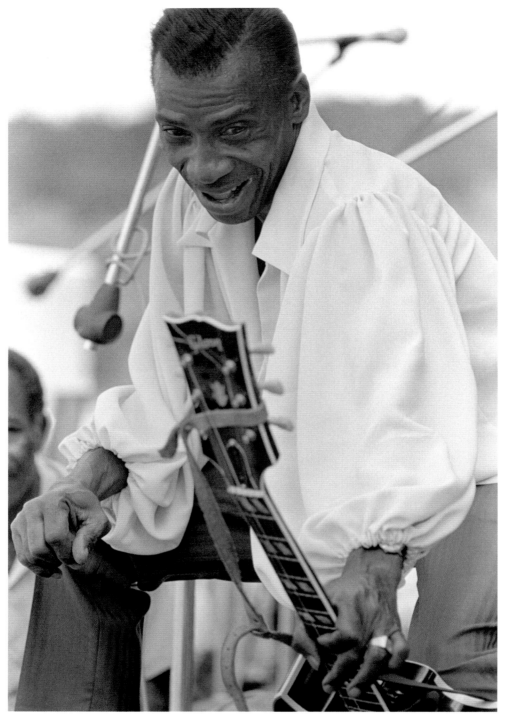

T-Bone Walker, Ann Arbor Blues Festival, MI, 1969

140

Sonny Rollins was wailing in performance at the Greek Theatre, an outdoor venue on the campus of the University of California in Berkeley. Notice Rollins' shadow behind the mic stand. I love the scale of this photo.

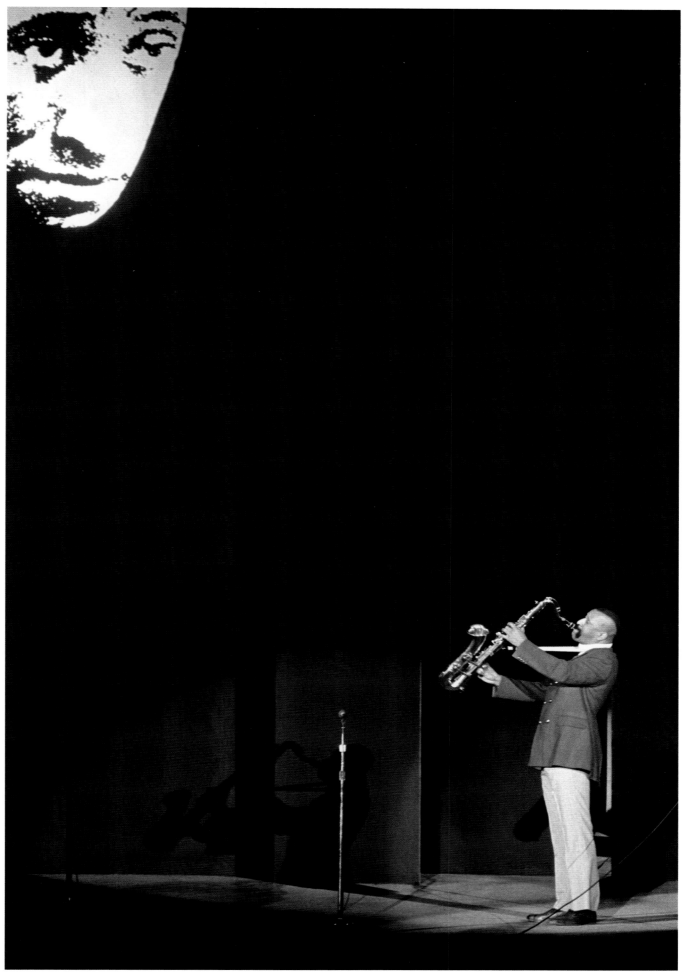

Sonny Rollins, Greek Theatre, University of California, Berkeley, CA, 1969

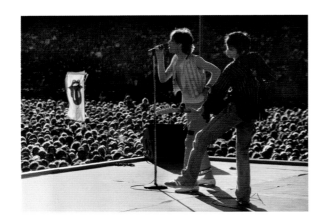

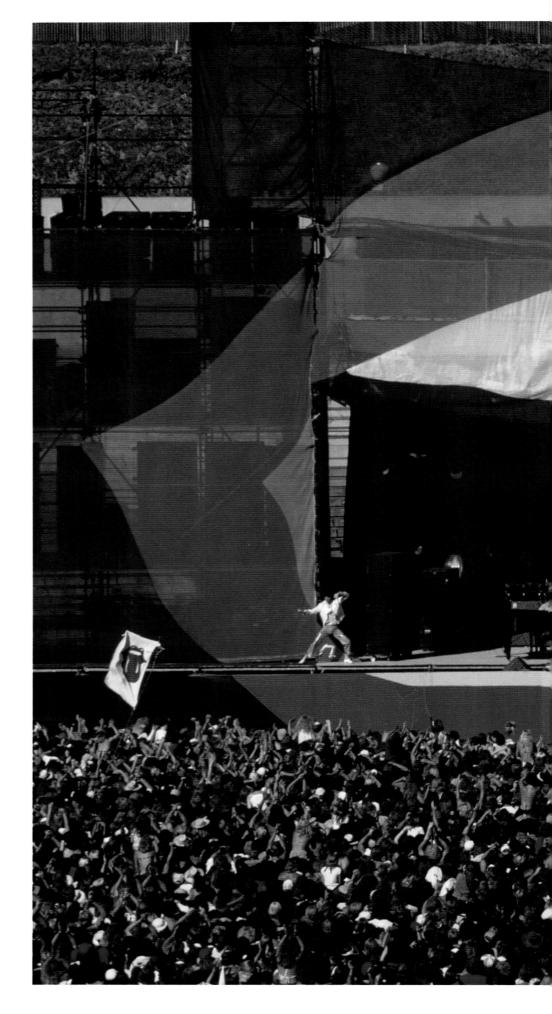

I considered it a gift from Bill and The Rolling Stones that they allowed me on stage to shoot the July 1978 show. It was the first time I had been on stage with the Stones and I tried to make the most of it. The pictures you get on stage are so different from the ones you get from the front. At Oakland the sunlight always came from the front of the stage so you could shoot some amazing back-lit pictures, like the Stones logo flag lit from behind. On stage you could include details that were pretty much obscured from the crowd; the parallel stripes on the classic Adidas sneakers that Keith Richards was wearing, for example.

The "big lips" that comprised the set of the July 1978 concert were allegedly a birthday present from Bill to the Stones, to Jagger, in particular. Mick was born on July 26, the date of the concert. For the record, this was the line-up for the day: Peter Tosh, Eddie Money, Santana, and The Rolling Stones. Not a bad afternoon of music. Ticket price: $12.50...!!!

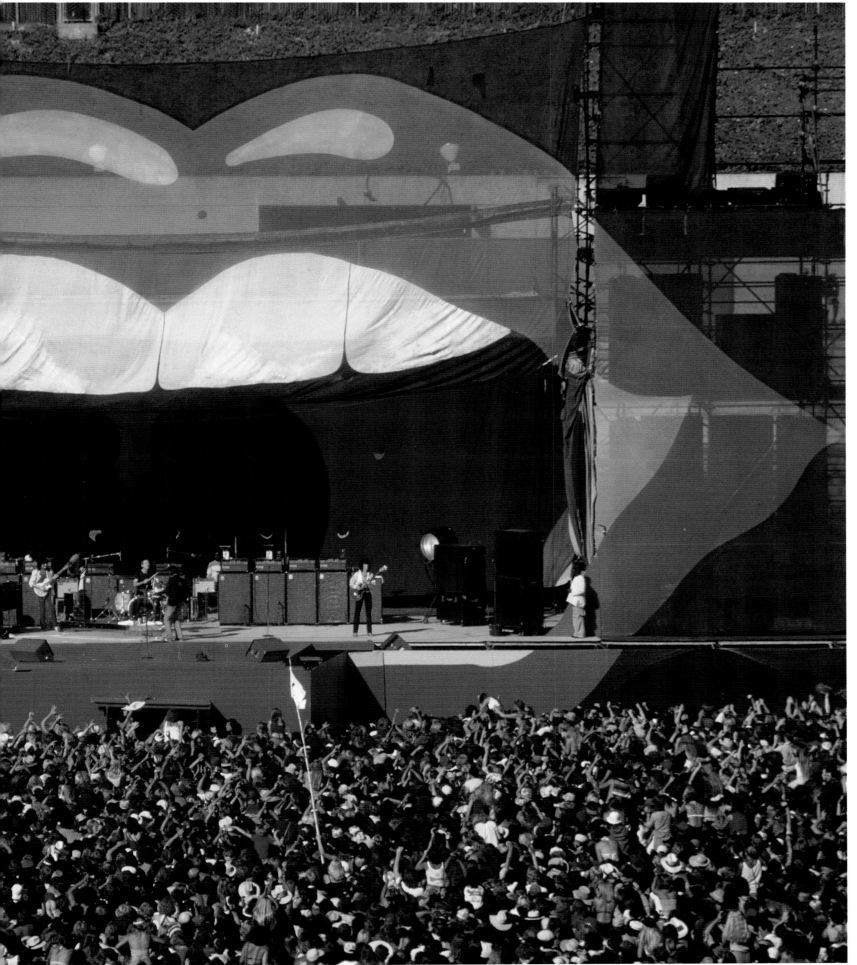

View from the audience, The Rolling Stones, Day On The Green, Oakland Coliseum, CA, 1978

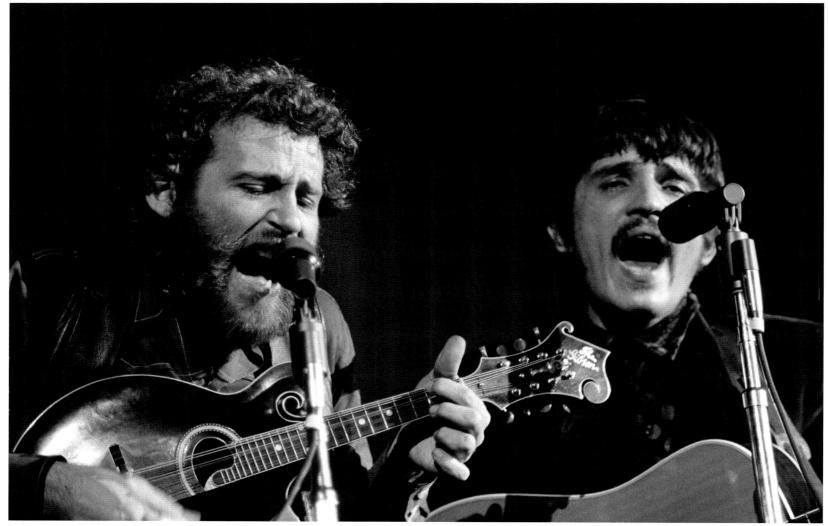

Levon Helm and Rick Danko, The Band, Winterland, San Francisco, 1969

When I photographed The Band in performance on Winterland's big stage it was virtually impossible to get the entire group into a single frame. I tried from a variety of angles but somehow the five of them were never arranged in such a way that I could fit them all into a good photo at one time. In the end I simply photographed them individually or two together. At the larger venues live photography presented considerable challenges, much different from shooting at the smaller clubs.

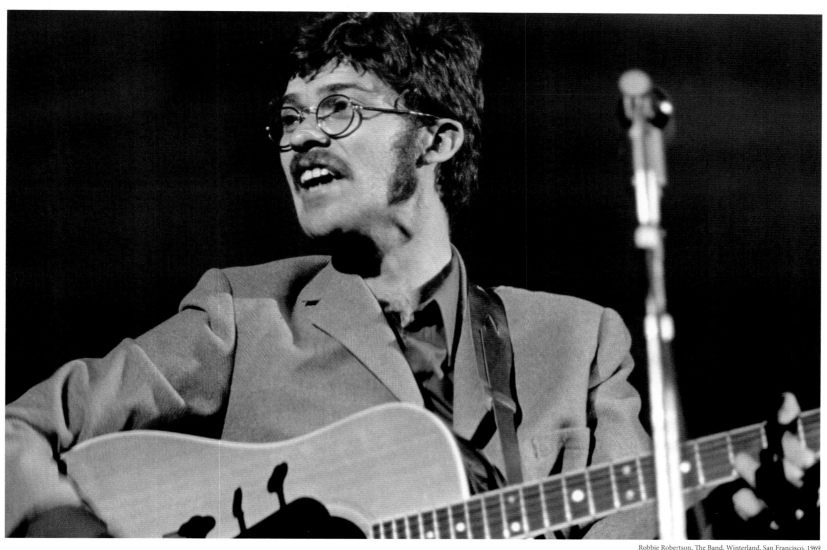

Robbie Robertson, The Band, Winterland, San Francisco, 1969

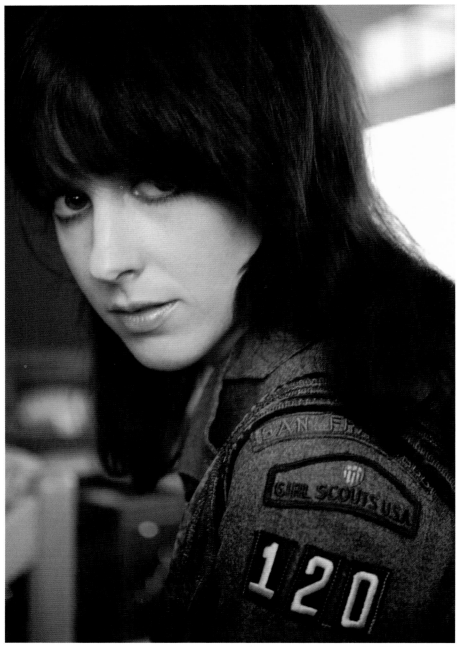

Grace Slick, San Francisco, 1968

For the issue of *Eye* which included a story on both Janis and Grace, I asked Grace to pose for me in her Girl Scout vest. From that session I got one particularly perfect, really cool photo of her, one that years later, when she started painting, she used as the basis for one of her canvases as well as her website logo.

Eye also needed color pictures of Janis performing for the same story. Because I didn't have any color pictures of Janis, I called her up to see if she had any concerts scheduled so I could shoot her singing in color. Unfortunately – or fortunately as it turned out – she didn't, so I suggested she come over

to the studio in the house. I told her I would set up the lights as if she was on stage and asked her to bring a microphone so we could simulate a real performance. I told her she could lip-sync, she didn't have to sing at all. To create the right environment she also brought along a little player with a Big Brother tape; she wanted

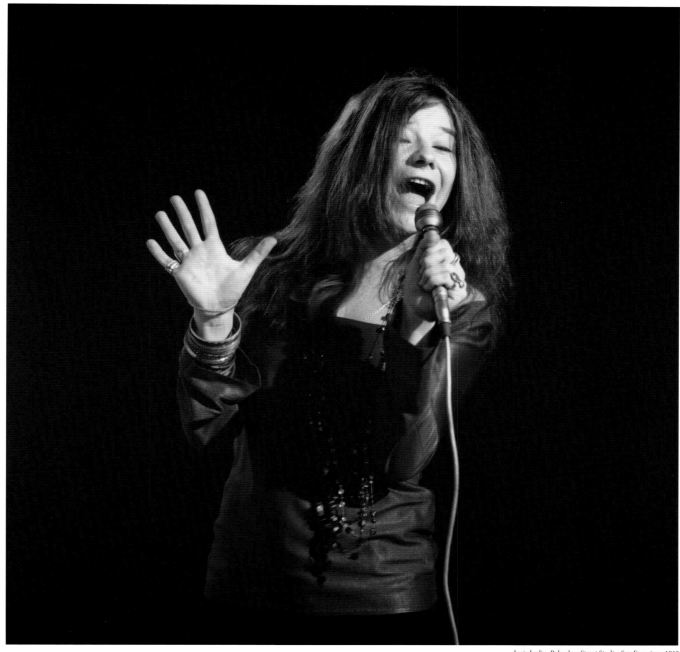

Janis Joplin, Belvedere Street Studio, San Francisco, 1968

some accompaniment. I switched on the lights and, as I had suggested, she started lip-synching – for about 30 seconds, then she started actually singing – very quietly – for about three minutes. But Janis being Janis, a few minutes later she was singing full-tilt, literally performing as if she were actually on stage. I don't know what goes on in the head of performers; maybe they either perform or they don't perform. But as I recall Janis could not "not" perform, so for an hour she gave me the gift of a Janis Joplin live performance. I call it "The Concert For One." I was taking pictures and she was singing just for me alone. Toward the end of the shoot Juliana came home from ballet practice, and because the studio was upstairs she heard the music but could tell it wasn't a recording. So she came up, peeked in and saw that Janis was singing and I was shooting. She ran down to Haight Street, bought a red rose, then raced back to the house and presented the rose to Janis.

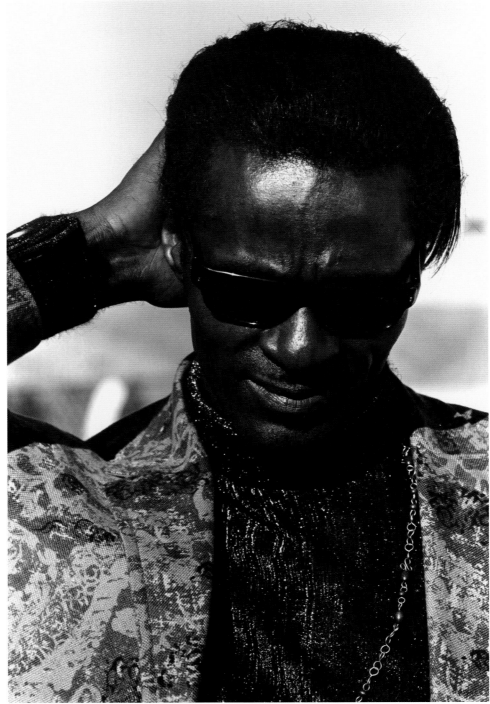

Chuck Berry, The Northern California Folk-Rock Festival, San Jose, CA 1969

In early 1969, Jim Marshall and I signed a contract to produce photos for a book to be called *Festival! The Book of American Music Celebrations*. Jerry Hopkins joined us to pen the text. As Jerry wrote in his introduction, "What could be done outside, under sky and trees – in groups – that would provide the merry outlet man seemed to enjoy, and perhaps need, so much?" In 1969, the answer became so evident that reports of the new phenomenon often swept news of the Vietnam War aside. The "answer" was the music festival. The Latin word for celebration is festum, meaning "feast." And that's what the contemporary music festival has become – a feast for all the senses, of sight and sound, and taste and smell and touch. It was to record this rejoicing that Jim and I set out that summer to visit an eclectic mix of American music festivals, from country and western to blues and folk, bluegrass, jazz, and rock and pop. Jim and I had our Nikons and our

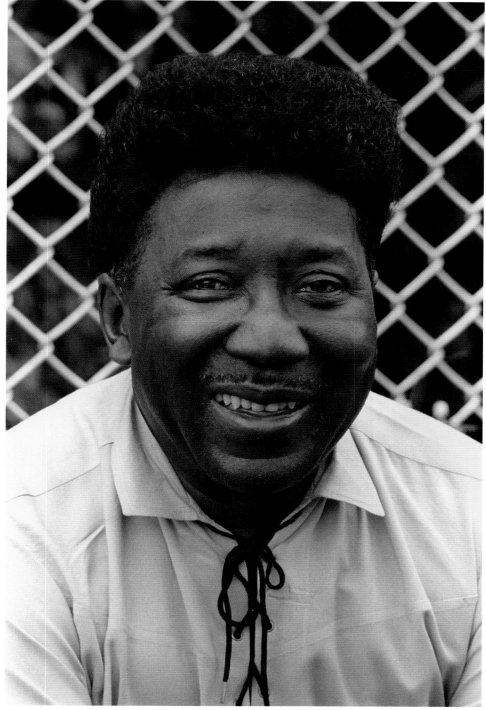

Muddy Waters, Ann Arbor Blues Festival, MI, 1969

Leicas and our all-access passes. We were doing what we loved – making honest pictures of truly memorable events. Some of the festivals we attended together, some alone. We wandered through the audiences and hung around backstage with the musicians. We had complete freedom to take pictures from any vantage point and of any subject. It was a dream project. When we first headed out on our festival expedition Woodstock was not on our itinerary. Somewhere along the line we became aware of what was planned for Sullivan County, New York, and detoured to Bethel, where the Woodstock Music & Art Fair finally landed. While Jim concentrated on the musicians, I turned my cameras mostly upon the crowd. *Time* magazine's story on Woodstock presciently suggested that the Woodstock festival: "may well rank as one of the significant political and sociological events of the age." And so it became.

The disaster at Altamont ended the dream that had begun at Woodstock. What was bright and full of joy at Bethel, New York, was dark and foreboding on the edge of the San Joaquin Valley, halfway between Livermore and Tracy, California. I looked out from the stage at Woodstock to a sea of calm, joyful, expectant faces. I looked out from a hillside at Altamont to a dark, gray scene, resembling a warlike tableau with the hordes descending upon the battleground. To this day most memories of Woodstock are happy ones. Nowadays, few people even remember Altamont; the ones who do recall a crowd that was agitated and progressively violent. In the words of one commentator, "Fueled by LSD and amphetamines, the crowd had also become antagonistic and unpredictable, attacking each other, the Angels, and the performers." Peace, love, and music were nowhere to be found.

Altamont Free Concert, Altamont Speedway, Livermore, CA, 1969

Flower children, Presidio, San Francisco, 1970

Timothy Leary tripping in Jann's *Rolling Stone* office, San Francisco, 1969

Lotti Golden, New York City, 1969

Ahmet Ertegun, New York City, 1969

Ahmet Ertegun and Jann were friends. After *Rolling Stone* moved to New York, Jann had more time to hang with the music executives he had admired, the ones who had helped him build his successful magazine. Ahmet would regularly tour the New York area clubs looking for new musical talent and Jann would often go along. Late one evening when I was in New York on assignment, Jann and I went clubbing with Ahmet. We would go into a club, sit there for a while, and Ahmet would decide whether or not he was interested in the band. He had a good ear, would make a pretty quick judgment. It went on like that late into the night; we'd leave one club, crawl back into the waiting limo and head off to the next. For whatever reason – somehow I remember Jann being briefly involved in her career – Ahmet signed a singer named Lotti Golden. Lotti wrote some good songs and sang well – and she was very photogenic! It's a shame her record was not more successful.

155

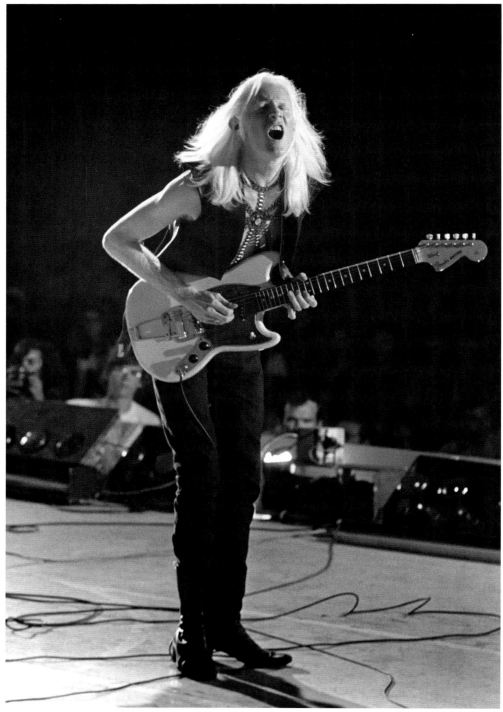

Johnny Winter, Memphis Blues Festival, TN, 1969

This picture of Johnny Winter was taken at the Memphis Blues Festival when Jim [Marshall] and I were on tour. We weren't always together at the same festival; between us we covered all the shows, sometimes alone, sometimes together. Memphis was a festival we both covered. Johnny was another example of a musician who was easy to photograph, if for no other reason than his bright white hair and pale white skin. He was so "unexpected" looking, especially for a blues guitarist, and anything that is unexpected, out of the ordinary, usually makes for wonderful pictures. Nor did Johnny Winter move with the particular elegance and grace often attributed to guitarists. Some guitarists are like dancers in the way they play and how they move – everything works together in visual harmony. Others either stand quietly concentrating on their fingering or, like Winter, jerk around in some discordant way. Here Johnny jerked and then stood tight, seeming to scream in pain (or ecstasy).

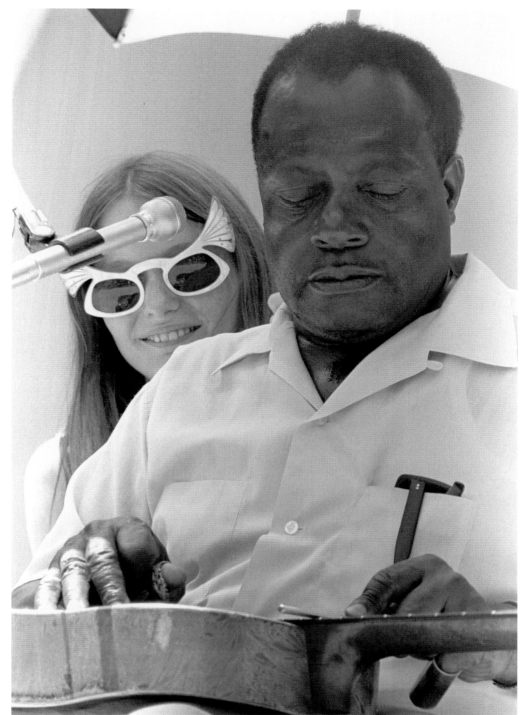

Bukka White, Memphis Blues Festival, TN, 1969

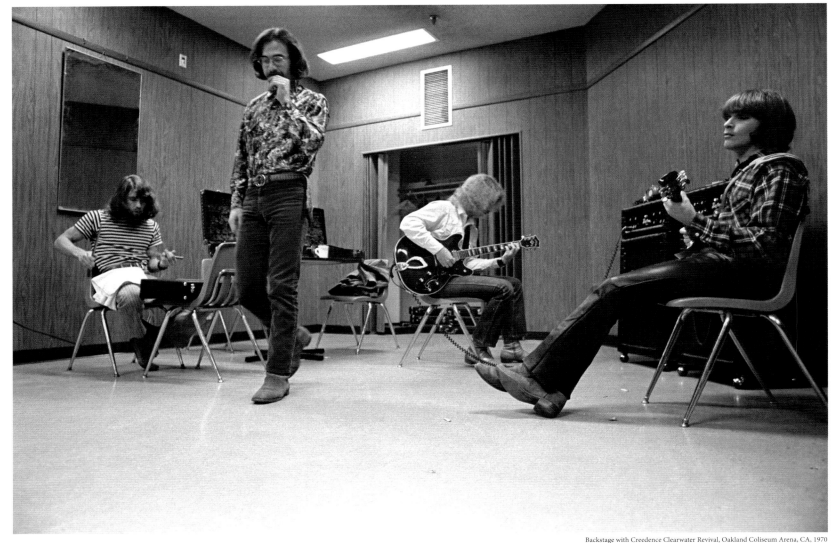

Midday on January 31, 1970, the four members of Creedence Clearwater Revival arrived on Belvedere Street in a black limo to be photographed in the upstairs studio at my home in the Haight-Ashbury. The photo session was for a *Rolling Stone* feature story; one of the pictures eventually ran on the cover of Issue No. 52.

Later that same day CCR played a concert in the Oakland Coliseum Arena, on the same stage where I had photographed the Stones for the first time only two months prior. Jim Marshall and I arrived early – Jim always arrived early everywhere. As usual, we both had all-access permission to go where we pleased; in the early Seventies the

bands still trusted us. We hung around backstage with the group as they tuned their guitars and their minds, then followed them to the stage for the performance. I grabbed a great shot of a camera-bedecked Jim before the band started playing, then wandered the stage as Creedence proceeded to move through their play-list to an adoring crowd.

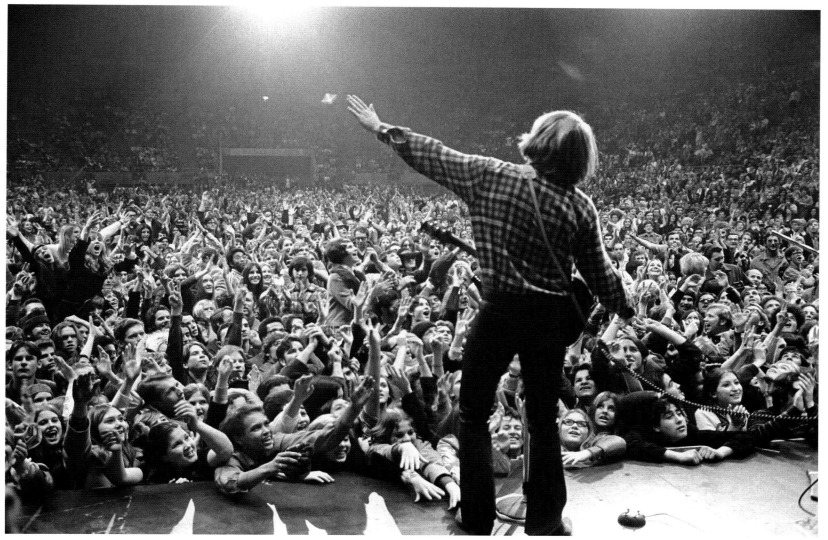

John Fogerty, CCR, Oakland Coliseum Arena, CA, 1970

After the debacle at Altamont a month earlier I was surprised not to see a security "moat" between the fans and the stage, but this was clearly a crowd of a different ilk: young and affectionate. In one of my favorite concert photos, John Fogerty, with his arm raised like a cleric addressing his flock, appears to be a musical evangelist.

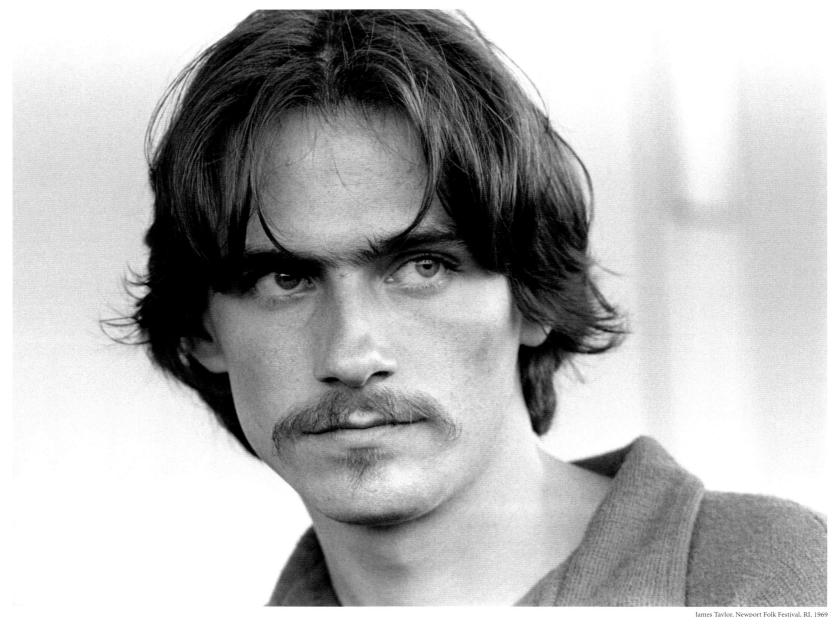

James Taylor, Newport Folk Festival, RI, 1969

This photo of a 21-year-old James Taylor was taken in the summer of 1969 at the Newport Folk Festival on our *Festival* book tour. I particularly like this picture because of the intensity of his eyes; there's something in his look that goes beyond normal, but maybe I'm reading too much into it. It was a great musical line up at Newport that year: Van Morrison, James Taylor, the Everly Brothers, Joni Mitchell, Big Mama Thornton, Pete Seeger, Judy Collins – the list was long, a terrific mixture of true folkies and blues musicians. It was at Newport in 1965 that Bob Dylan went electric for the first time, allegedly to boos from the audience, although there is now some question as to whether that was indeed how the audience reacted.

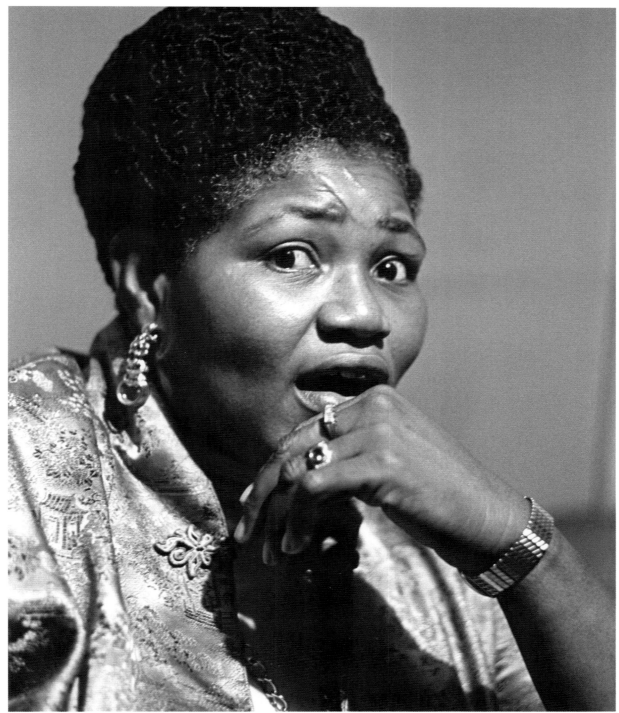

Willie Mae "Big Mama" Thornton, San Francisco, 1968

Willie Mae "Big Mama" Thornton sang at the Newport Folk Festival, one of our stops on our 1969 *Festival* tour. Janis always gave credit to Big Mama, explained how she had been hugely inspired by her, that she listened a lot to Big Mama's music. Big Mama's song 'Ball And Chain' became a Janis classic.

One night at Newport Jim and I were both shooting at an outdoor stage. It was crystal clear with a full bright moon hanging overhead, a perfect summer night, a night I'll never forget. I looked up and said, "Jim, think about it. Those mother-fuckers are walking on the moon right now while we're shooting this concert."

It was July 20, 1969 and Neil Armstrong was up there in the sky talking about "one small step for man…" Had you asked Jim, he would have told you how time suddenly stood still for us and what an amazing moment that was.

161

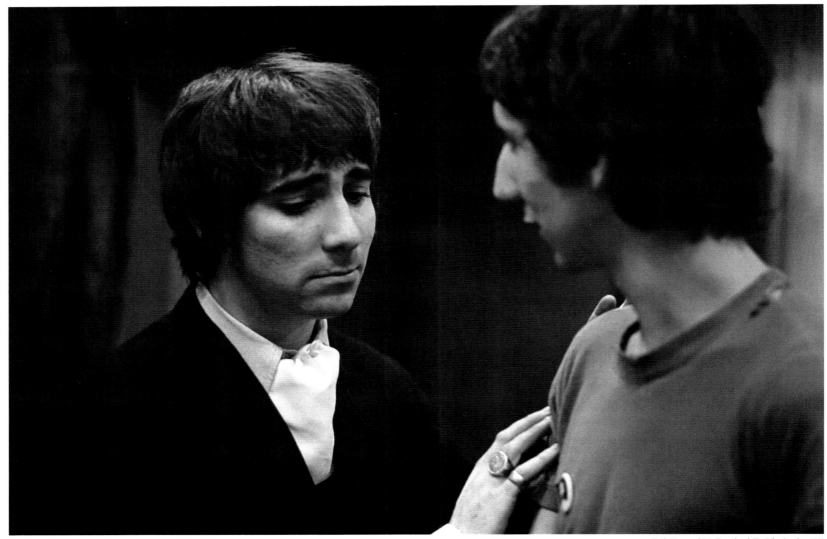

Although The Who's energetic (to put it mildly) drummer Keith Moon passed away pretty much 10 years to the day after I made this photo, I've always imagined the picture reflected a premonition of his early demise. Not that he didn't help the process along – his behavior was widely understood as "irregular" and often self-destructive.

Or was he thinking here of the lyrics he wrote for The Who's song, 'I Need You'? "Please talk to me again, I need you."

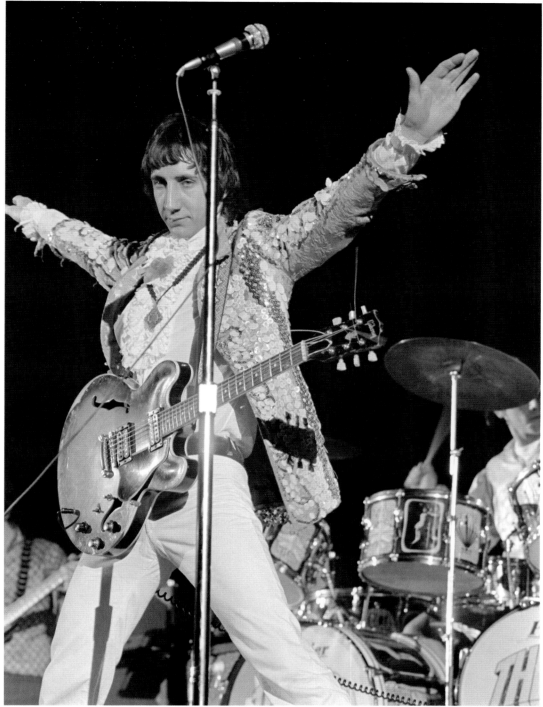

Pete Townshend, The Who, San Francisco, 1967

Every photographer has a series of photographs he or she considers "iconic," moments captured in time that somehow communicate an emotion. This shot of Pete Townshend is an example of one of mine, as are those of Jimi Hendrix, Jerry Garcia, Frank Zappa, Johnny Cash, Mick Jagger and only a few others.

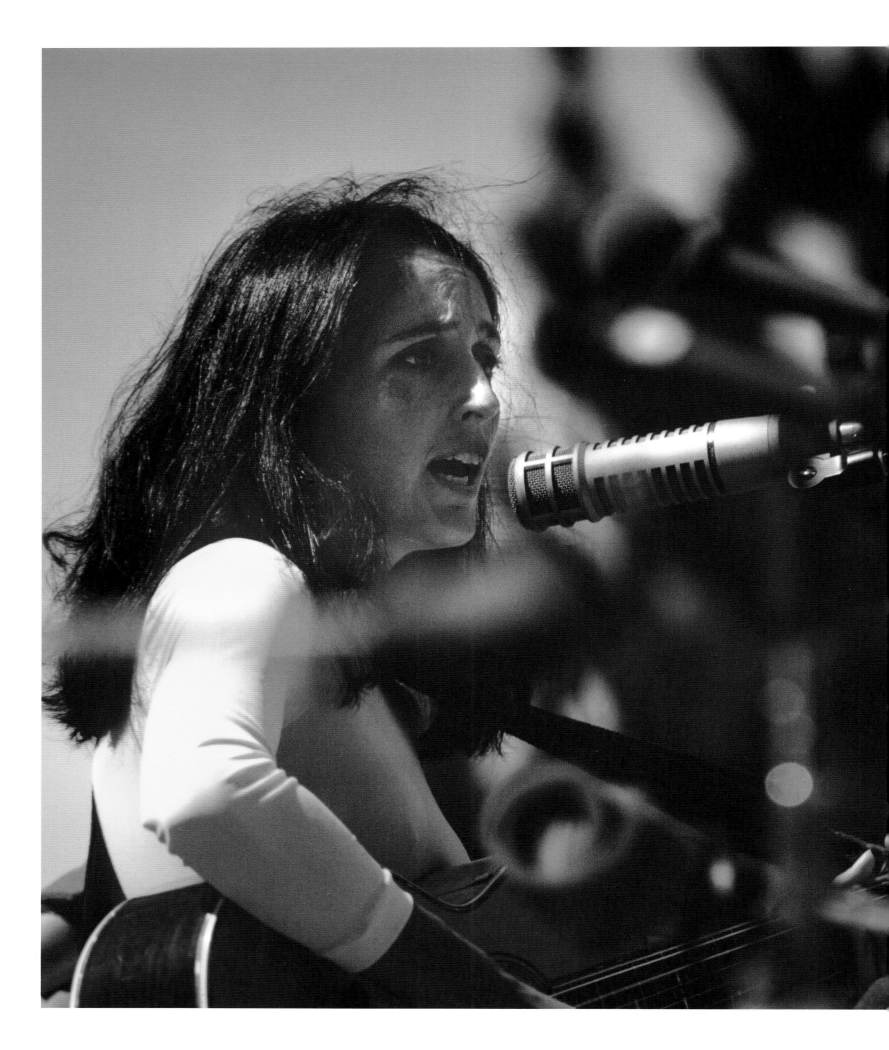

Joan Baez, Big Sur Folk Festival, Esalen, Big Sur, CA, 1969

The current (and unacceptable to me, at least) burden put upon music photographers who are shooting concerts is an odious rule dictated by management: "You get two, maybe three songs and you're done." As somebody who has respect for musicians, the audience, and the profession of photography, I'm offended by the rule. What possible difference does it make to anybody's concert experience if professionals are taking pictures (and respectful of the musicians and the audience)? Who does it affect? My personal theory about the origin of the "two song rule" is that it began with Joan Baez.

Joanie played acoustic almost all the time, accompanying her serene lovely voice; she sang solo but not very loud. A Joan Baez concert was hushed, much like a classical music performance. She would start singing: quietly and beautifully and pretty soon you would hear "click click click click," shutters snapping, camera mirrors bouncing up and down. Everybody in the audience would hear the noise and look around; how could you not? At one particular concert in Madison, Wisconsin, I remember that Joan stopped mid-song and said, "OK, hold on, let's just stop here for a moment. I appreciate the fact that you're here and that you want to record the moment and take my picture but listen to the noise you're making. There are people here who don't want to take pictures, who are here to hear the music. So I'll tell you what, you can take all the pictures you want for two songs; snap to your heart's content but after that I don't want to hear anymore cameras. Please."

Pictures from the first two songs, even if they are technically and compositionally brilliant, will all look the same; everybody there shoots the same picture. What's the point? Who is the beneficiary?

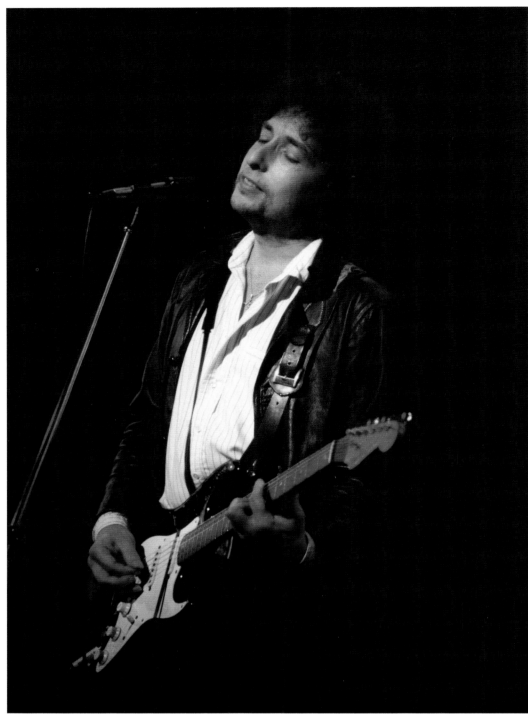

Bob Dylan, *Slow Train Coming* tour, San Francisco, 1979

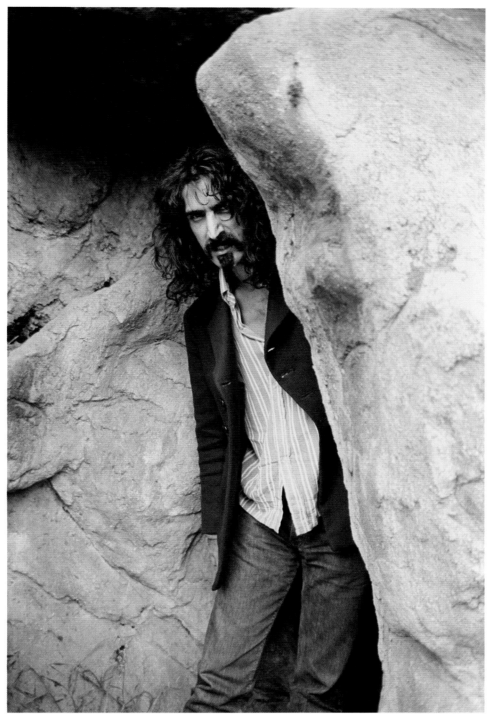

Frank Zappa at home in Laurel Canyon, Los Angeles, 1968

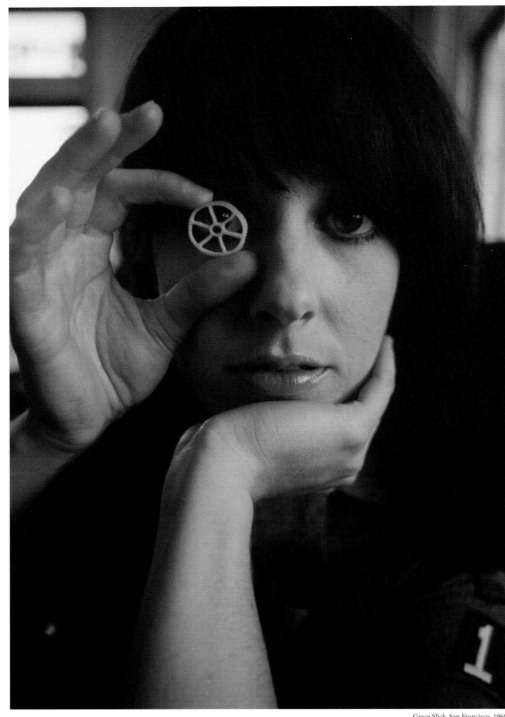

Grace Slick, San Francisco, 1968

Grace Slick had an ironic, eccentric and razor-sharp sense of humor. Just the way she regularly wore her Girl Scout dress said something about her attitude toward both the organization and the trappings of the good-girl-world from which she had come. Grace is a talented and lovely woman and, to my eyes, in the Sixties she was incredibly beautiful. Hers was the perfect Sixties female face – perfect features, perfect mascara, perfect lip gloss, plus she was intelligent and she was an extremely talented singer. When I looked through the lens at those liquid lips I wanted to reach out and kiss her. But I was married and kept my desire in check. The film *Blow-Up* and first-hand experience taught me much about women and photography, paving the way to many memorable studio experiences. Other than the murder and the Bentley convertible seen in the film, those were my days, too: rock music, fashion, lovely young women, and gritty street photojournalism. It was a wonderful life…

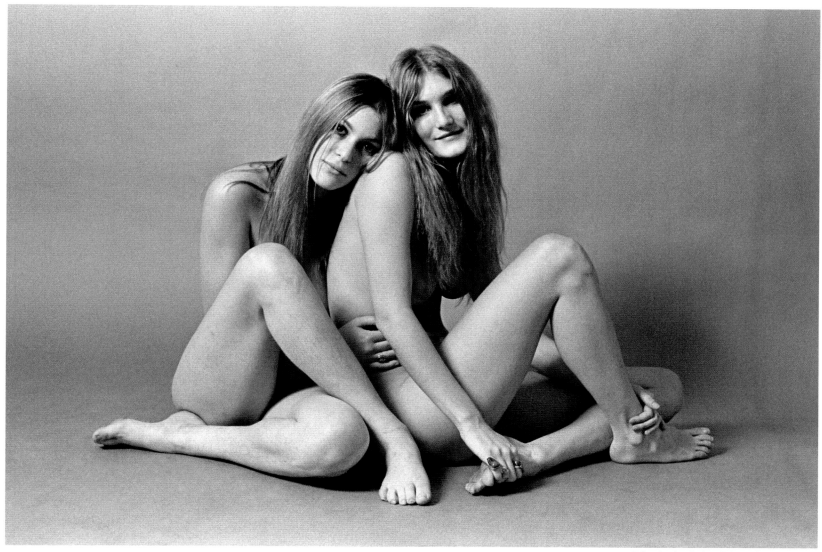

Vicki and Marlene, "We're With The Band," San Francisco, 1969

Periodically bands would come to my home studio to be photographed. One particular band arrived with some beautiful young women (what else) in tow. I shot the photos of the musicians and when we were done the guys told the girls to get naked so I could photograph them all together. Two of the women also posed together for me alone; one of those shots turned out great, more than great, so the next day I took a print into *Rolling Stone*. Everybody in the office also loved the shot and it was published in the next issue on the same page as the publishing information. That particular spot was always reserved for a unique horizontal photo, sometimes even without a caption – just an excellent picture speaking for itself. I loved that Jann had the audacity and the confidence to run even nude photos for no reason other than they were first-rate pictures.

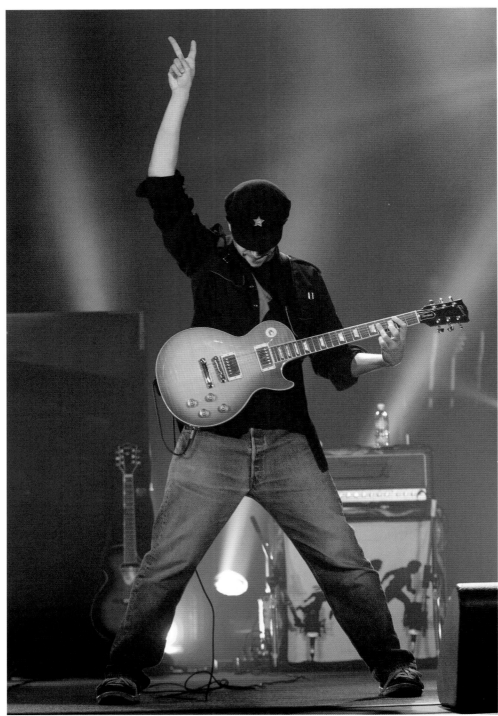

Tom Morello, Audioslave, Warfield Theatre, San Francisco, 2003

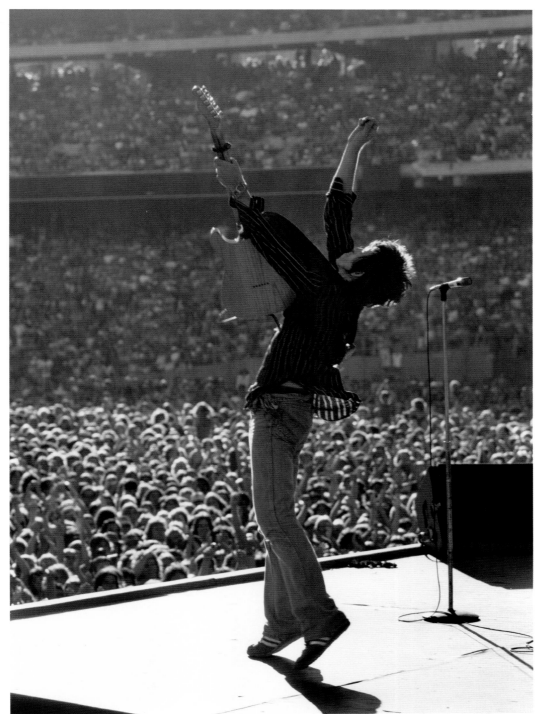

Keith Richards, Oakland Coliseum, CA, 1978

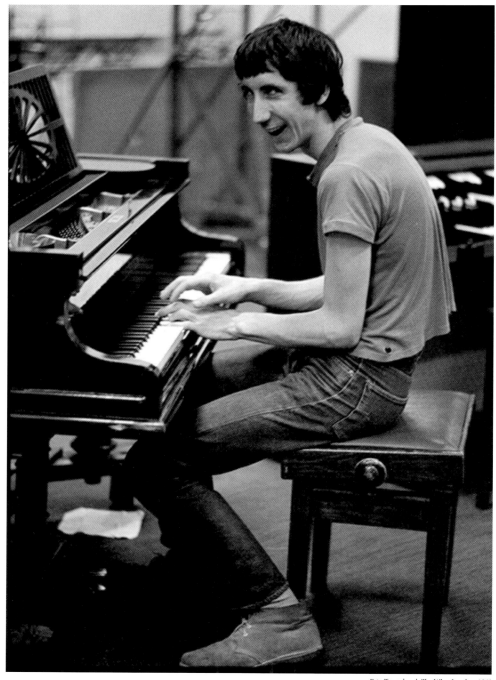

Pete Townshend, The Who, London, 1968

Rock music, fashion, lovely young women, and gritty street photojournalism.

It's a wonderful life...

When Everything Was Possible

There is something that all the great photographers I have worked with seem to have in common when it comes to assessing their work. They feel it's neither good enough nor extensive enough. Not a ploy to garner reassuring compliments but sincere humble frustration, recalling opportunities felt missed and the desire for better results. Pioneers in music photography such as Barry Feinstein, Jim Marshall, Bob Whitaker, and even the truly prolific David Gahr, all recognize no more than a handful of their own images they would call "great".

Baron Wolman, also a pioneer in the field of music journalism, says much the same thing but at times more strongly, partly because his music archive covers a smaller, more specific window in time than many of his contemporaries, and less than he would, with hindsight, have liked. When looking through his archive it is clear that this is an important collection for many reasons. The volume, although larger than suggested, is not an issue when you see that what Baron did capture is more important than anything he may have missed and like most working photographers, an edit that fulfilled the brief at the time left many other great shots overlooked.

Baron not only witnessed what is without doubt the most important period of change in popular music and popular culture but his photographs helped shape it. By 1967 it was clear that rock 'n' roll was indeed "here to stay" and the first wave of teenagers to feel its influence were now themselves, in a position of power and influence. *Rolling Stone* magazine encapsulated and distilled the most important events and changes as they were taking place. Each issue would speak to this evolving youth culture in a language that was all their own and Baron's photos captured the events and personalities and visualized the music.

Fans could see the musicians they listened to in ways they would never normally get to see, unguarded, honest, trusting and at times... equal. *Rolling Stone* readers could see the artists they knew and loved and also be exposed to new talent they had never heard of. They would copy the looks, adopt the poses, or simply admire and learn as much as they could about their idols.

Baron's informal – but not simple – style enhanced the persona and at the same time pulled back the curtain revealing the reality of his subjects. Jimi Hendrix seemingly out of control performing, a soft introspective smile in the quiet of his suite; The Who joking around in the studio as they record the epic *Tommy*, smashing guitars and letting off bombs in concert; Johnny Cash's troubled stare in his dressing room, the perfect country showman on stage; Janis performing a unique solo set in his bedroom or hanging out playing pool and so on. Insights like these are expected now and without exception, stage managed by media savvy artists and their advisers, but back then it was all new, exciting, and incredibly influential.

What is also very important but often overlooked, is how Baron's photography opened the door for the countless people who, inspired by his photographs, decided to pick up a camera and shoot music themselves. He was the first in a long line of acclaimed photographers to shoot for *Rolling Stone* or cover the music scene as we now expect to see it, each developing his or her own style out of what was learned from their predecessors. In the pre-digital photography world, every frame counted. Film, processing, and printing was time consuming and costly with deadlines always looming. Baron's experience as a photojournalist brought technical excellence, an understanding of light, composition, and timing, instinctively feeling what each photograph needed.

Rock 'n' roll has become acceptable, even respectable as a way of life, a way of earning a living as a musician, writer, or a photographer but only because of the pioneers in each respective field. Baron's *Rolling Stone* years captured that brief period when everything was possible and everything was changing. Part of this change, over many years, saw access to artists dramatically restricted and with little long-term benefit to anyone. As a result there are glaring photographic omissions in parts of the careers of many big name artists who perhaps foolishly decided they didn't need photographers around them. Even younger bands in tiny venues now control access, assigning "passes" to a photographer who may have to sign away ownership of their pictures and their point of view. Artists are more guarded and controlled, fans more demanding and fickle and the need for new information constant, regardless of quality. Baron moved on from shooting music just as these conditions started to creep in, successfully working in other areas of photography that allowed the freedom he needed and expected.

As for these pictures telling a story, they certainly do. Every musical genre is covered, decade's spanned, history recorded and lives changed. Today's musicians try to recreate the perfect guitar pose or appear cool and natural offstage, ironically enough just as they had seen in vintage copies of *Rolling Stone*. No matter how hard they try it can never look the same because they are trying, and it's all been done before, now many times over.

Everything has changed but then again, not much has changed.

Dave Brolan, Picture Editor, London 2011

Dreams That Came True

The times they have a-changed, the music has changed, the cameras have changed, but my gratitude for the opportunity to document a unique and significant moment in the history of our country persists.

I couldn't have done any of this without parents who allowed me to "follow my bliss," without the many talented artists who make and play the music, without the vision of a young Jann Wenner.

When I picked up my first camera and looked at the world through its viewfinder, I discovered form within chaos. Although I didn't realize it at the time, my life had changed dramatically and forever, my course was set. Because I often become lost in the rapture of taking pictures and find myself in the "zone" – as creative people often describe moments of extreme creativity – I am reluctant to take credit for my photographic successes. The "zone" is a place where I feel the creative force flowing through me, not from me.

Control was required, however, over my cameras, mostly Nikons with an occasional Leica and Hasselblad. In those days there was no auto-exposure, no auto-focus, no motor drive, so I needed to be absolutely familiar with the basics of photography. The majority of my photos in this collection was taken with the then new Nikon-F and its several lenses, a highly reliable and desirable system. I shot film, mostly Kodak Tri-X, developed it, and made contact sheets and prints in my own darkroom.

This book, too, was totally under our control, from conception through gestation and birth. Dave Brolan, friend first and picture editor extraordinaire second, proposed the idea, arranged the contract with… After several oh-so-difficult days in the cafés of Paris recording my reminiscences – from which much of the book's conversational styled text is comprised – Dave moved into my Santa Fe guestroom and studio where he spent hours poring over my small (he thinks it's big) archive of music photos.

My trusted associate and friend, Dianne Duenzl, scanned her heart out, creating digital files of Dave's selections. Dianne also helped us edit, both text and pictures – her suggestions were often insightful and inspired, and for her input I'm hugely grateful.

Graphic designer Don Wise – yet another of the innovative Wise brothers – took the book's raw material and together in the company of his own trusted associate, Kim Maharaj-Mariano, built this outstanding paper elegy to the "important and exhilarating" Sixties.

Thanks also to Tony Lane and Jerry Hopkins for putting words on paper to introduce this book of events remembered and dreams that came true.

Baron Wolman, Santa Fe, 2011